GUERNICA

THE LANDMARK LIBRARY

Chapters in the History of Civilization

The Landmark Library is a record of the achievements of humankind from the late Stone Age to the present day. Each volume in the series is devoted to a crucial theme in the history of civilization, and offers a concise and authoritative text accompanied by a generous complement of images. Contributing authors to the Landmark Library are chosen for their ability to combine scholarship with a flair for communicating their specialist knowledge to a wider, non-specialist readership.

GUERNICA

Painting the End of the World

JAMES ATTLEE

Head of ZEUS

An Apollo Book

Painting is not done to
decorate apartments.
It is an instrument of
war.[1]

PABLO PICASSO

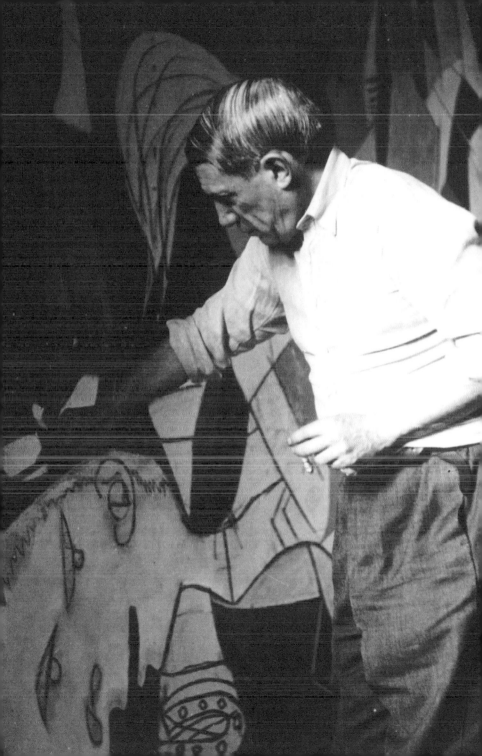

INTRODUCTION
A Mystery
in Plain Sight

I hate Guernica because
of the amount of bad books
that have been written and
will be written and because
none of them express
my contempt satisfactorily.[1]

ANTONIO SAURA
Contra el Guernica, 1982

Pablo Picasso's painting *Guernica* has always been at the centre of things: a magnetic attractor of attention, discussion, eulogies and argument in equal measure. Created in 1937 for display at an international exhibition in Paris, it was born onto a world stage, a position it has never relinquished. After it left Paris, it remained outside Spain for the first forty-four years of its life, its location as much a statement as its subject matter. Wherever it has been shown it has stirred debate. Critics have seen it as either its creator's career masterpiece or his fall from grace; the route by which he reconnected with his social conscience or the moment he lost his way. Politicians have praised it and railed against it, both in print and in the forums provided by the very different nations they inhabit. Artists have had to face up to its challenge, absorbing its lessons or overthrowing it in an Oedipal struggle, in order to make their own way forward. On its final arrival in Spain in 1981, it became the only painting in history to be widely associated with the transition of a nation from dictatorship to democracy.

Inspired by a specific event, the bombing in April 1937 of an undefended Basque town during the Spanish Civil War by the

French postcard, 1937

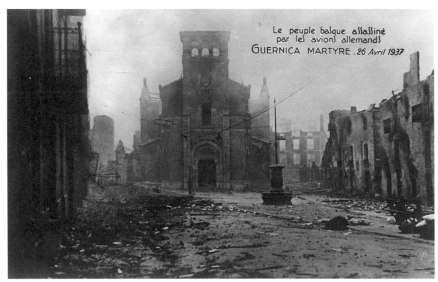

German Luftwaffe, it contains nothing that refers directly to that place or the people who suffered there. Instead it features figural elements and themes that have already resonated throughout Picasso's career and will continue to do so: a bull, a tortured horse, a woman holding up a lamp, another woman weeping over a dead child. Over the past eighty-odd years, these and other symbolic motifs that haunt *Guernica*, as well as the setting in which they are placed, have been variously interpreted by some of the world's leading art historians and by countless other commentators. Much that has been written has focused on Picasso's biography in an attempt to decode the painting's meaning in a manner that does not always add to our understanding.

When considering a work as overtly polemical yet stubbornly opaque as this one, it is essential to know something of the historical moment that gave birth to it; an atmosphere still adheres to its visibly aged surface, the electrical energy of a gathering storm that was soon to engulf the world. *Guernica* was born out of a fratricidal civil war Picasso never saw with his own eyes, but to which he was connected through bonds of friendship, family and identity. It raged in his psyche, just as a few hundred kilometres away it was playing out in reality, sinking Spain into what he described, in a famous letter to *The New York Times*, as 'an ocean of pain and death'. Information travelled in a different way in 1937 to the way it does now. News of the war in Spain reached Picasso through personal letters, newspaper articles, pamphlets, posters and conversations with displaced Spanish officials, artists, poets and friends. Despite his exile, he was a combatant. Untrained in the use of a rifle or in aerial combat, the weapons he deployed were borrowed from his artistic forebears in the Prado Museum or learnt while watching the *corrida de toros* in the bullrings of his homeland. To trace these wellsprings back to their source is to enrich our response to the painting itself.

Once *Guernica* had left its moorings in Paris it toured the world, subject to new interpretations and controversies wherever it went. Released from its first function as a propaganda weapon and fundraising tool, it swiftly took on a second life as a post-religious icon, somehow able to represent the victims of conflicts as far apart in geography and time as the Soviet invasion of Hungary, the Vietnam War and the conflict in Syria. When its physical fragility brought its wanderings to an end, its likeness continued to spread through global consciousness via every conceivable manner of reproduction, ranging from life-size tapestries to postage stamps, from walls of art books to the millions of versions that surround us in the digital cloud. Equally part of its story are the works it has inspired by other artists; the political debates it remains central to; the way in which, through new contexts or re-makings, it continues to acquire fresh meanings for succeeding generations of viewers. At various times its entombment in a gallery and its ubiquity in reproduction have threatened to rob it of its power, but it has never been long before it has returned to the front pages, whether through being defaced by activists, covered up by politicians or brandished as a banner in the faces of TV crews and the police. In a remarkable way it has vaulted the wall of the museum to become public property, to the extent we might be justified in asking where – or *which* – is the real *Guernica*?

Picasso had a horror of 'finishing' a work. 'Only death finishes something,' he told his friend the photographer Brassaï. 'To finish, achieve – don't these words have a double meaning? To terminate, to execute, but also to put to death, to give the *coup-de-grace*?' As far as he was concerned, when he stepped back from a painting it continued to mutate, remaining an active agent, only achieving its final state in the mind of the viewer. If we take him at his word there are an infinite number of

*Guernica*s in the world, locked in the museums each of us carries behind our eyes – yet there is also just one. Today history has once more conspired to reanimate Picasso's painting. The forces of nationalism and militarism are on the rise as old alliances fracture: demagogic politicians bestride the stage, their language eerily similar to that heard at the time the painting was created; and atrocities are committed on a regular basis, both by states determined to maintain their hold on power and by individuals gripped by apocalyptic religious ideologies. In 1937, *Guernica* sounded a warning of where this would all lead. As we approach the third decade of the twenty-first century, that warning note remains as relevant as ever.

– III –

Guernica is a mystery in plain sight. One of the best-known paintings of the modern period, the interpretations placed upon it jostle and contradict each other, while its location remains politically charged, a matter of dispute between central government and the Basque region of Spain. Linked forever to a particular event, its roots reach back throughout its creator's life and beyond, into the history of art, of Spain, and on into prehistory, to the beginnings of humanity itself. How does one trace the bloodline of an icon? In order to do so, we must first survey the landscape of the time, the political and personal events that were bearing down on the artist as he began work. Let us take one day as our starting point: a day on which, after a period of hesitation and uncertainty, Picasso discovers his subject; when inner promptings and international events combine and the touchpaper is lit on a process which will result, some five weeks later, in the painting's first public appearance, in the Pavilion of the Spanish Republic at the World's Fair in Paris.

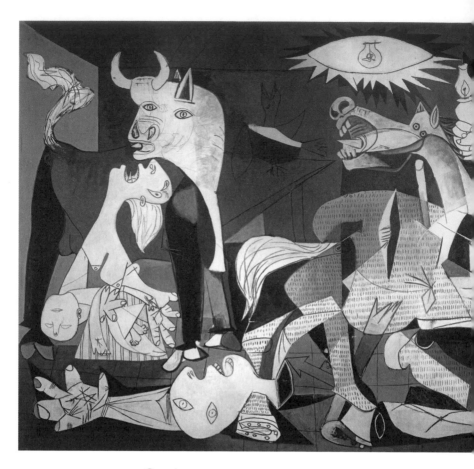

PICASSO, *Guernica,* 1937
Museo Nacional Centro de Arte Reina Sofía

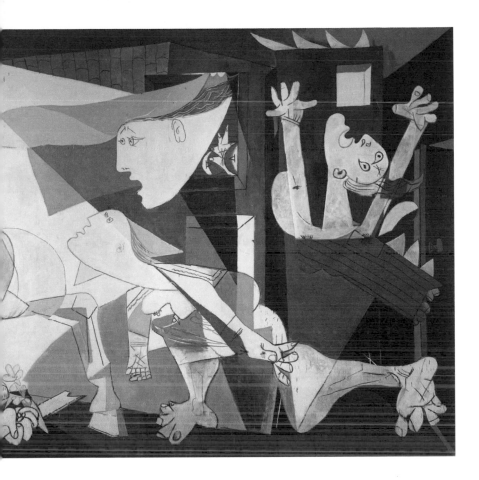

The Disintegration
of the World

GUERNICA

The great Spanish painter
Pablo Picasso, creator of Cubism,
who has been such a powerful
influence on contemporary plastic
art, has wanted to express in this
work the disintegration of a world
prey to the horrors of war.

Text printed on the reverse
of a souvenir postcard of *Guernica*
published by the Spanish Republican
Government, 1937

It is the first of May 1937, the public holiday known in France as *la fête du travail*. The streets of the French capital are thronged with the largest workers' parade in the city's history. Women sell sprigs of lily of the valley gathered in woods outside Paris and couples place them in their buttonholes. A heavily bearded man, his eyes two black holes behind his dark glasses, stares directly into the camera held by Robert Capa, who has been commissioned to capture the day's events for *Ce Soir*. On the man's shoulders, wearing his best coat and matching beret, sits a young boy. Tentatively he curls his fingers into a fist like those raised in solidarity around him, his momentary gesture captured and immortalized in Capa's photograph. The image transforms the child into a symbol: an allusion perhaps to the figure of Julie in Romain Rolland's play *Le quatorze juillet* (*The Fourteenth of July*), in which a little girl becomes the mascot of the crowd that bears her aloft as they storm the Bastille. Written in 1902, the play is revived in Paris in 1936, in a production for which the stage curtain is painted by a man said to be the most famous artist in the world.

In the attic studio of a seventeenth-century townhouse on the narrow rue des Grands Augustins, a minute's walk from the river, that artist has left the streets to work through the public holiday, as is his habit. Although he might appear isolated from the electric atmosphere outside, as more than a million marchers follow the traditional route from the Place de la République to the Bastille, it is clear from the first sketches dating from that day that Picasso is portraying a moment of conflict. The drawings relate to a commission he has accepted some four months earlier and for which, so far, he has struggled to find a subject. In the first week of January, a delegation had arrived at the door of Picasso's apartment at number 23 rue La Boétie. It includes the Catalan architect Josep Lluís Sert, an old friend from Barce-

ROBERT CAPA, *Paris. May 1st, 1937*
May Day celebrations

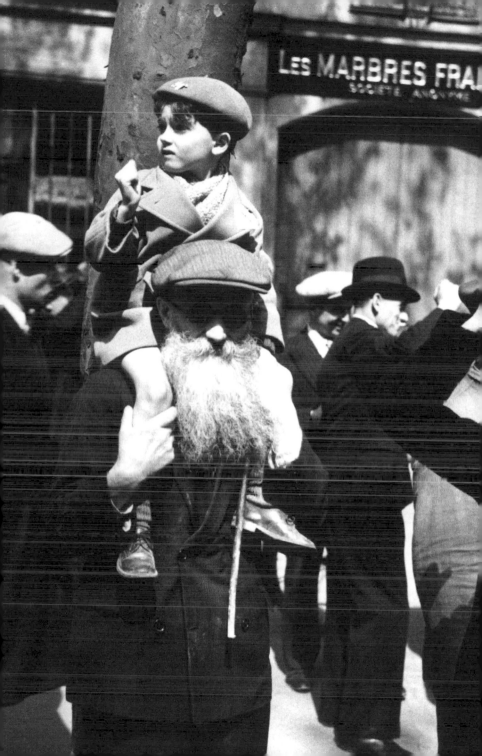

lona, accompanied by his architectural partner Luis Lacasa; together they will be responsible for the design of the Spanish Republic's pavilion at the *Exposition Internationale des Arts et Techniques dans la Vie Moderne* (International Exhibition of Art and Technology in Modern Life), which is due to open in Paris in May. They are joined by the writer Max Aub, the Republican government's cultural attaché in Paris; the photographer and photomontage artist Josep Renau, director of fine arts for the Republican government, and two poets: José Bergamín and Juan Larrea. (In addition to their literary activities, Bergamín is in charge of protecting the collection of the Museo Nacional del Prado, while Larrea is director of *Agence Espagne* in Paris, the propaganda office for the Republic that is funded by the Comintern.) This disparate artistic group has been entrusted by the embattled government of Picasso's homeland with the task of persuading him to contribute a major work to the Spanish Pavilion – something that will make clear his abhorrence of the Nationalist rebellion that threatens the continued existence of democracy in Spain.

For their part, the French government's intention is that the exhibition showcases the latest developments in science and technology, with a particular emphasis, of course, on the achievements of the host nation and its empire. Despite its importance, the World's Fair comes at a challenging time. Political instability has been the hallmark of the decade so far: between 1930 and 1936 the country has seen twelve prime ministers and six different governing parties come and go. The current administration, the *Front Populaire* (Popular Front), elected in May 1936 under the slogan 'Bread, Peace and Liberty', is a precarious coalition of different factions on the left headed by Léon Blum, France's first Jewish, socialist prime minister. Although workers have won significant rights, including the guarantee of paid holidays and union representation, economic reforms have failed to mitigate the effects of the Depression while the benefits of

wage increases have largely been wiped out by inflation. Divisions in French society, between the immense wealth of the two hundred families said to own much of the nation's resources and the rest, have never looked so extreme. As well as providing an opportunity to showcase their achievements, the Popular Front must be hoping the exhibition will provide a focus around which the nation can unite.

Picasso hates commissions; this one comes loaded with particular challenges and responsibilities. He has never created a work at the scale required by the pavilion; even more significantly, he has never looked beyond his personal artistic universe to address a contemporary situation like the civil war in Spain. It is not surprising, therefore, that he initially tells the Republican delegation he is not at all sure he can produce a picture of the kind they need.

Art, for Picasso, arises from an inner urge to unburden himself of what he has absorbed from the world around him. While it inevitably reflects external events, it has a reality independent of them. 'In the end [art] all depends on oneself,' he tells Roland Penrose in 1932. 'It is a sun with a thousand rays, inside one. The rest is nothing.' By instinct and inclination he is also apolitical; some four years earlier he had stated that he would 'never make art with the preconceived idea of serving the interests of the political, religious or military art of a country.' The studio is his kingdom and he defends it against distractions – whatever their source – which will get in the way of his work.

Events of the previous year, however, have seen his barricades overrun. As well as the intensely distressing news emerging from Spain, his personal life has entered a period that future biographers will pore over with relish, part of the 'horrible penumbra of gossip and hero-worship' that dogs him for the rest of his life.[1] He has separated from his wife of nineteen years, the Russian ballerina Olga Khokhlova, and is engaged in a bitter fight with her about a settlement. Meanwhile he has fathered a

child with his mistress Marie-Thérèse Walter, whom he has installed outside Paris in the house of his friend, the art dealer Ambroise Vollard, which he visits at weekends. He is also deeply involved in a relationship with the talented and volatile photographer Henriette Theodora Markovitch, better known by her artist name of Dora Maar. Maar is immersed in left-wing politics and the Parisian avant-garde and also knows Spain, having travelled there on her own while completing a street photography project in Picasso's former hometown of Barcelona in 1934. Maar's importance in the gestation and execution of *Guernica* is indisputable; as she is often cited as having pointed out, Picasso's art is at any one time a function of the changes in alignment of five elements – his mistress, his house, his poet, his circle of admirers and his dog. Perhaps one more could be added to this list: his studio. Having abandoned Olga, he is on the lookout for somewhere large enough to accommodate a canvas required to command the position allocated to it in the pavilion – a space he has been to inspect as building work in the Trocadéro Gardens continues.*

The studio he finds – or that finds him – is in the former Hôtel de Savoie, at number 7 rue des Grands Augustins. From a practical point of view it is ideal, with some of the qualities of a fortress. It is reached by a spiral staircase, on which the light bulb is often broken. A brass nameplate indicates visitors have arrived at the *Association des Huissiers* [Bailiffs] *de la Seine*, a sign Picasso hopes will deter all but the most determined. On his own door he simply pins a piece of paper with the words '*C'est ici*'. On the top floor, reached by an internal staircase, is the attic known as *Le Grenier* (the granary), with large windows and views across the rooftops of the neighbourhood. Its cavernous interior can accommodate the 3.51 x 7.82-metre (11.5 x

* For the 1937 *Exposition Internationale*, the old Palais du Trocadéro, built for the 1878 World's Fair, was demolished and replaced with the Palais de Chaillot.

25.6 ft) canvas prepared for the commission, although it must be tilted slightly to fit beneath the exposed beams of the ceiling. The studio's undecorated walls give it the air of an artisanal workshop which Picasso finds sympathetic, the chill of its stone floors mitigated by an enormous, cast-iron heater he has installed. It is a space in which to experiment, hoard objects of interest, receive visitors and mount impromptu juxtapositions of works in progress for his own interest. In terms of position it is a few minutes walk from his favourite cafés and bars around the Boulevard Saint-Germain and from Dora Maar's apartment.

But Picasso's studio has more important attributes than these – imaginative, even spiritual ones that must have made its appearance in his life seem fated. In recent years it has served as a focal point for the avant-garde on the left bank. Theatre director Jean-Louis Barrault has used it for rehearsals and as a bohemian, communal live–work space, where, as he was to recall later, 'often, when I returned at night I found people in my bed. I had founded a "company"'. After Barrault moved on, *Le Grenier* hosted meetings of the left-wing group *Contre-Attaque,* founded by Surrealist author Georges Bataille, whose writings are a strong influence on Picasso. Dora, previously Bataille's lover, attended these meetings and is often credited with finding the studio. In fact, she is only one in a series of links connecting the artist and 7 rue des Grands Augustins. In the opening months of 1937, the building had been used as a storeroom by the contractors working on the Spanish Pavilion, and it is Juan Larrea who secures its use for Picasso.

In a more extraordinary coincidence, the building is the setting of a story by Honoré de Balzac called *Le Chef-d'oeuvre inconnu* ('The Unknown Masterpiece'), published in *Études philosophiques* in 1837, a century before Picasso takes possession. The story has many resonances for Picasso, as it does with other artists of his generation; he has even illustrated a new edition of it published by Ambroise Vollard in 1934. It features

three painters: Nicolas Poussin, a young Bohemian from the provinces who has just arrived in the city and whose threadbare clothes and burning ambition cannot fail to remind Picasso of his younger self; Porbus, who is a successful court painter; and Frenhofer, a mysterious genius who believes he has discovered a new visual language that is able to transcend 'art' and conjure reality itself. When Poussin and Porbus eventually come face-to-face with the painting Frenhofer keeps locked in his studio, the culmination of his life's work, they wonder if the painter has been pulling their leg; instead of a masterpiece they can see only one remarkably lifelike naked foot, emerging from beneath 'colours daubed one on top of another and contained by a mass of strange lines forming a wall of paint.' Picasso has faced critical onslaughts worse than this; he will do so again when *Guernica* enters the public realm.

The tensions that exist beyond the studio walls are echoed throughout Europe. Italy has rekindled its dreams of conquest in Africa by invading Abyssinia with half a million troops. The Nazi regime in Germany appears increasingly belligerent, demonstrating its contempt for the terms of the Treaty of Versailles by occupying the Rhineland in March 1936. But it is the civil war in Spain which is the ghost at the feast at the May Day celebrations in 1937. Workers from the Renault factory, veterans of several industrial actions over the past twelve months, gather to listen to a speech by Pascual Tomás, a delegate from the Spanish UGT union. He movingly describes the deaths of women and children during the Nationalist bombing of Madrid, as well as sharing breaking news of an attack on the undefended Basque town of Gernika that has happened a mere four days previously, on 26 April.

The commission for the pavilion is not the first public recognition Picasso has received from the Spanish Republic. Two months after the outbreak of the civil war, he is appointed director of the Museo Nacional del Prado in Madrid. The role is

largely symbolic; despite repeated invitations, he never visits the museum, a strange omission given the fact that for him the Prado is holy ground: a temple containing the artists he most reveres, whose works he studied and made copies of as a student. Goya, Velázquez, Zurbarán, El Greco – these are his true family, their works the highlights of the mental museum he draws on throughout his career. On 16 November, during weeks of bombing raids on Madrid, the Prado is hit. The priceless collection is hurriedly wrapped and packed in the back of trucks by Republican soldiers and evacuated to Valencia, leaving Picasso, as he puts it to a friend, director of a 'phantom museum'. Like the besieged government, the art collection has to keep moving as the war front advances. Two paintings by one of Picasso's favourite artists, Francisco Goya – *El 2 de mayo de 1808 en Madrid* (*The Second of May 1808*) and *El 3 de mayo de 1808 en Madrid* (*The Third of May 1808*) – are damaged when a truck, passing through a village on its way to Girona, is involved in a crash, splitting the canvases and leaving fragments of *The Second of May* on the road. The fate of the paintings is a symptom of the upside-down world the war has created, in which artistic masterpieces are relegated to the status of everyday goods, subject to random bombardment – a blow to Picasso's psyche as great, perhaps, as any other in the war.

While art is being rescued from destruction in Madrid, in Paris it is being put to other uses. The *Front Populaire* is keen to signal through the *Exposition Internationale* that France is a modern, technologically innovative state, open for international trade and investment despite the civil unrest of the previous twelve months. The Spanish Republic has rather different priorities in mind: above all, they need guns. For Luis Araquistáin, who combines the role of Spanish ambassador in Paris with acquiring weapons for the Republican forces, the exhibition is a unique opportunity to argue for an end to the Non-Intervention Treaty, signed by Britain, France and Germany,

which places an embargo on the supply of arms to the Spanish Republic. Without a major military transfusion, loyalist forces have no chance of overcoming the combined might of Franco's army and the troops and airpower being provided by Nazi Germany and fascist Italy in contravention of the treaty. This, then, is the first and perhaps the greatest irony associated with a painting now recognized internationally as a symbol of peace; it was commissioned in the hope it would help end an arms embargo and allow the equipping of an army.

Alongside the Republic, forty-two other countries will be represented: the exhibition will be a city within a city, a microcosm of the world. The Spanish Pavilion's contents will showcase the Republic's achievements in education, industry, agriculture and the arts, while also highlighting the Spanish people's heroic resistance to Franco's Nationalist assault. Persuading the greatest living Spanish artist to participate will both boost visitor numbers and achieve a propaganda coup equivalent, Araquistáin believes, to a major military victory.

Ranged against the Republican government are the supporters of the strongly centralized and hierarchical 'Old Spain', determined to protect their wealth, property and ancient privileges; they include the owners of huge landed estates, industrialists, bankers, members of the fascist Falange party, military families, monarchists and high-ranking clerics in the Catholic Church. Three generals, José Sanjurjo, Emilio Mola and Francisco Franco, answer their call for a second *reconquista* to rid the nation of communism, atheism and troublesome Basque and Catalan nationalists. General Franco, who has openly called for the annulment of the election of 16 February, has been dispatched by the government to the Canary Islands in the hope such physical isolation will prevent him plotting against the Second Republic. His acquiescence to this banishment, along with his apparent reluctance to back an armed insurrection, earns him the mockery of some on the right – he even acquires

the nickname 'Miss Canary Islands 1936' – but he is galvanized by the assassination on 13 July of the right-wing politician José Calvo Sotelo in Madrid by the Republican police force. In a sign of the shared interests of the ruling classes within and beyond Spain's borders, it is a civilian plane flown by an English pilot from a British airport that collects him from Las Palmas and flies him to Tétouan, capital of the Spanish protectorate of Morocco.

The revolt begins with the mutiny of the army in Spanish Morocco on 17 July 1936; a day later troops attempt a coup on the mainland. In Spain itself, the insurrection falters. Nationalist forces take Seville, but working-class militia and loyal elements in the police and military, with support from the public, defeat uprisings in Madrid, Valencia and Barcelona while loyalists hold on to other important cities including Málaga and Bilbao. The country is divided. General José Sanjurjo decides the time is right to return from exile in Estoril to take up the role of *caudillo* of Nationalist Spain. However, he is killed when the small biplane he has chosen to fly in crashes on 20 July, allegedly because of the weight of the large number of dress uniforms it is carrying that he feels are essential to his new role. The reprieve is only temporary; the Republic now faces an existential threat from across the straits of Gibraltar.

Once again, when Franco finds himself cut off by the sea, it is foreign aircraft that come to his aid. Benito Mussolini does not hold the Spanish in high regard, partly because he believes there is an Arab constituent to their racial makeup, but he is keen to end British naval supremacy in the Mediterranean and also urgently needs to recoup some of the expense of the Abyssinian war. The latter has left Italy with huge debts and the prospect of arms sales to the Nationalists overrides any misgivings he might have. Adolf Hitler hears about the attempted coup during his annual visit to the Wagner festival at Bayreuth. In classic Hitlerian manner, events are simplified to become the

stuff of operatic drama. 'Soviet wire-pullers' are behind the crisis in Spain, he tells the crowd at a Nuremburg rally on 9 September, agents of an 'international Jewish revolutionary headquarters in Moscow'; they must be resisted at all costs. Inspired by the third act of Wagner's *Siegfried*, in which Brünnhilde is encircled by protective flames, he sets in motion *Unternehmen Feuerzauber* (Operation Magic Fire), the code name for the first mass airlift of troops and equipment in military history.

Fourteen thousand soldiers, including thousands of Moorish troops in *chilaba* robes, red fezzes and turbans, board German and Italian planes in Morocco and disembark in Seville, from where they march north. The campaign is immediately marked by atrocities of the most brutal kind, encouraged by Nationalist commanders: the shooting of pregnant women, the branding of women's breasts with Francoist emblems, indiscriminate murder and widespread looting. Any measures, it seems, are justified; speaking to the *Chicago Tribune* on 29 July, Franco declares himself prepared to kill fifty per cent of Spain's population in order to complete his mission. On the 14 August, the city of Badajoz falls to Nationalist forces led by General Yagüe. For the next few weeks his troops carry out the massacres known in Spanish as the *limpieza* (cleansing): the city's bullring becomes a place of execution where thousands of alleged Republican sympathizers are held in bullpens with no access to lawyers or trials, awaiting their turn to be machine-gunned in front of cheering onlookers, before their bodies are soaked in petrol and burnt.

The French government's reaction to these events has polarized public opinion so sharply that some compare it to the Dreyfus Affair that divided the nation at the turn of the twentieth century. Although the Spanish Republican administration would seem to be a natural ally for France's Popular Front, since its election observers in Paris have been alarmed not only by reports of the mass killings of supporters of the

coup during the Battle of Madrid, but also by those of church burnings, violent strikes and land seizures – exactly the kind of incidents they wish to avoid at home. Nevertheless, Léon Blum's first instinct is to supply the Republic with military resources. His intentions leak to the press and reach the ears of the British government, France's chief ally against Nazi expansionism. Stanley Baldwin, a strong advocate of non-interference in the Spanish Civil War, makes his displeasure clear. Under pressure both from abroad and from within his own administration, and fearing a fascist uprising at home, Blum decides in August 1936 that France should sign the Non-Intervention Agreement, along with twenty-six other European nations. This effectively prevents the Republic from acquiring arms, despite the fact that as a democratically elected national government it has every right to do so. Meanwhile Nazi Germany and fascist Italy continue to pour weapons and military support via Portugal to Franco's rebel troops unchallenged. Throughout the war, Franco is able to access unlimited petrol from large American producers, including Standard Oil and Texaco, all of which is provided on credit. The Nationalist rebellion is bankrolled to the tune of many millions of dollars by the United States oil industry, while at the same time the United States government actively seeks to prevent Mexico from providing material support to the Spanish government.* Far from remaining neutral, Britain, America and France are effectively signing the Republic's death warrant.

* In 1936 Texaco provided Nationalist troops with 344,000 metric tons of petrol on credit, in 1937 with 420,000 tons, in 1938 with 478,000 tons and in 1939 with 624,000 tons. (Herbert Feis, Economic Adviser to the US Embassy in Madrid, quoted in *Greater Manchester Men Who Fought in Spain* (Manchester: Greater Manchester International Brigade Memorial Committee, 1983), p. 19.)

– II –

The *Fête du Travail* in 1937 takes place during a media blackout of a kind: it is the first day in the history of French newspapers when none has appeared on the newsstands. Instead, pamphlets and reviews circulate, among them *Durango Ville Martyre* (Durango Martyred City), an account of an attack by the rebel air force on a Basque town at the beginning of April that features the bombing of a church full of worshippers. A dramatic photograph in the pamphlet shows the body of the priest dressed in full vestments spreadeagled on the floor of the ruined church. Rebel forces under the command of General Mola have opened a new offensive in northern Spain, close to France's border, with the aim of taking the heavily fortified city of Bilbao. Over the previous few days, news has broken, in conflicting and contradictory newspaper reports, of another massacre in the Basque country; the undefended town of Gernika has been reduced to smoking rubble. While some French newspapers correctly attribute the damage to bombing raids by the Condor Legion of the German Luftwaffe, with a small number of Italian planes in support, others uncritically publish Nationalist claims that this is a Republican lie and that the retreating 'Reds' have destroyed Gernika themselves, burning it to the ground to gain a propaganda victory.

These competing claims are the first salvo in a war of pamphlets, dispatches, investigative reports and newspaper articles unleashed by the event, of which *Guernica* will become a part. The visual arts have a vital role in winning hearts and minds among the poorly educated public in Spain, just as the religious imagery in the country's churches and cathedrals has done for centuries. The Spanish Civil War is perhaps the first full-blown media conflict, fought as fiercely by the press officers on both sides as by regular troops, with film, posters, photography, pho-

30 GUERNICA

tomontage and graphic design playing almost as significant a role as bullets and shells.

Just as the Republican government is adapting the new visual language developed by Constructivist artists in Russia and the Bauhaus in Germany to make their case, Nationalist military commanders in Spain are keen to put new theories of warfare to the test. Among the most influential of these arise from the writings of the Italian military theorist Colonel Giulio Douhet, whose book *Il domino dell'aria* (*The Command of the Air*) was first published in 1921. In it Douhet argues the air force will play a critical role in wars of the future, its task to 'inflict attacks on the enemy of a terrifying nature to which he can in no way react'. Colonel Wolfram von Richthofen, commander of the German Condor Legion, is one of a new breed of military leaders eager to try out Douhet's theories in a European theatre of war. 'Fear,' he writes in his diary, 'which cannot be stimulated in peaceful training of troops, is very important, because it affects morale. Morale is more important in winning battles than weapons. Continuously repeated, concentrated air attacks have the most effect on the morale of the enemy.' For him, the Condor Legion is as much a psychological as a physical weapon, rather like Franco's Moorish shock troops, whose presence in Spain trigger deep, atavistic fears dating back to the Islamic conquest of the Iberian peninsula centuries before. Ettore Bastico, the commander of Italian troops in the north of Spain, although an early critic of Douhet's theories about the supremacy of aerial power in the 1920s, has subsequently masterminded bombing campaigns in Abyssinia using mustard gas on civilians to devastating effect, earning himself the nickname among his troops of 'Bombastico'.

Like many of his generation, Picasso is both fascinated and terrified by aerial warfare. 'That death could fall from heaven on so many, right in the middle of rushed life has always had a

great meaning for me', he will tell an interviewer as an old man, some forty years later.[2] The shift in point of view and velocity provided by aeroplanes has been central to the work of Futurist artists in Italy since early in the century, fracturing vision in a way that is as radical as that effected by his own invention of Cubism. Flight is deeply embedded in the iconography of modernism, yet it is also associated with something much darker. His friend, the writer André Malraux, served with the Republican forces in 1936. In *L'Espoir (Man's Hope)*, the novel he based on his experiences, he describes the birth of a new religion in Spain: the religion of fear, felt by a people dwelling 'under the menace of the sky'. Picasso tasted something of that fear during a Zeppelin air raid on Paris in March 1915, when he spent much of the night sitting under a table with Gertrude Stein, from which position he was able to observe Alice B. Toklas's knees knocking together.

The air raids of the current war are far more brutal and intense, happening in a place from which he is exiled but where his family still lives, at the mercy of the menace Malraux describes. One by one, locations in Spain that have formed him, and that he still carries with him in his head, are being pounded into dust. He is particularly affected by the reports of the bombing of Madrid written by French journalist Louis Delaprée, the correspondent in Spain for the mass-circulation newspaper *Paris-Soir*. As they increasingly showed the Nationalist side in a bad light, Delaprée's reports were censored or not run at all by the paper, which devoted more space to the love life of the British monarch Edward VIII than the massacre of civilians in Madrid — as the journalist put it in his last dispatch to his editors, 'the killing of a hundred Spanish kids is less interesting than a sigh from Mrs Simpson, the *putain royale* [royal whore].' In an attempt to get around his employers' obstructiveness, Delaprée publishes his hallucinatory version of events *Madrid sous les bombes* in the magazine *Marianne* under a pseudonym, on 25

November 1936. He never returns to Paris; the French embassy plane carrying him across the border into France is shot down in mysterious circumstances and he dies in Madrid on 11 December 1936.

Picasso may not be a regular reader of *Paris-Soir* but he certainly sees *Madrid sous les bombes* when it is reprinted in *L'Humanité* on 8 January 1937. In all probability he also sees the journalist's collected articles from Spain published in pamphlet form the day before. The censoring of Delaprée's dispatches, his death at the hands of unknown agents and his final, furious message to his newspaper become a cause célèbre for *L'Humanité* and for the left in Paris. A poster campaign is organized at the end of December 1936 by Picasso's friend, the communist poet Louis Aragon: Delaprée's face haunts the streets of the city he will never see again, accompanied by the headline: 'The voice of a dead man accuses the lying Press'.

In January 1937 the Nationalists attack Málaga, the city of Picasso's birth. The Hungarian-born writer Arthur Koestler is an eyewitness to events, describing in his book *Spanish Testament* (1937) 'entire streets in ruins, deserted pavements strewn with shells', while the air is filled with 'the pungent odour of burned flesh'. In Paris, *Regards* magazine runs a cover feature with photographs by Gerda Taro and her lover Robert Capa of refugees fleeing the city. The destruction of the streets of his childhood haunts Picasso. History can no longer be left at the studio door; instead, as he tells a friend two days after the city falls to the Nationalists in February, 'it holds us by the throat'. Within days of the first attack on Málaga, at exactly the time of the republication of *Madrid sous les bombes* in *L'Humanité*, and probably after conversations with José Bergamín who has recently returned from Spain, he produces the first work that will make explicit his feelings about the civil war and those who have brought it about.

The weapon Picasso wields against the Nationalist leader is

satire, rather than invective. The etchings *Songe et mensonge de Franco* (*Dream and Lie of Franco*) comprise two sheets of cartoon-like depictions of the picaresque adventures of the general in the form of a mutant polyp, or, as Picasso admits in a later comment, a turd: obscene, ridiculous, with a single cyclops eye and two snouts, puffed up with vainglory and murderous instincts. The etchings' form is borrowed from the Spanish religious print known as an *alelulya,* comprising three rows of three images. The first sheet Picasso completes in a single day on 8 January, while the second is worked on during and after the painting of *Guernica* and contains many of the themes and images explored in the painting. Produced in a limited run of 1,000 copies, the etchings are put on sale, together with a separate sheet containing a poem by Picasso, to raise funds for Spanish relief, with all eighteen designs also sold separately as postcards.

Franco's progress is marked in the first etching by his changes of costume, particularly headwear: he seems to have as many outfits to choose from as the ones that caused José Sanjurjo's plane to crash to earth. In the first image, at the top-right of the sheet, he is wearing a crown whilst holding a sword and a religious banner, mounted on a prancing horse that appears to have been disembowelled, its entrails flopping into the dust as the sun laughs at the absurdity on display. In the next image, he walks a tightrope, the banner now attached to his erect penis, while on his head he wears the fez sported by his Moroccan troops. In the third image, sporting a clerical hat, he appears to be about to attack a classical statue with a pickaxe. This scene may allude to an episode that took place in Spain the previous autumn, which, along with the murder of the poet Federico García Lorca by a Falangist militia in Granada, helped clarify Picasso's view of the fascists. On 12 October the Nationalist military commander José Millán Astray, the creator of the Spanish Legion, gave a speech at the University of Salamanca in which

he promised fascism would be the surgeon that would cut the cancer of 'Reds', Catalans and Basques from the body of Spain. Astray had a fearful appearance; having lost an eye and an arm in the colonial wars in North Africa, he revelled in the nickname *El Glorioso Mutilado* – 'The Glorious Mutilated One'. The audience was packed with his supporters, including many armed Spanish Legion soldiers who became increasingly excited by his rhetoric; one could not resist shouting out the slogan of the Legion, *¡Viva la Muerte!* (Long Live Death!). Also present on the speakers' platform that evening was Miguel de Unamuno, a leading Basque philosopher and intellectual, who made a fearless speech in reply, beginning by attacking the 'senseless and necrophiliac cry *¡Viva la Muerte!*'. General Astray, he suggested, 'would like to make a new Spain in his own image, a negative creation, a mutilated Spain'. In the uproar that followed Millán Astray is said to have screamed *¡Muera la inteligencia!* (Death to Intelligence!). Unamuno was only able to slip from

PICASSO, *Dream and Lie of Franco I*, 8 January 1937

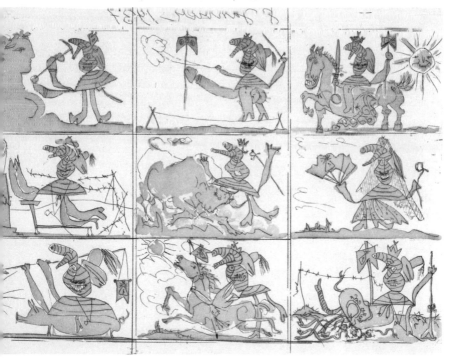

the hall unharmed when Franco's wife, Doña Carmen Franco, took his arm and they left together.

'The war in Spain is a reaction – against the people, against liberty,' Picasso writes when he hears about the incident:

> My whole life as an artist has been a continual struggle against reaction, and the death of art. In the panel on which I am working and which I shall call *Guernica*, and in all my recent works of art, I clearly express my abhorrence of the military caste, which has plunged Spain into an ocean of pain and death. Everyone is acquainted with the barbarous bombardment of the Prado Museum by rebel airplanes and everyone also knows how the militiamen succeeded in saving the art treasures at the risk of their own lives. There are no doubts possible here… In Salamanca, Millán Astray cries out 'Death to Intelligence!' In Granada, García Lorca is assassinated…

Picasso's reluctance to take sides has evaporated: the Nationalists are not just enemies of liberty but the murderers of poets, the destroyers of art, and of intelligence itself, represented by the classical bust being mutilated by Franco in the etching. Is she related to the Cubist muse described by Lorca in his great essay *Theory and Play of the Duende* as having a 'four-sided nose her great friend Picasso has painted her with'? The serene, classical profiles that haunt so many of Picasso's works act as counterpoints to the carnage of the bullring or the battlefield; a vision of femininity that contrasts starkly with the figure of Franco in drag, depicted in the *Dream and Lie*, wearing a Spanish mantilla and carrying a fan, but still sporting the Generalissimo's trademark moustache. Miss Canary Islands 1936, perhaps?

Monday is market day in Gernika. The authorities have tried to prevent it taking place on 26 April but, despite their pronouncements, they are unable to hold back the ancient rhythms of the rural community. Peasant farmers roll into town in oxcarts with solid wooden wheels to sell their produce in the main square, attracting crowds from Gernika and the surrounding region, which is heavily dependent on the market as a source of food. An influx of refugees, a scheduled *pelota* championship and the presence of two Basque battalions of Republican soldiers further swell the number of people in the town to around 12,000. Although it is only a few miles from the front lines in the Nationalist push towards Bilbao, and is the site of the Astra small-arms factory, Gernika has not been involved in the war so far and has no anti-aircraft defences. At 4.30 in the afternoon, the busiest time of day at the market, a single peal of bells rings out, signalling an impending air raid. The first aircraft to appear is a biplane. Almost casually it wheels above the town and drops its bombs near the train station before machine-gunning the populace at random and leaving. Three Heinkels HE 111s from the experimental bomber group VB/88 of the Condor Legion unload their bombs on the church of San Juan and a square crowded with people, as well as destroying water pumps that supply the town. As the German planes finish their first sortie, three Italian bombers arrive accompanied by attack planes to continue the bombardment. Those not caught in the open and killed or injured in these first attacks run to take cover in the shelters.

After about forty minutes the skies grow quiet and people emerge to tend to the wounded and put out fires. The damage Gernika has suffered at this point is on a scale with similar raids targeting civilian populations in the Basque towns of Durango, Otxandio, Elorrio and Elgeta. No one on the ground expects the

attack to resume. But resume it does, on a far greater scale. The second wave of bombers are accompanied by attack planes, including the first six Messerschmitt Bf 109 B1s, sent straight off the production line to be tested in Spain. These, along with Italian aircraft, swoop low, strafing both civilians and market animals with their machine guns. Those attempting to run out of the town to neighbouring woods and fields are also strafed and driven back, herded into a ring of fire where they will be burnt in the streets or asphyxiated in underground shelters.

The sheer scale of the assault on an undefended and relatively insignificant target – the latest research indicates at least twenty-seven bombers and thirty-two fighters are involved in sorties over Gernika that day – indicate there are agendas other than immediate military ones at play. Imanol Agirre, who survived the bombardment as a young boy, remembers taking shelter in 'a small factory where shell-parts are made. Bombs were dropping without a stop; we were almost choked with smoke and dust. But no bomb hit the factory. Factories are the safest places to be, far safer than hospitals.' Of course, an arms factory (or indeed any factory) would be a primary target in a conventional attack, as would the Errenteria Bridge over the Oka River, which is left undamaged. Indeed, specific targeting is not a feature of the raid, which conforms to the new 'terror bombing' model of total and indiscriminate destruction of civilian areas. Wolfram von Richthofen, Hermann Göring's proxy in Spain, is well aware that critical voices within German High Command are questioning the Luftwaffe's grasp of military strategy. The time has come to dazzle the Führer with a demonstration of *blitzkrieg*. The plan is to present Hitler with photographic evidence of a spectacular attack on his birthday, 20 April.

As things turn out, logistics prevent such exact timing, and the birthday present arrives late, as they often do. Göring celebrates with Hitler on the twentieth and then goes on holiday to Italy. He therefore does not select Gernika as the target himself,

but the Basque town has the misfortune to fulfil the criteria of all those fighting on the Nationalist side. From Mola's point of view, it is close enough to Bilbao to strike terror into the hearts of the city's defenders and to act as a warning of what will happen if they don't surrender. For the Germans, it is small enough and close enough to the front line to be swiftly overrun with ground troops after the aerial attack, the combination of air and ground power central to the theory of *blitzkrieg*. Von Richthofen is personally involved in the selection of explosives for the raid, which include three different types of incendiaries as well as blast bombs powerful enough to crack the foundations of buildings, so that burning thermite powder can penetrate subterranean shelters. Planes from the Condor Legion are tasked with taking 'before and after' photographs to be sent back to Germany to present to the Führer. In his diary, von Richthofen describes the results of the raid as 'absolutely fabulous! City... completely closed off for 24 hours; that would have guaranteed immediate conquest if troops had attacked right away. But at least it [has] been a complete technical success...'

But Gernika is not any market town; it has other characteristics of enormous symbolic importance in Spain, which add to its mythic status; a status that, by a process of transference, adheres to Picasso's depiction of its destruction. Since the Middle Ages, the Basques have pioneered their own form of democracy, remarkable enough to attract a visitor from America in the eighteenth century named John Adams, who serves as the new federal republic's first vice president. The Basques 'have never known a landless class, either slave or villein', he writes admiringly in 1786. 'One of the privileges they have most insisted on is not to have a king.' Instead, Castilian monarchs visited Gernika and beneath the spreading boughs of its sacred oak tree, swore to respect the *fueros* (privileges), customs and liberties of the Basques, in return for their loyalty. These ancient rights have often come under attack from the central government but

on 1 October 1936 the Basques have once more been granted regional autonomy by the Republic, causing the new president of the Basque government, José Antonio Aguirre, to declare 'the sacred Tree that in Gernika grows (is) no longer a relic, but… again the living symbol of our history.' Such statements are blasphemy for many on the Nationalist side. The bombs that fall on Gernika are intended not only to flatten buildings and demonstrate the latest techniques in warfare, but also to crush democracy itself into the dust.

While Gernika waits for an artist to translate its suffering into a masterpiece it is fortunate in one way at least: it finds others willing to put its fate into words which both inform and eerily echo Picasso's visual rendering. One of the greatest of these witnesses is South African-born journalist George Steer, reporting on the civil war for *The Times* in London, who arrives in Gernika around midnight, between four and five hours after the end of the attack, accompanied by three other correspondents. Steer's account is printed in *The Times* on 27 April and reprinted in *L'Humanité* on 29 April, where it is read by Picasso. So strong are the simultaneous denials of responsibility issued by the Nationalist press corps that Steer is forced by his employers to return and double-check his facts the following day. But his involvement with the story does not end with his newspaper reports; at great personal risk, Steer remains in Bilbao until the last moment before it falls to Mola's forces. Before he leaves the city, as its inhabitants flee, he walks into the abandoned office of President José Antonio Aguirre, picks up the president's pen and the last notepad on his desk and uses them to begin his book *The Tree of Gernika*. In it he has the space to include fuller descriptions of the results of the bombing. 'On the shattered houses, whose carpets and curtains, splintered beams and floors and furniture were knocked into angles and ready for the burning,' he wrote,

the planes threw silver flakes. Tubes of two pounds, long as your forearm, glistening silver from their aluminium and elektron casing; inside them, as in Prometheus' reed, slept fire. Fire in a silver powder, sixty-five grammes in weight, ready to slip through six holes at the base of the glittering tube. So, as the houses were broken to pieces over the people, sheathed fire descended from heaven to burn them up.

If Steer, through his reference to Prometheus, takes us back to mankind's beginnings, Reuters correspondent Christopher Holme, who accompanied him into Gernika, moves in the opposite direction. His poem 'Gernika, April 26 1937' will remain unpublished until 1997, six years after his death. It opens with a single sentence: *The world ended tonight.*

Disintegration. Ending. Fire. The apocalyptic language surrounding Gernika echoes images printed in newspapers and magazines of the merciless bombing of Spanish cities and reports of murders and assassinations carried out by both sides. War as theatre, on a stage stalked by characters with names like *Bombastico* and *El Glorioso Mutilado*; war as painting: the president of the Spanish Second Republic, Manuel Azaña Díaz, describes, 'politics as an art, with the people as the palette.'⁹ Perhaps he comes closer to the truth later, when he calls the civil war 'a collective hallucination' in which selfless heroism shares the stage with barbarity of the worst kind. Fear spreads outwards from Gernika, seeping under Picasso's studio door in Paris along with a fog of misinformation: Nationalist forces enter the town on 29 April and all evidence of the aerial onslaught, including the bodies of the dead and fragments of ordinance, is removed. The task Picasso sets himself is to grant recognition to those obliterated in the bombing and to acknowledge the suffering of those who remain. To do so he will employ a visual language that, like the war itself, is both intensely modern yet connected to the oldest and deepest instincts of man.

Materializing
a Dream

And you will ask: why doesn't his poetry
speak of dreams and leaves
and the great volcanoes of his native land?

Come and see the blood in the streets.
Come and see
the blood in the streets.
Come and see the blood
in the streets!

PABLO NERUDA
'I'm Explaining a Few Things'
translated by Nathaniel Tarn, in Pablo
Neruda Selected Poems (Penguin Books)

Legend surrounds Picasso's decision to choose the bombing of Gernika as the subject of his painting for the Spanish Pavilion, as it does so much of his life. In one version of the story, it is the intervention of Juan Larrea that lights the touchpaper. On 27 April, according to the poet's own account, he is exiting the Champs-Élysées metro station when he meets the Basque artist José Maria Ucelay, who stops to tell him about the attack on Gernika the previous evening. (Reports won't appear in the Paris newspapers until the following day.) Larrea is struck with certainty that this is the subject Picasso has been searching for and decides to seek him out immediately.* Wasting no time he jumps in a taxi to the Café de Flore, practically an annex of Picasso's studio, where the painter can be relied on to put in an appearance every day. Cigarettes, coffee, hand gestures, as the white-jacketed waiters come and go: Picasso listens, but tells the poet he doesn't know what a bombed town looks like. Like a bull run amok in a china shop, Larrea says, a phrase that is a little too perfect; worn smooth perhaps through repetition, like a pebble in a stream.

In reality Picasso knows more than his reported comment suggests, if only through the vivid descriptions he has read of the bombing of Madrid, the accounts of friends and family, and photographs regularly reproduced in the Paris newspapers. If he hasn't yet found a way to process such information visually, he has explored it in the writings he has turned to over the past year as an escape from the cul-de-sac he feels himself in as a painter. These literary excursions have become darker as the war progresses; a piece written a month before his conversation with Larrea and simply entitled '20.3.37' seems to evoke the effects of bombardment on a domestic setting, the worst nightmare of a man with family still living in Barcelona.

* Perhaps he is receiving a literary message from the future: he will be the first to write a book on *Guernica*, published in 1947 – a combination of poetic insights, psychoanalytical digression and baffling interpretations of the painting's symbolism.

Letting themselves fall from the ceiling to the floor on their
breasts bouncing off the window panes injuring themselves
cutting themselves staining with their blood the walls the floor
the ceiling the cooker cutting it into pieces chopping it finely
pressing it with their weight… entrails hung in garlands on
nails stuck in the heart of this story of flags torn by bullets
stifled cries of the forks and spoons…

These aren't the words of someone who has never thought
about how bomb damage might look; who has not felt, even at
one remove, what George Steer called 'the obvious and occult
terror of the aeroplane' felt by the Spanish in 1937. Perhaps what
Larrea contributes most essentially is a *title* rather than a sub-
ject for the painting – Picasso will be perfectly aware of the im-
mediate currency such an association will give his work – as
well as stoking his indignation to a pitch at which tackling the
brutality of warfare head-on becomes irresistible.*

Picasso has a visual mentor in his study of war in the artist
to whom he returns again and again for inspiration: Francisco
Goya. The Franco-Spanish War at the beginning of the nine-
teenth century and the Spanish Civil War 130 years later have
marked similarities. The Napoleonic invasion of Spain led to
deep and enduring divisions, many among the educated classes
sided with the French, hoping they would bring enlightenment
values to their backward country, while traditionalists and the
general population detested them. Some even believed their
feelings were shared by the animal kingdom – a popular story
of the time claims that starving wolves in the countryside out-
side Madrid left the bodies of fallen French soldiers untouched.
There is another remarkable similarity in the two campaigns in
that both Napoleon and Franco used North African mercenar-
ies to suppress and terrorize the Spanish population, stirring up

* The suffering of citizens under bombardment is one of the subjects suggested by those
organizing the pavilion, taken up by a number of artists. In this regard at least, Picasso fulfills
his commission.

ancient memories of the Moorish occupation of Spain. This sense of historical precedent is current at the time Picasso begins working on *Guernica* and is captured in contemporary pamphlets such as *Spain Against the Invaders*, published by anti-fascist press United Editorial Limited in London in 1938. The cover features the heads of Napoleon, Hitler, Mussolini and a turbaned Moorish soldier, the four spectres haunting democratic Spain.

Parisian newspapers declare Goya the best guide to current events in the war, and a special edition of Goya's series of etchings inspired by the brutality of the Napoleonic invasion, *Los desastres de la guerra* (*The Disasters of War*), is put on sale in the Spanish Pavilion.*

There is one etching among *The Disasters of War* series that seems particularly relevant to both the subject matter and composition of *Guernica*. In his *Narrative of the Siege of Zaragoza* (1809), Charles Richard Vaughan describes an incident at the end of June 1808 when the explosion of a powder magazine reduced a street to rubble; the inhabitants, he wrote, are 'scarcely recovered from their consternation at this fatal, and irreparable, loss, and from the labour of extricating their fellow-citizens from the ruins of their houses, when the French... open(ed) a destructive fire upon the city.' The etching *Estragos de la guerra* (*Ravages of War*) captures such a moment with photographic immediacy in what is perhaps the first image showing the effects of aerial bombardment in Western art. The enemy is invisible; destruction comes from above. The etching's strong, triangular composition bears a remarkable resemblance to the central structure of *Guernica*, and there are other echoes in its depiction of broken diagonal beams, domestic furniture, a fall-

* In a sign of the complexity of Spanish sensibilities, Goya is claimed by both the left and right during the war: for the right he symbolizes the desire to preserve Spanish identity and drive out the foreign ideas represented by Napoleonic invaders.

Spain Against the Invaders, 1938

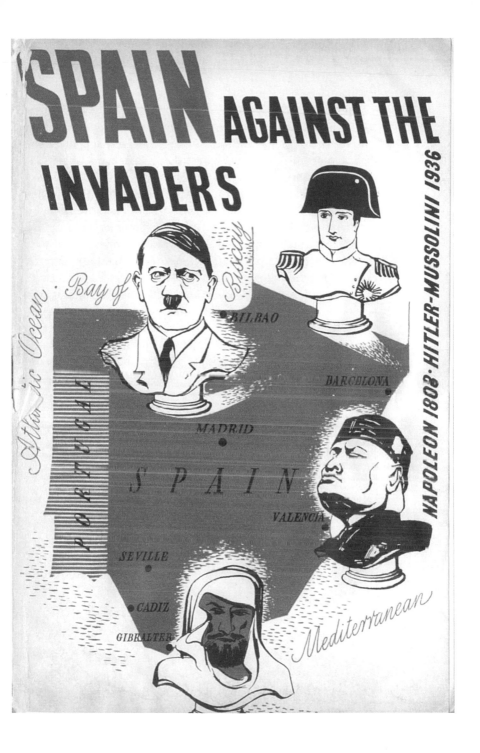

SPAIN AGAINST THE INVADERS

NAPOLEON 1808 · HITLER-MUSSOLINI 1936

Atlantic Ocean

Bay of Biscay

PORTUGAL

S P A I N

BILBAO

BARCELONA

MADRID

VALENCIA

SEVILLE

CADIZ

GIBRALTER

Mediterranean

ing female figure, the profile of a dead man lying on his back with his mouth open and a baby with its head lolling on its neck so that its face, with closed eyes, is presented to the viewer upside down.

Guernica is by no means the first work by Picasso that uses the triangular structure found in *Estragos de la guerra* and, of course, Goya follows countless others who have employed the device to organize their works: yet the triangular motif is in Picasso's mind even before he has decided on his subject. It is there in a sketch he does on 18 April entitled *The Studio: The Painter and his Model* (the first theme he has been working on for the pavilion commission), either signifying light spilled from a lamp or, as suggested by Kathleen Brunner in her book *Picasso Rewriting Picasso*, the shape of the painter's easel. A sketch done the following day, *The Studio: The Painter and his Model: Arm Holding a Hammer and Sickle,* includes an upraised arm with a clenched fist in an overtly communist, anti-fascist salute, occupying the space between the artist – depicted seated with palette in hand and brush raised – and his easel, that has a canvas already in place. Below the easel is the first appearance

FRANCISCO GOYA, 'Ravages of War', from *The Disasters of War*, 1810–14

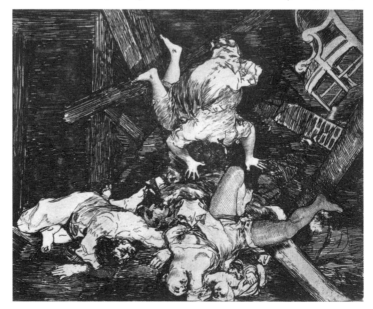

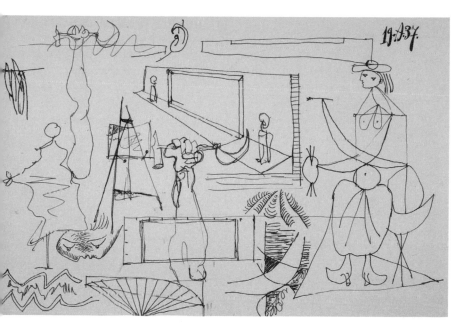

PICASSO, *The Studio: The Painter and his Model: Arm Holding a Hammer and Sickle, 1937*

of a troubled female face that will reappear in *Guernica*, where it will be looking up in search of light. The raised arm is repeated in ghostly form in the background of the sketch, while a solitary ear floats at the top of the page. Picasso can no longer work, he seems to be telling us, without encountering the struggle. Sequestered in his studio, he hears and sees everything. Without degenerating into mere agitprop, his art must take the form of resistance. 'Painting is not done to decorate apartments,' he will later tell Alfred H. Barr, director of the Museum of Modern Art in New York, clearly with reference to *Guernica* and other works inspired by conflict, 'it is an instrument of war...' against 'brutality and darkness.'

On 1 May, he makes his first drawings directly related to *Guernica*. The painting is the first in the history of modern art to have its evolution so meticulously documented, from Picasso's numbered and dated sketches to the photographs taken of the canvas itself by Dora Maar at different stages of its evolution. In part, this is a conscious performance – *Guernica* is painted in a very public way, with influential artists, writers and other cultural figures invited to the studio to see it in progress; but it also arises from Picasso's genuine fascination with the way a work is born. 'It would be very interesting to preserve photographically, not the stages, but the metamorphoses of a picture,' he had said a couple of years before, in 1935. 'Possibly one might then discover the path followed by the brain in materializing a dream. But there is one very odd thing – to notice that basically a picture doesn't change, that the first "vision" remains almost the same, in spite of appearances.'[1] In the case of *Guernica* the evidence bears him out. The first, rapidly executed sketches bearing the numbers *1er Mai 37 (I)* and *(II)* contain many of the elements of the picture that will emerge from the studio five weeks later. In both we can see a figure leaning from the window of a tall building holding a lamp. The bull and the horse are present: the bull impassive, the horse, as so often in previous works, a torture victim, its head thrown back in pain. In both pictures there is another visitor: in the first, a bird has alighted on the back of the bull; in the second it has morphed into a miniature winged Pegasus, a clear signifier that we are both in the present and the mythic past.

During the first day, Picasso continues to experiment with sketches related to the overall composition of the painting as well as individual details. A composition study (number VI) contains many features that will appear in the final painting. In it the bull appears to be crowned and Pegasus departs from a wound in the horse's side, the departing soul at the point of

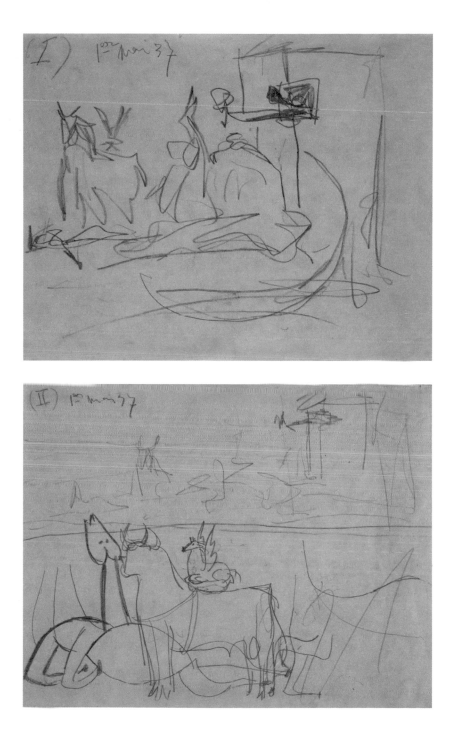

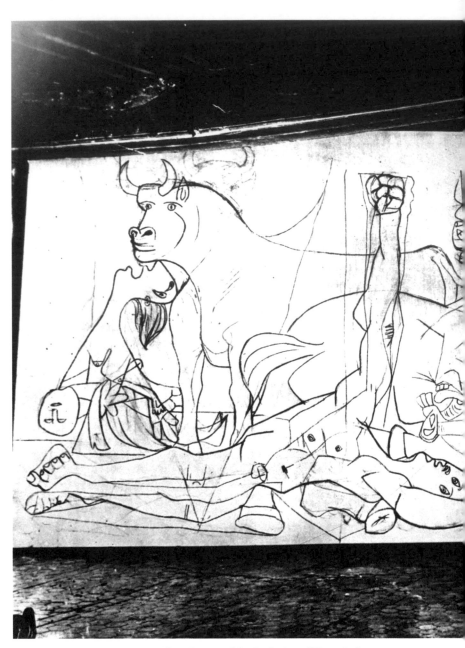

DORA MAAR, *Photo Report of the Evolution of 'Guernica'*, stage I, 1937
Museo Nacional Centro de Arte Reina Sofía

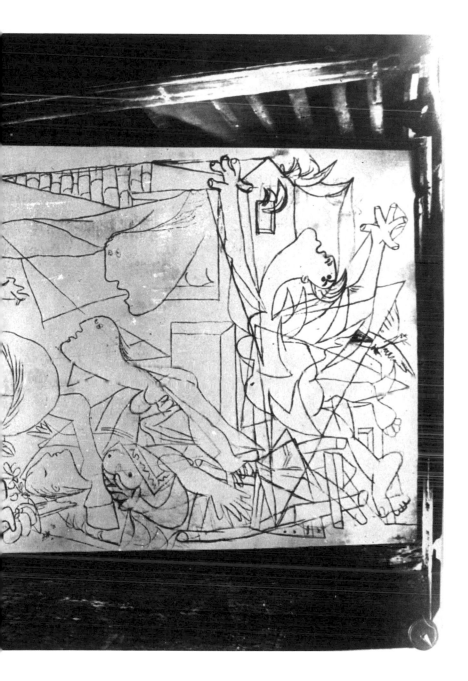

death, a motif that has appeared in previous sketches by Picasso of wounded horses in the bullring. The dead soldier who lies on the ground is a helmeted figure from the classical past, clutching a spear. Other sketches made that day explore the figure of the horse, in styles ranging from a childish pictogram to an expressionistic rendering of collapse in *Guernica sketch no. 5*.

It is not clear when Picasso realizes that the almost sixty sketches and oils produced during this period of feverish activity constitute a work of art in themselves. We will return to certain of them as we examine the painting: others we can summarize in terms of the themes that emerge over the next days and weeks. On paper and on canvas the horse is tumbled this way and that, its neck bent down to the ground or straining upward in agony, its head, gaping mouth and dagger-like, projecting tongue repeatedly explored in a separate oil painting on 2 May. The mother carrying the dead baby first appears as a version of the crouching, crawling woman on the right of the final painting, with her leg extended behind her, but Picasso also experiments with portraying her climbing a ladder. As late as 27 May he is trying out the idea of making the falling figure at the right of the painting a bearded man rather than a woman. The soldier mutates from a classical, helmeted warrior to a decapitated figure akin to a fragmented sculpture. The bull, particularly the bull's head, is depicted again and again, sometimes with human features, linking it to the Minotaur that Picasso has etched, drawn and painted frequently over the years, and to which he will return for the rest of his life. He continues to make studies even after he has begun working on the canvas, propping them up against the painting and remarking on them to André Malraux, 'if only they could crawl in to the picture all by themselves, like cockroaches'. These endless reworkings spawn their own offspring, subjects in their own right. The multiple images of distraught female faces among the sketches for *Guernica*, with mouths open in grief and tears that

chart their own course, appearing to take on solid form, continue to develop and mutate after the completion of the painting resulting in a number of works in various media on the theme of 'the Weeping Woman'.

By 9 May, Picasso has progressed sufficiently far in his thinking to make a compositional sketch that includes many of the elements of the final painting: two days later he is transferring it to the stretched canvas beneath the beams of the attic studio, where it is recorded in the first of a series of photographs by Dora Maar, her *Reportage sur l'évolution de 'Guernica'* (*Photo Report of the Evolution of 'Guernica'*).

A further seven of Maar's photographs make up the series as usually reproduced or displayed: in two of them one can see the lamps she used in efforts to illuminate the painting, the poor natural light forcing her to retouch her photographs in an attempt to get better quality images. In the initial cartoon captured by the camera, the relative positions of the principal protagonists are established: the lamp-bearer, the falling figure and the crawling woman on the right; the fallen soldier on the ground; the bull and the mother and baby on the left and the wounded horse in the middle, but the relationships between them are not established and the centre of the composition is a muddle. Picasso tries to create an upward, central movement by having the stricken soldier raise a muscled arm, very much like the one in the sketch *The Studio: The Painter and his Model: Arm Holding a Hammer and Sickle*, in a clenched fist salute. The bull stands aloof to the action but its body has not been curved around the woman and child, leaving its hindquarters at the heart of the composition. The grieving mother already has the form she will maintain until the finished picture, as does the lamp-bearer, but the horse, with its neck twisted awkwardly downward, has still to find its pose. As well as the dead soldier there is a bare-breasted woman lying on the ground; all trace of her will disappear from the completed painting apart from the

overleaf
DORA MARR, *Photo Report of the Evolution of 'Guernica'*, stage II, 1937
Museo Nacional Centro de Arte Reina Sofía

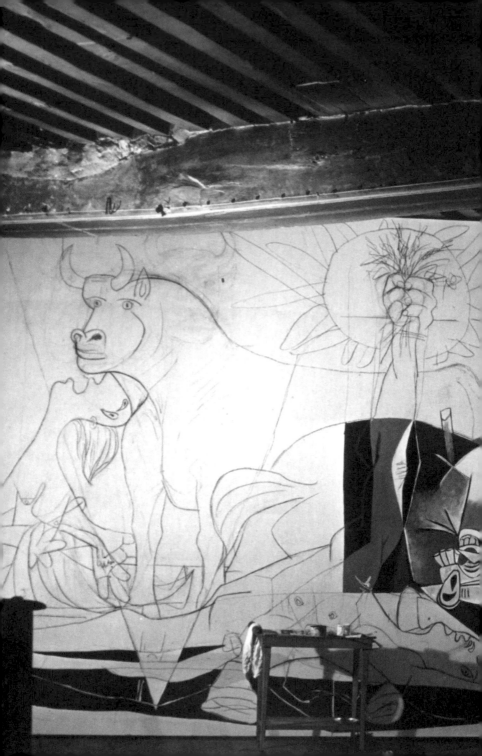

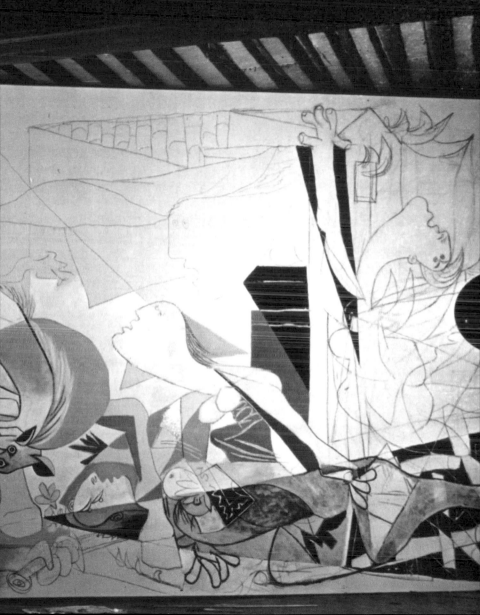

rapidly sketched hand at the end of her outstretched arm, which will be transformed into a flower. However, her temporary presence establishes a link with another work we will return to, the etching *Minotauromachy (La Minotauromachie),* done in 1935.

In the second stage photograph, the clenched fist clutches a sheaf of grain, a symbol of Republican victory. It is silhouetted in front of a sun which art historians usually describe as Mithraic, although it may be that they overemphasize any such possible connection in the artist's mind. In any case, by the third stage photograph it has gone, along with the somewhat heavy-handed symbolism of the raised arm, to be replaced by something between an eye and a spotlight that will evolve gradually into the electric bulb familiar from the final painting. The horse has been worked on, its neck bowed to the floor and its head inverted, but it already has the distinctive mismatched nostrils and protruding tongue which will survive into the final picture.

Picasso takes time out while working on the painting to visit the Spanish Pavilion, in order to assess the demands of the space his painting must command. What he sees there will influence the content of *Guernica* in varied and significant ways. The building for which the first stone is laid (somewhat late) on 27 February, and which rises rapidly, is a supremely rationalist, essentially modern construction, employing prefabricated materials; its design is largely the work of Josep Lluís Sert, the avant-garde architect from Barcelona who has also spent three years working in Le Corbusier's studio in Paris. This is nothing like the galleries in which Picasso's works are normally shown: *Guernica* will be displayed on the partially open ground floor, beneath a roof but with air circulating from both sides, next to a patio with a retractable canopy (a deliberately Hispanic touch) and a stage where performances will be held. The effect this will have had on Picasso's thinking, and even the painting's recep-

tion, is often overlooked: photographs of the painting *in situ* that are usually published are tightly cropped, giving little sense of the nature of its setting. For this reason, it is helpful to visit the reconstruction of the pavilion created in Barcelona for the 1992 Olympic Games, now used as a library by the University of Barcelona.

A reproduction of *Guernica* has been painted onto a wall to show its original position, subject to shifting natural illumination from both sides: in front of it would have been situated Alexander Calder's extraordinary poison fountain *Spanish Mercury from Almadén;* on the opposite wall a large-scale portrait of Federico García Lorca, the poet Picasso had drunk with at *El Canario de la Garriga* in Barcelona, *fusillé à Grenade* (shot in Granada) as the caption has it. To its left from the viewer's perspective is an open courtyard, sometimes covered by the

Reconstruction of the 1937 Spanish Pavilion in Barcelona, built in 1992

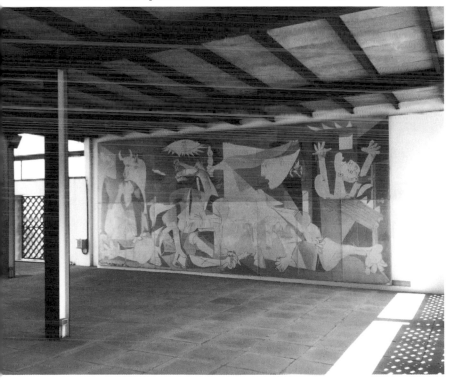

retractable canopy, sometimes not; on sunny days a crosshatched chequerboard of shadows demarcates the floor. (Paris, being less brightly illuminated than Barcelona, required the painting to be floodlit for the entire duration of the exhibition.) It is a space through which visitors – not the usual museum-going crowd but an international cross-section of the public – will be funnelled on arrival, before ascending to the third-floor exhibition via a ramp and descending and exiting via the second floor. They will already have been struck by the pavilion's distinctive white, grey and red façade, constructed from Celotex panels and asbestos cement, emblazoned with political slogans and monumental photomontage works by Josep Renau; by Alberto Sanchez's three-metre-high (9.8 ft) sculpture *El pueblo español tiene un camino que conduce a una estrella* (*The Spanish People Have a Path that Leads to a Star*); by the concrete cast of Picasso's sculpture *Woman with a Vase,* the bronze version of which he will later request stands over his grave. Yet, despite these grand gestures, the relatively modest scale of the building will have been impressed upon them by the proximity of the monumental Soviet and German pavilions.

What emerges in the successive stages of Picasso's design for *Guernica*, captured by Maar's lens, is a move from complexity towards graphic simplicity. It is possible this is driven by Picasso's growing understanding that he is painting for a moving audience, in a contested space; in a pavilion overshadowed by the grand architectural statements of its enemies and with works by artists supporting the Nationalist side on display at the nearby Vatican Pavilion. He may also be influenced by the art his painting will be keeping company with, particularly the photo-works of Josep Renau. Finally, the process of recording the evolution of the painting itself, of looking at Maar's high contrast photographs, of noticing the wooden beams in the attic studio that appear in her pictures and seem to echo the exposed metallic H-beams in the ceiling of the pavilion, all combine to

feed into the final composition, an organic process that is part of his method and that eludes definitive analysis. Picasso hates letting go of a work, as is well known: years later, Josep Lluís Sert will recount to a symposium at the Museum of Modern Art how the artist tells him, 'I don't know when I will finish it, maybe never. You had better come and take it whenever you need it.'[2] But still he keeps painting. To ensure he delivers, an 'assistant' is appointed by the management of the fair. The role is taken by a young painter, the Chilean Roberto Sebastián Antonio Matta Echaurren, better known simply as Matta, who has already joined Breton's Surrealist circle in Paris and is working in Le Corbusier's architectural office. Malitte Matta, formerly married to the painter, remembers him telling her the assignment was a challenging one. 'Matta's job was to go get *Guernica* out of Picasso's studio so they could put it in the Pavilion,' she recalls. 'So he was going every day to try and stop Picasso painting, so he could carry *Guernica* away.'[3]

Death and Geometry

If we fail to invest the bullfight
with transcendental and necessary
meaning it ceases to seem
at all serious.

LUIS MIGUEL DOMINGUÍN,
introduction to *Toros y Toreros*

Eventually the job is done. In a little more than a month – between thirty-three and thirty-five days – from the time he first sketches outlined forms onto the canvas, the dream Picasso spoke of has materialized and taken solid form. The finished painting bears little relation to factual war reportage. Instead, its flattened pictorial space has the feeling of a stage set on which the painting's dramatis personae, human and animal, gesticulate and howl – something nearer to a Greek tragedy than the news-desk of a 1930s newspaper.

Guernica is made up of three sections, almost like the panels of a triptych, and is painted in shades of black, white and grey, using an ultra-matte, non-reflective version of Ripolin paint that has been developed by the manufacturer at Picasso's request.* The strongly triangulated composition of the central panel draws our eyes upwards from the dismembered soldier on the ground towards an electric bulb, the screaming head of a mortally wounded horse and to the chief light source in the picture, a lamp gripped in the outstretched hand of a woman leaning out of a window.

On the left of the painting, a mother holding what is clearly a dead baby has flung her head up in a cry of grief. Behind her stands the figure, familiar from so many of Picasso's works, of a bull. Next to the bull's head, standing on what appears to be a table, is a bird, its beak open, with spread wings. The mother's silent ululation is echoed on the right of the picture, where a woman plunges from a burning building, mouth wide in terror, arms outstretched. Another woman enters in a crouching run, her face turned upwards to the light falling from the lamp, held out by the figure in the window. These then are the living pro-

* The first commercially distributed brand of ready-mixed enamel paint, named after a Dutch chemist, Carl Julius Ferdinand Riep.

tagonists in the drama unfolding before us: four women, two of them directly affected by the catastrophe that has just occurred, two who appear to be observers of the action; two animals and a bird. The other human figures in the painting, the soldier whose severed arm still grips a sword and the baby in its mother's arms, are both dead.

What can we tell of the setting in which these dramatis personae find themselves? Previous commentators on the painting are divided as to whether it represents an internal or external space. While the early stages of the painting captured by Dora Maar seem to represent an exterior view, the architecture of *Guernica* is contradictory: the lightbulb appears fixed to a domestic ceiling and the woman creeping in from the right seems to have entered through an open door, yet the lamp-bearer looks as though she is leaning out of a window in an open square, just as the falling woman seems to plunge from a separate building with a window illuminated by flames. We are, then, both inside and outside, rather as *Guernica* itself was when first shown within the modernist architectural space of the Spanish Pavilion; or rather, the barriers between the two states have been torn aside like a stage curtain, just as the facades of buildings disintegrate during a bombardment to reveal the private domestic worlds normally hidden behind exterior walls.

It is night. We know this from the gloom of the background, the glowing bulb with its jagged beams, and the lamp carried by the woman in the window that casts its pale light on the central section of the painting. In choosing to depict these events during the hours of darkness, Picasso departs from the historical facts: Gernika, as we know, was bombed from roughly 4.30 in the afternoon to 7.45 in the evening; the sun would not have set in late April in Spain until at least an hour later. Perhaps he is influenced by George Steer's article, published in translation in *L'Humanité*; Steer arrived in Gernika at night

when the town was already on fire. He may also be haunted by the accounts he has read of the bombing of Madrid by Louis Delaprée, which are full of nocturnal lighting effects, such as those in this description of a fireman at work after a raid:

> He sees the child's body, which is still in the road and might get crushed again. So he adroitly removes the broken glass, picks up the tiny corpse and places it on the woman's heart, next to the right breast, which is unharmed. A final flicker of the flashlight shows us the small infant's head on that maternal heart and everything sinks back into the night.[1]

The drama created by flickering, handheld lighting is carried over into *Guernica,* the fireman's torch replaced with a lamp. (The electric bulb, mysteriously, illuminates only itself.) The lamp's radiance is selective, falling on the faces and bodies of the painting's protagonists while their surroundings sink into shadow. In the case of the bull, its head and neck are in the light while its body, apart from its arching tail, blends into the dark. Picasso may have learnt about selective lighting through his study of Goya's masterpiece relating to a previous Spanish war, *The Third of May 1808.* Around the time he is working on *Guernica* he discusses Goya's painting with his friend André Malraux, particularly the light sources contained within it, one of which, the black sky, 'we do not understand… It bathes everything, like moonlight: the sierra, the bell-tower, the firing squad…' The other light in *The Third of May 1808* comes from a large square lantern, placed on the ground. 'That lantern,' he tells Malraux, 'what does it illuminate? The fellow with upraised arms, the martyr. You look carefully: its light falls only on him. *The lantern is death* [author's italics]. Why? We don't know. Nor did Goya. But Goya, he knew it had to be like that.'[2]

There are two light sources in Goya's painting, one ostensibly natural (although behaving in an unnatural manner), one man-made. There are two light sources in *Guernica* also: one,

the electric light, was originally a sun, as we have seen from Dora Maar's photographs, but this natural object has been transformed, in response, perhaps, to the glorification of technology that characterizes other pavilions at the exhibition.* Within Picasso's painting, progress seems to be running backwards: the modern bulb is entirely ineffective, emitting only the negative light that falls from Goya's black sky. In contrast, the lamp acts as a spotlight but sheds its beams selectively, foregrounding the protagonists of the painting against the dark background, almost as though they are cut and pasted from elsewhere. This quality – of subjects being picked out and juxtaposed in surprising combinations with each other and their setting – is shared with Josep Renau's photomontage murals at the pavilion.

Photomontage first made an appearance at the time of a cataclysm of a different kind.[3] The San Francisco earthquake of 1906 required photographers to cut up and rearrange photographs of the city in order to create images of the moment of its destruction. In the first two decades of the twentieth century it swiftly becomes the medium best suited to communicate, in a world shaken by war, social breakdown and revolution. Picasso is familiar with the works of Dadaists like John Heartfield, whose art Picasso's friend Louis Aragon describes as 'a knife that cuts into every heart', and also of Russian Constructivists like Alexander Rodchenko and El Lissitzky. Arguably Picasso's own pioneering use of collage has influenced photomontage's development.

According to art historian Lutz Becker, a key realization ushered in by the wars and upheavals of the first half of the twentieth century was that instead of experiencing the whole

* It is worth remembering that Picasso was first attracted to Paris in 1900 by another World's Fair, the *Exposition Universelle*, the centrepiece of which was the *Palais de l'Electricité* which contained a power station generating energy for the whole exhibition.

<div style="text-align:center">

overleaf
FRANCISCO GOYA,
The Third of May 1808, 1814

</div>

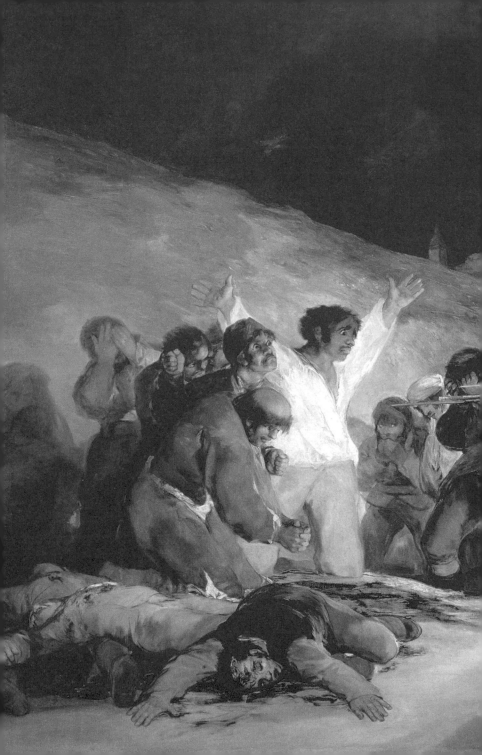

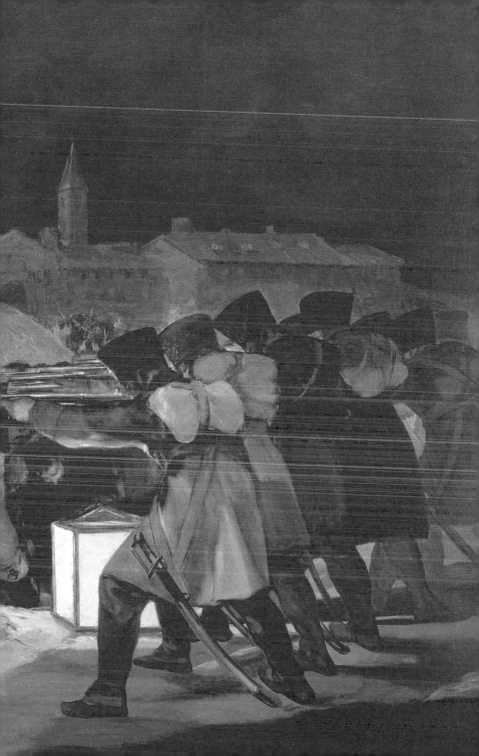

we could now only grasp at fragments. Men left home to go to war and returned shell-shocked and shattered, changed beyond recognition in a conflict that was happening elsewhere.[4] Photomontage provides the perfect medium to capture this sense of a fractured world. By the 1930s, ubiquitous and somewhat debased, it has lost the shock value of its first appearance, routinely used for everything from political posters to magazine covers: it is a feature of the decorations of national pavilions of all political hues at the exhibition. Nevertheless, in Josep Renau Spain has a master photomonteur. In his work for the pavilion he aims to show the Republic as a modern European state in which modernity is linked to progressive politics and humanist values. He and his team work with the pavilion's architecture in ways that break new ground, incorporating images by photographers including Robert Capa and Gerda Taro, combining them with texts and enlarging them to heroic scale on its outer walls. Inside the pavilion, panels tell a dynamic story about the changes taking place in Spanish society by juxtaposing images of the old, traditional ways of life in rural Spain with the new forces of democracy, education, women's equality and workers' rights.

We can deduce that Picasso was captivated by these works from a photograph taken of him in his studio by Brassaï in 1939. In the background, propped against a wall, is the Catalan peasant featured in one of Renau's photomontages; presumably he must have asked to keep it after the pavilion was dismantled. This image, of course, would have special significance to Picasso, the elective Catalan, but the connections between photomontage, the artist and *Guernica* run a little deeper than mere sentiment. Never before have the masses been bludgeoned with propaganda as they are in the 1920s and 1930s; whether in Soviet Russia, Nazi Germany, Depression-era America or France and Spain under Popular Front administrations, artists are hard at work designing posters, magazine covers, murals,

Photomural by Josep Renau, 1917.
'The new woman of Spain has rid herself of the
superstitions and misery of her past enslavement and
is reborn and capable of taking part in the celebration
of the future.'

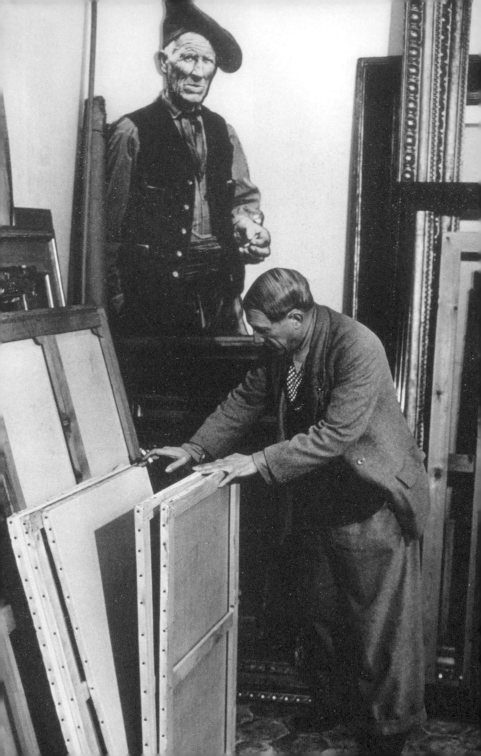

book jackets, paintings and collages, using startling juxtapositions and striking graphics to rally followers to their cause. This is the world into which *Guernica* must speak, the noise above which it must be heard. Renau's works share at least three elements with the painting: bold composition, black and white colouration and scale; while Picasso is dwarfed by the Catalan in Brassaï's photograph he appears even smaller when standing with a brush before *Guernica*, captured by Dora Maar.

The arts of collage and photography have been combined for some time in the world of art photography, not least by Maar herself; in a series of striking works made in 1936 she creates Surrealist photo collages which isolate human figures against incongruous natural and architectural backgrounds to startling effect. Picasso is well aware of these experiments and respects Maar's skills, collaborating with her on a number of works in 1936 and 1937 using the *cliché verre* technique, in which drawings, etchings or oils are transferred from glass to light-sensitive paper. In a previously untranscribed interview with Maar, conducted in Paris in 1990, Frances Morris, now director of Tate Modern but then a curator of collections, asks Maar whether she feels her photography had had an effect on *Guernica*. Maar replies, 'I think so, something like that... *Guernica* is like a photograph because it's absolutely modern. It's important to recognize that Picasso was influenced by photography and that this painting is in black and white. He was thinking of a *moment* you find in photographs.'[5] She makes an important point. Photographs are all about time: but they only show the present. The time they contain is the fast-moving time of modernity rather than the languorous time encoded into, for instance, a French classical painting. *Guernica* aspires to the flash of instantaneity a photograph can provide and this, Maar insists, lies behind Picasso's decision not to use colour. 'The whole thing', Marr goes on to insist, 'is an immense photograph.'

BRASSAÏ, *Picasso in his studio in the rue des Grands Augustins with The Catalan*, 1939

As well as denoting a nocturnal timeframe, black and white is the medium of reportage, adding to *Guernica*'s atmosphere of immediacy: it has the tonal palette of newspaper photographs, as many critics have pointed out. In the same interview, Morris asks Maar whether she thinks this is also a reason for the painting's colour scheme. Maar is not convinced. 'Alright, newspapers are in black and white – but you have to remember Picasso also used newspapers in his collages, so I am not sure that's why he did it… If it hadn't been in black and white it would have been a lot more "worked".' Black, white and grey is also the tonal range of experimental cinema, through which artists of all kinds during the 1930s are learning radical new ways of portraying the world. (In the Spanish Pavilion, *Guernica* will be exhibited alongside a courtyard where a continual programme of film is playing, one medium speaking to another.) Finally, its colours are also those of newsreels, the short news-based films playing in dedicated theatres, shaping a mass audience's understanding of world events. The British poet Stephen Spender compared seeing the painting to the 'second-hand experience' of the newspaper and the newsreel, which he called 'one of the most dominating realities of our time'.[6] *Guernica* brings news from elsewhere, but it is mediated news, marked by the latest technology, unafraid to acknowledge the channels of its transmission.

– II –

Before exploring what the figures Picasso depicts in *Guernica* may or may not symbolize, it is worth remembering that Picasso himself resisted all attempts to pin specific interpretations on the content of his paintings. 'It is not the role of the painter to create symbols', he wrote to his dealer Daniel-Henry Kahnweiler

in 1947, 'if it were, he would be better to write everything down instead of painting it. The observer interprets bull and horse as symbols, for that is how he knows them.' The viewer is the one who creates symbols and attributes meaning, in other words, rather than the artist. This determination to retain the ambiguity of imagery was standard among the avant-garde of Picasso's generation. One is reminded of Max Beckmann's response to a dealer's request to explain the imagery of his anti-Nazi triptych *Departure* (1932–5), so that he could explain it to visitors to his gallery: Beckmann told him if this was essential he should 'either take the painting away or send it back'.*

In the attempt to decode Picasso, details in his works are routinely linked to events in his life, a biographical approach reinforced by his own reference to his artistic output as a kind of diary. Yet these endeavours, rooted in the Romantic notion of the artist as individual genius, are undermined repeatedly by other statements made by Picasso in which he clearly rejects intellectual analysis in favour of a more visceral appreciation. 'Everyone wants to understand art,' he told his friend and collaborator Christian Zervos in 1935. 'Why not try to understand the songs of a bird? Why does one love the night, flowers, everything around one, without trying to understand them? But in the case of a painting people have to *understand*.'

In the context of what Picasso refers to as 'understanding' – a purely intellectual comprehension, one suspects – it is instructive to be reminded of the artist's description, in a conversation with André Malraux in 1937, of seeing African masks for the first time in a decrepit ethnographic museum in Paris two decades earlier. 'When I went to the Trocadéro it was disgusting,' he recalled. 'The flea market. The smell. I was all alone. I wanted to get away. But I didn't leave. I stayed. I stayed. I understood

* *Departure* hung for many years at the top of the stairs leading to the room containing *Guernica* at the Museum of Modern Art in New York.

something very important: *something was happening to me, wasn't it?* [author's italics]. The masks weren't like other kinds of sculpture. Not at all. They were magical things.'[7] Such artefacts are not subjected to aesthetic judgement by the culture that creates them but are charged with an authority that allows them to effect changes in material reality. For complex cultural and historical reasons *Guernica* too will be invested with authority by generations of viewers in countless different contexts, its presence a comment on global realpolitik or the herald of change.

We have already discussed the light in *Guernica,* but what of the woman who is herself a light source, whose body is resolved into a head, neck and arm sinuously flowing from a window, holding out a lamp? Let us start our investigation of the painting with her. Female lamp-bearers have appeared repeatedly in earlier works by Picasso, from etchings to sculpture. The one that resonates most closely with *Guernica* appears in the etching *La Minotauromachie (Minotauromachy;* 1935), a haunting work that takes us to the heart of Picasso's personal image library, drawn from bullfighting, art history, elements of autobiography and classical mythology. The contrast between the central figures of the young girl and the Minotaur – youth, purity and innocence on the one hand and an ancient, animalistic physicality on the other – is obvious; yet the girl is the more powerful. She holds up a lamp, casting a light from which the Minotaur is forced to protect itself with a raised palm, as if it cannot bear the truth it emits. The horse in *Minotauromachy,* eviscerated by a bull's horn, its entrails spilling onto the ground, is drawn straight from Picasso's lifelong fellowship with *aficionados* of the *corrida de toros.* Across the horse's back lies a bare-breasted female matador, eyes closed, either in death or sleep; as we have noted, her ghost appears in the first of Dora Maar's staged photographs of *Guernica,* lying on the ground. As Herschel B. Chipp has pointed

PICASSO, *Guernica,* 1937 (detail)
Museo Nacional Centro de Arte Reina Sofía

overleaf
PICASSO, *Minotauromachy,* 1935

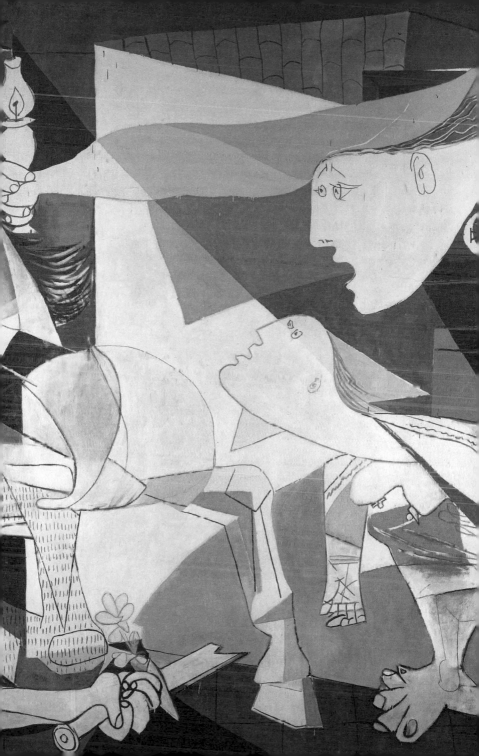

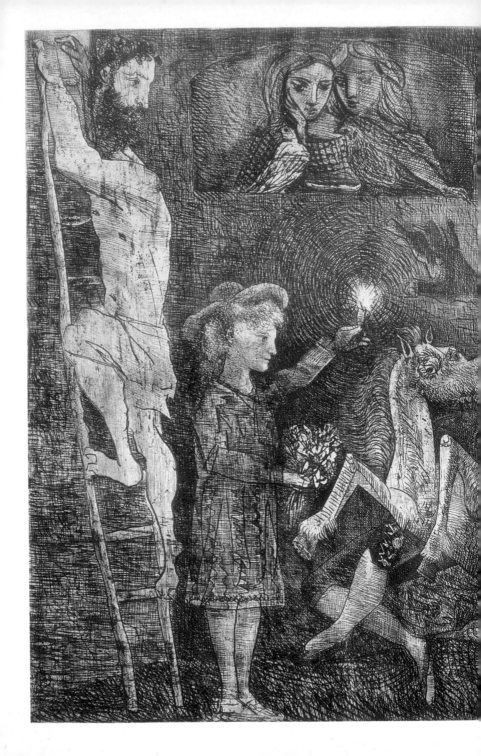

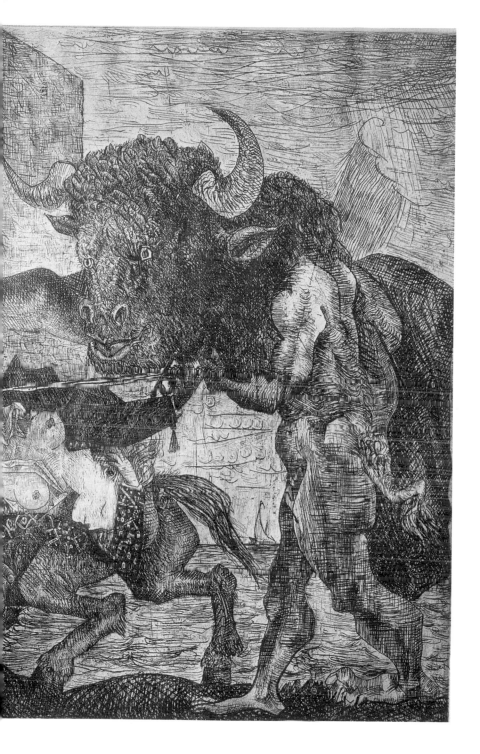

out, if *Minotauromachy* is reversed as it would have been drawn onto the plate, its foreshadowing of *Guernica*'s composition is more evident: the Minotaur occupies roughly the same space as the bull, the man on the ladder that of the falling woman, the watchers in the window that of the lamp-bearer.

Picasso's biographer John Richardson links both the figure of the girl holding the lamp in *Minotauromachy* and the woman reaching from the window in *Guernica* with Picasso's sister Conchita, who died of diphtheria when Picasso was fourteen.[8] Picasso vowed to give up drawing and painting if his sister survived; he broke his vow and she died, possibly leaving the artist's psyche marked by guilt. For Richardson, this brings a 'votive' element to *Guernica;* Picasso is still atoning for the past, working out his own complicated family history, using it to add psychological depth to his portrayal of a very different tragedy. For this viewer, the *function* of the light-bringer is more important than her identity as a figure from the artist's past, real life being merely the raw material from which Picasso creates something entirely new; the lamp illuminates, brings truth – but instead of holding the powerful at bay, as it does in *Minotauromachy,* it can only reveal the horror of war.

The lamp-bearer's arm brings us to the heart of the composition at the top of the pyramid shape at its centre. We are joined in this movement by a female figure advancing from the right, who has possibly entered through an open door and onto whose lifted face the light of the lamp falls. She appears stupefied, her arms swinging free, her giant left leg extended behind her, her bare buttocks splashed with black paint and her breasts finishing in nipples rendered as something between mechanical fixtures and the teat on a baby's bottle. There is something cartoon-like about the simplicity of her outline, spotted by the correspondent for *Life* magazine, who writes that the 'creature running at lower right suggests the work of James Thurber of *The New Yorker*.'[9] For American critic Robert Rosenblum, her body

language 'recalls the awestruck, kneeling posture of prayer associated with Catholic traditions of rural feminine piety, an expression of wide-eyed, simpleminded faith often recorded by Goya.'[10]

The British artist Henry Moore, who visits rue des Grands Augustins in late May 1937 while Picasso is working on *Guernica*, along with Roland Penrose, Paul Éluard, Max Ernst, André Breton and Alberto Giacometti, provides a more earthy explanation. '*Guernica* was still a long way from being finished,' he recalls in his autobiography.

> It was just a cartoon laid in black and grey, he could have coloured it as he coloured his sketches. Anyway, you know the woman who comes running out of the little cabin on the right with one hand held in front of her? Well, Picasso told us there was something missing there and he went and fetched a roll of toilet paper and stuck it into the woman's hand, as much to say that she'd been caught in the bathroom when the bombs came.

'"There, that leaves no doubt about the commonest and most primitive effect of fear,"' Moore remembers Picasso saying – the same Picasso who had watched Alice Toklas's knees knocking together from under a table as a Zeppelin drifted across the sky above Paris – adding 'that was just like him of course, to be tremendously moved about Spain and yet turn it aside with a joke'.

– III –

Drawn into the converging trajectories of the two women, the viewer arrives at the head of the wounded horse, its silent scream at the vortex of the composition, where two light sources do battle for our attention. A common word for lightbulb in Spanish is *bombilla* (similar to the word *bomba* for bomb) and

the electric light's jagged rays may bring to mind either aerial bombardment or Dora Maar's exploding flashbulb. The horse's head, flung back over its shoulder on its long neck, gives a vivid impression of terror mixed with pain, its mismatched yin and yang nostrils flared, its mouth wide revealing its jutting tongue, its teeth and the striations of its palate. Again, in a controlled experiment, Picasso has allowed the paint to drip from the horse's teeth and chin, suggesting saliva. Its body is treated in a manner that recalls the Cubism of previous decades, its planes delineated more by differences in markings than three-dimensional modelling. What is clear is that the horse has been transfixed by a spear from above, its side pierced by a vertical, gaping wound and another, smaller wound spraying blood in the manner of so many Spanish religious paintings. The horse's body and three of its legs are marked with short, regular, vertical brushstrokes. It is moving forward and yet pulling back, as if caught at the moment of crisis that has arrived from the sky; its front left leg ends in a hoof which is one of the few convincingly three-dimensional objects in the painting, rather like the hoof of a horse in a fairground ride, while its right front leg is bent either in obeisance or collapse. The tail is half-raised in fear, revealing its anus, and its right back foot, next to the head of the soldier, is lifted off the ground displaying a semi-circular horseshoe.

So much for the immediately apparent evidence of our eyes: however, in a work by Picasso, a horse – particularly a wounded horse – comes weighted with references that stretch back to the beginnings of his career; most often it is held in tension with the other major animal character in *Guernica,* the bull. Picasso has been following the fate of these two creatures, as well as drawing, painting and engraving them, since he was a child in Málaga. To understand *Guernica,* to understand Picasso, perhaps it might be argued to understand Spain (at least the Spain of the twentieth century) one cannot ignore the *plaza de*

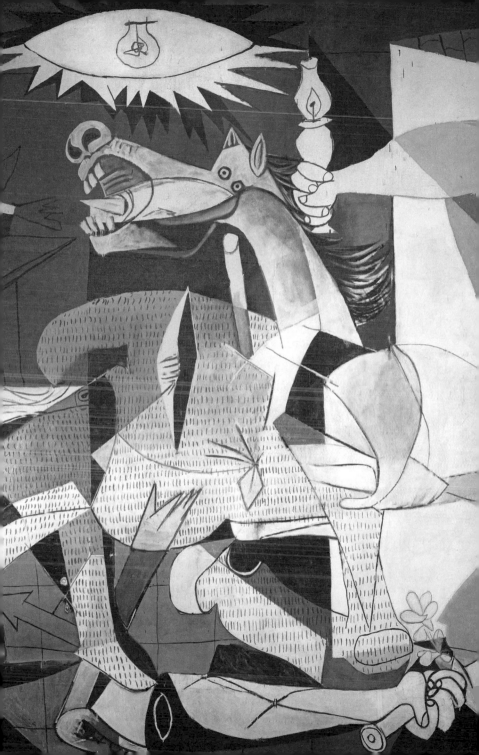

toros, the monumental structure that still rivals the football stadium for stature in many Spanish cities.* Picasso first saw a bullfight aged eight or nine years old. 'At that time', he tells an interviewer many years later, 'the bulls were different, massive. They attacked the horses again and again, up to twenty times. The horses dropped like flies, their entrails flying everywhere. A dreadful sight!' Yet it is a sight fully sanctioned by the culture he grows up in; Spanish children are taught that the shape of the Iberian Peninsula resembles a bull's hide, the nation by implication steeped in blood sacrifice. Bull and matador are alternately aggressor and victim, powerful and vulnerable. For the most part the horse plays the role of martyr, while the audience judge and comment on the action like a classical chorus in arenas that recall, and in some cases literally are, Roman amphitheatres.

The bullfight provides Picasso with a subject sufficiently charged with violence, braggadocio and metaphor to sustain his imagination for the rest of his life; a cast of characters to be dealt out like tarot cards in different combinations, applicable to any given situation. His identity as an *aficionado* transcends even politics.† Why put a stricken horse at the centre of a depiction of an aerial bombardment? Perhaps for the same reason the photographer Robert Capa often chooses, while in a war zone, to show the face of a mother or a distressed child rather than marching troops or columns of tanks. As he tells his friend John Steinbeck, 'you cannot photograph war, because it is largely an emotion.' This is particularly true of the Spanish Civil War,

* I take it as read that the majority of my readers will share my abhorrence at the cruelty to animals involved in bullfighting, while also acknowledging its importance in Picasso's art and historically in Spanish culture.

† In the 1950s, living in Vallauris in the South of France, Picasso is friendly with Louis Miguel Dominguín, a talented bullfighter who is also a hunting companion of General Franco and probably acts as a spy for him. Picasso wants to buy a local sports ground to convert into a bullring to showcase his talents. Dominguín writes the preface to a catalogue of Picasso's lithographs of bullfights, *Toros y Toreros*.

where fear – of attack from the air, of Moorish soldiers, of extreme violence at the hands of former neighbours and colleagues – is a defining feature. That fear is felt not only by human beings but also by the animals that share their world.

Animals are present in many of the reports of the war in Spain, even in the heart of the capital. Catholic priest Father Alberto Onaindía, an eyewitness to the bombing of the 'defenceless inhabitants' of Gernika, recalled how 'through the streets wandered the animals brought to market, donkeys, pigs, chickens. In the midst of that conflagration we saw people who fled screaming, praying or gesticulating against the attackers.' Humans and animals alike are 'defenceless inhabitants', sharing the town's embattled space, strafed by planes. They share the space of Picasso's *Guernica* also, equally able to convey emotions, including Capa's elusive 'emotion' of war.

In a bullfight, the relationship between horse and bull is relatively simple to understand: the bull attempts to disembowel the horse, which is forced to approach by its rider, while the apparently innocent horse delivers pain to the bull by providing a mount for the picador, whose aim is to thrust pikes into its shoulders during the opening stage of the bullfight. (A thrust from a pike is known as a *picazo*.) Horses in bullfights today, for the most part, wear protective padding, although they can still suffer injury; when Picasso was a child they had no such protection and their vocal chords were cut to prevent their screams disrupting the enjoyment of the audience. Bullfighting, as Hemingway points out in *Death in the Afternoon*, is 'not a sport in the Anglo-Saxon sense of the word', with its connotations of fair play, but 'rather it is a tragedy... in which there is danger for the man but certain death for the animal.' The bull must die and the matador must evade death; but unless the elaborate choreography of the death ritual is executed with precision and grace, the matador can expect nothing but derision from *aficionados* in the stands. The writer who best explains what has captivated

artists from Goya to Francis Bacon about *la corrida* is Federico García Lorca, in his essay *Theory and Function of the Duende*, an exploration of the dark spirit that animates Spanish culture. For García Lorca, all the arts of Spain – in which he includes Zurbarán, El Greco, Goya, sculpture, church architecture, pilgrimages and 'the innumerable Good Friday ceremonies which, together with the most civilized spectacle of bullfighting, constitute the popular triumph of death in Spain' – are animated by the *duende*. However, he maintains, 'it is in bullfighting that the *duende* attains its most impressive character, because, on the one hand, it has to fight with death, which may bring destruction, and on the other hand with geometry.' Death and geometry; precisely the monsters Picasso must wrestle with when he raises the banner of art against the forces of darkness in Spain.

The horse, then, seems to stand for suffering: but whose? The suffering of the people of Gernika? Of Spain? Or of innocents caught in war in general, as Picasso's close friend and secretary Jaime Sabartés believed? These are the most usual readings of the animal's symbolic meaning. Yet Juan Larrea, in his book *Guernica: Pablo Picasso*, written in the immediate aftermath of both the war in Spain and the Second World War, maintains the horse represents 'nothing more nor less than Nationalist Spain', while the bull embodies the stalwart forces of the Republicans. (After all, as Larrea points out, the bull is a 'totem of the Peninsula, and Spaniards attend its sacrifice with passionate enthusiasm.') Picasso is, in effect, taking revenge, his brush bursting out 'in a magic imprecation... calling down on Franco's fascism a spasm of agony and its final doom.' Larrea's is, to say the least, a singular reading, attributing motivations to the artist that perhaps more closely mirror his own. It is worth noting nonetheless, if only to highlight the way in which interpretations of the painting shift and slip according to the predisposition of its viewer, adapting to the tenor of the time: precisely the quality that has allowed it to remain vital in different

geographical and political settings for almost a century.

Pinned down by an earnest young American GI named Jerome Seckler in Paris in 1945, Picasso admits that *Guernica* employs symbolism and allegory more explicitly than is his normal practice, because it has been created 'for the definite expression and solution of a problem.' The horse, he agrees, 'represents the people', while the bull 'is not fascism, but it is brutality and darkness.' Yet even these clues are undermined elsewhere in the interview when he tells Seckler, who has already offered his own interpretation of another work, that 'if you give a meaning to certain things in my paintings it may be very true, but it was not my idea to give this meaning... I make a painting for the painting. I paint the objects for what they are. It's in my subconscious.'[11] On another occasion he will go even further in renouncing ownership of the painting's content, saying 'it's up to the public to see what it wants to see'.[12] With this statement Picasso dismisses much of the writing that surrounds *Guernica,* which attributes meaning to it dependent on his alleged purpose in creating it. As Theodor W. Adorno will argue, while an artist's motivation is present in an artwork, it is by no means as all-determining as is often assumed. The 'confusion of the intention, what the artist supposedly wants to say, with the content of the work' he regarded as 'the most disastrous' among the sources of error in the interpretation of art.[13] Moreover, he insists, there is no such thing as art made in total isolation from human society. The very material of the artwork 'is itself sedimented spirit, preformed socially by human consciousness... Therefore [the artist's] struggle with the material is a struggle with society, precisely to the extent that society has migrated into the work.'[14] The autonomous life of the artwork asserts itself even during its creation and continues to do so long after its creator has left the stage. These ideas have undeniable resonance when considering *Guernica,* an image formed in response to human events that, once

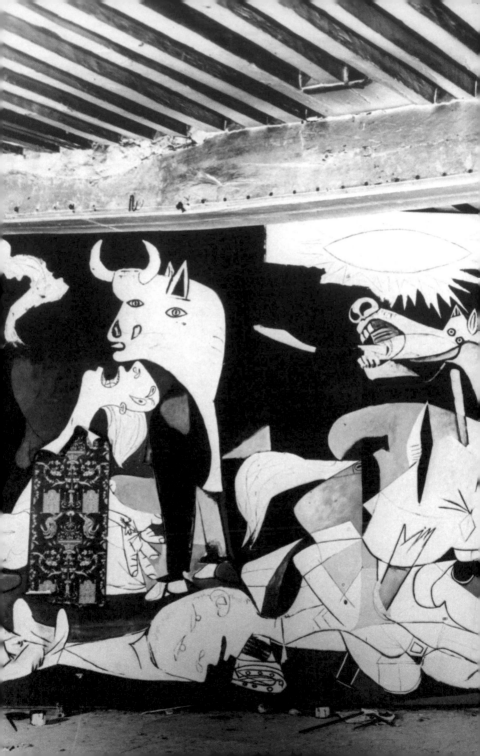

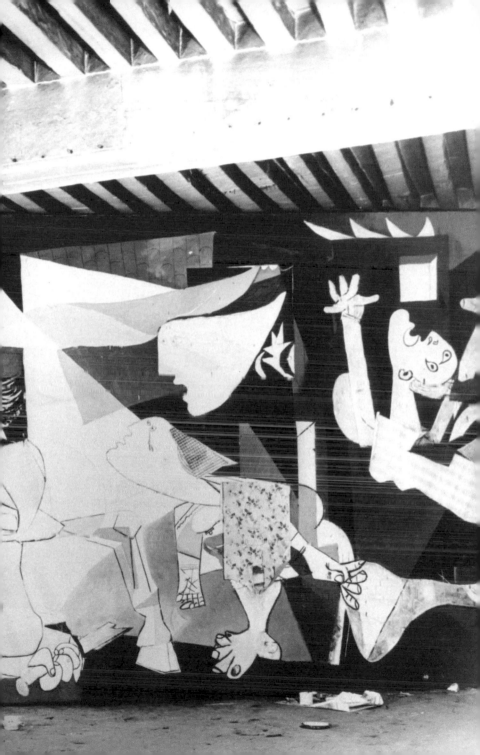

released from the studio, is subject to multiple interpretations and appropriations beyond Picasso's control.

According to Dora Maar, Picasso assures her that the horse represents *la douleur et la mort* (pain and death) and also the Four Horsemen of the Apocalypse, a reference to the Book of Revelation later picked up by Robert Rosenblum, who will see the horse as 'a biblical image of the end of the world, now consummated through modern warfare'.[15] Maar's involvement with *Guernica* goes beyond documenting it on film; for some time it has been known that at the last moment before it left the rue des Grands Augustins she completed the painting of the horse, although how much of its surface she intervened in has been hard to establish. 'We were at the Zervos's,' she tells Frances Morris in their recorded conversation. 'It was necessary to take a photograph.' (This was the last of those chronicling the development of the painting.) 'Picasso said, "I haven't got the time now to go and do it... Go, take the photograph and paint the last few lines [*traits*] that are missing on the horse's leg [*patte*] before you take it." We had to give the photo to the printers straight away for the next issue of *Cahiers d'Art*.' Maar's contribution seems to be limited to working on one leg, then – but what are the lines Picasso speaks of? The most likely interpretation of '*traits*' seems to be the repeated vertical marks on the body of the horse, which distinguish it from the background. This would mean Maar is entrusted simply with copying the pattern already created elsewhere by Picasso on a remaining section of leg before photographing the completed painting, a task he knew she was more than capable of.

The marks on the horse's body have often been compared to newsprint, an interpretation influenced perhaps by the frequent appearance of newspapers in Cubist still lifes by Picasso and Juan Gris among others. This could be seen as strengthening the argument that *Guernica* is somehow inspired by newspaper reportage; however the brushstrokes are not broken up in any

way into sentences or paragraphs but remain uniform, creating an effect more like horsehair than newsprint. They play a vital role in differentiating the horse's body from the severed head and arm of the soldier in the foreground, and the jumbled and indistinct wreckage behind it, bringing a sense of surface and depth to the painting that has been missing. During the preceding days, Picasso has been attaching pieces of patterned paper to the painting in a return to Cubist collage techniques captured in Dora Maar's penultimate photograph of *Guernica*'s development (see pages 88–9); it is possible these experiments have allowed him to see that treating the horse's hide differently will achieve his goal of pulling the final composition together.

Maar's intervention in *Guernica* in terms of painting therefore seems to have been a limited one. Nevertheless, by applying her brush to the horse, Maar continues a long-standing connection between women and horses in Picasso's oeuvre. The subject of women on horseback recurs in his work throughout his life, a fascination sparked perhaps by his affair as a teenager in Barcelona with the circus performer and equestrienne Rosita del Oro. He will tell more than one companion that his many depictions of gored horses – even the maimed horses themselves, dragged from the bullring – represent the women he has known. 'Like any artist', he is 'primarily the painter of woman', he will explain to his lover Françoise Gilot in 1943; and woman is 'essentially a machine for suffering… I want to underline the anguish of the flesh, which, even in the hour of its triumph, its "beauty", is frightened by the first signs of the alteration of time.'[16] Such statements have provoked justified outrage about Picasso's misogyny down the years, clouding our ability to see his work clearly.* It is true that women's bodies are very often the place where drama in his works is played out, often in terms

* Picasso will later tell Geneviève Laporte, 'I am a woman', hinting at an identification with his subjects that slightly complicates any reading of his attitude.

of erotically charged or threatened violence. In *Guernica*, their role is different; it is women and animals that express through their physicality the horror of what has taken place. For John Berger, the 'protest' contained in the painting lies 'in what has happened to the bodies – to the hands, the soles of the feet, the horse's tongue, the mother's breasts, the eyes in the head. What has happened to them *in being painted* is the imaginative equivalent of what happened to them… in the flesh. We are made to feel their pain with our eyes. And pain is the protest of the body.'[17]

From the horse we move to its eternal partner in the dance of death, the bull that dominates the left-hand side of the painting. Between them is one of the least distinct and most rapidly drawn areas of the composition: a bird, sketched in black on the dark grey background, brightened by a single splash of light. It is impossible, given the history of European art, not to see the bird as related to the dove that is the symbol of the Holy Spirit in so many religious paintings, just as it is also connected to the domestic fowl that wandered in and out of the Spanish houses of Picasso's youth and the birds strung up in so many still lifes in the Prado. If it is a dove, it is one that has crashed to earth, swapping the heavens for a domestic tabletop, holy radiance for a crude black outline and serenity for an undignified squawk of fear.

The symbolic meaning of the bull in *Guernica* has divided commentators from the moment the painting was first seen in public. Dora Maar's voice on the tape made by Frances Morris is firm as it reaches back into her memory, speaking in English and then French for emphasis: 'Picasso said "the bull is the Spanish people – *C'est le peuple Espagnol*".' For Alfred H. Barr, who will stable the animal for many years at the Museum of Modern Art in New York, the bull 'stands surveying the scene in apparent triumph… the symbol of implacable power.'[18] For Christian Zervos, it is 'a majestic dreamer, in the fullness of

strength freed from death, in possession of time and destiny.'[19] Even Vernon Clark, a fierce critic of the painting on its arrival in North America, maintains 'the bull, *villain of the piece*, is the only figure in the mural that has any dignity.'[20] For Anthony Blunt, the bull stands 'as if hypnotized by the light at which he stares, defiant yet terrified'.

How can we reconcile these observations, particularly Maar's comment, with Picasso's statement that the bull, although it 'is not fascism... is brutality and darkness'? Such an interpretation is also at odds with that of Juan Larrea, so close to the commissioning, execution and first display of the painting, who sees the bull's role as that of protector of the mother and child. It is true the curve of its body insulates the Pietà scene from the central trauma of the painting, its testicles hanging heavy by the woman's right shoulder, its tail positioned, according to some accounts, to conceal water damage to the canvas caused by the leaking of the studio roof.

In the sketches and studies for *Guernica* in which the bull features it is a calm figure, variously depicted with a Pegasus on its back, wearing a classical garland and with a human face. By 10 May a detailed study of its head shows it fully morphed into a Minotaur with human features, a direction explored further in drawings on 11 and 20 May. Self-portraits, perhaps? John Richardson certainly thinks so, seeing the 'magnificent drawings of Picasso in the role of a bearded Minotaur' among the studies as suggesting *Guernica* has 'a more personal significance... In the painting he portrays himself as a Minotaur who coolly turns away from the carnage, seemingly unfazed by the mother figure holding a dead baby in her arms.'[21]

Given these conflicting interpretations, I hope the reader will forgive me for offering one more. Standing before *Guernica* in the Museo Reina Sofía in Madrid, what strikes me is that the bull is the only character in the painting to look (even given his oddly placed eyes) directly at the viewer.

The phrase I record in my notebook is

the bull is the witness

The animal does not appear either terrified or aggressive, 'cool' or 'unfazed' – rather than bellowing before a charge, its partially opened mouth suggests instead it is making a comment, perhaps in the manner of the rhetorical remarks beneath Goya's etchings of war: *Yo lo Vi* (*I Saw It*); or *Por Qué?* (*Why?*). Perhaps my impression that intelligence emanates from the bull is intensified by *Guernica*'s current location, only a few minutes walk from the Prado and therefore within the force field of another great work by Goya, *The Second of May 1808*, also known as *La lucha con los mamelucos* (*The Charge of the Mamelukes* or *The Fight Against the Mamelukes*).

Goya's *The Third of May 1808* is more often discussed as a possible influence on *Guernica*, but *The Second of May 1808* was painted to be displayed with its companion piece, and Picasso would have known it equally well from visiting the Prado. The twin works depict events in the Spanish capital over a forty-eight-hour period: the uprising of the working-class citizens of Madrid in an attempt to prevent the removal of the last members of the Spanish royal family by French General Murat and the brutal reprisals by French troops the next day. The dead, arms outstretched, mouths open, slip from saddles or litter the ground. There is no bull in *The Second of May*. Instead, horses have the role of witnesses: in the heart of the madness and slaughter, surrounded on all sides by men stabbing and hacking each other to death, including Egyptian mercenaries in red turbans and pantaloons, helmeted French soldiers and the rabble of locksmiths, muleteers, cobblers and coachmen that official records would later reveal comprised the patriots, appear two noble equine heads. Seemingly the only rational beings in Madrid's Puerta del Sol, their direct gaze interrogates our complicity in the ability of men to descend so swiftly into barbarism.

PICASSO, *Guernica,* 1937 (detail)
Museo Nacional Centro de Arte Reina Sofía

overleaf
FRANCISCO GOYA, *The Second of May 1808* or
'*The Fight Against the Mamelukes*', 1814

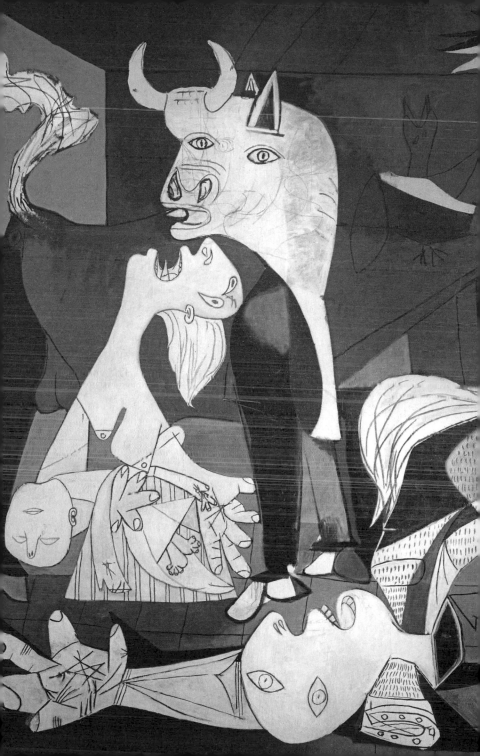

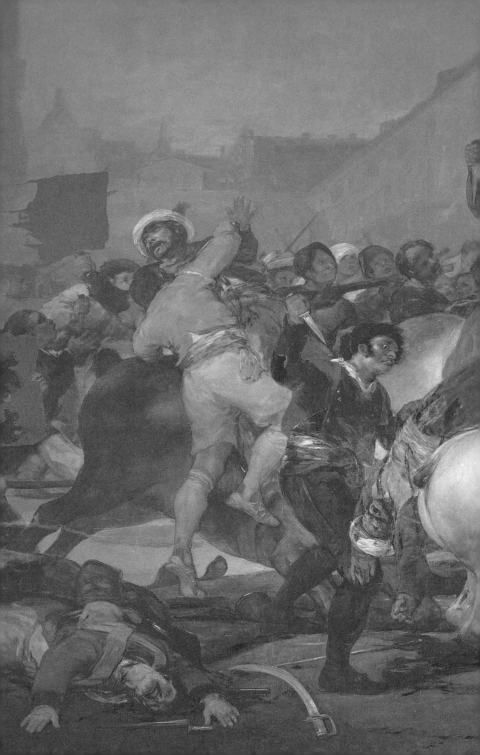

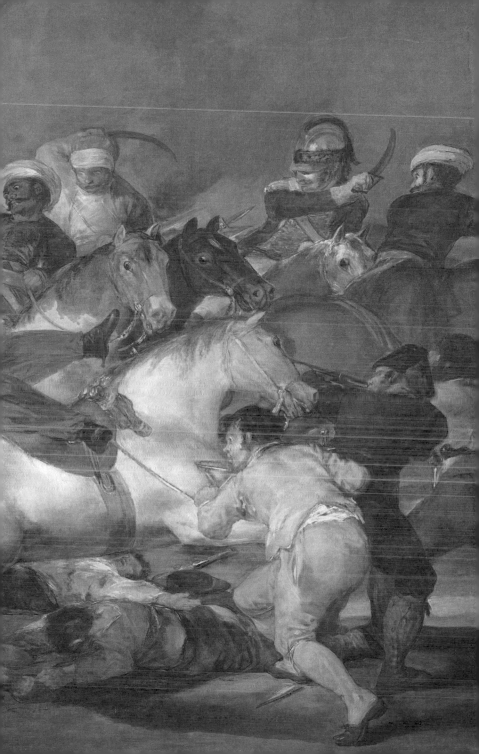

As *The Second of May* reminds us, Islamic soldiers were deployed by Napoleonic forces to repress the Spanish people, just as *regulares* (Moroccan troops) were used by Franco, the great defender of the Roman Catholic Church, over a century later. The depth of the cultural anxieties their presence awoke in the Spanish psyche in the 1930s, particularly in that of a malagueño like Picasso, born within scent of Morocco, is embedded in the Spanish language to this day. The phrase '*no hay moros en la costa*', literally translated as 'there are no Moors on the coast', figuratively means 'everything's OK and no troubles are looming on the horizon'. While there are no direct visual references to the *regulares* in Picasso's painting (like all other aggressors they remain unseen), there may be a clue to these xenophobic terrors encoded into its composition. More than one commentator has claimed that the horseshoe on the rear right foot of the horse, close to the face of the fallen warrior, symbolizes the crescent of Islam. At first sight tenuous, this interpretation gains support from Dora Maar's claim that she remembers Picasso constantly railing about the second Moorish invasion during the painting of the picture.

– IV –

The most direct effects of the murderous impulses unleashed by war lie trampled beneath the horse's feet. The body of the fallen warrior is in pieces, like a classical sculpture toppled from its pedestal. His journey towards the final composition has begun on 1 May in a sketch done on a wooden panel, in which his body lay in the opposite direction, wearing a Greek or Roman helmet and clutching a spear, resembling the illustrations Picasso had made for an edition of Aristophanes' *Lysistrata* in 1933. It is not until 10 June that Picasso arrives at the distinctive bald

head and staring eyes that appear in *Guernica*. It is possible that he finds inspiration for them in the eleventh-century Romanesque manuscript *The Saint-Sever Beatus*, the eighth folio of which contains extraordinary imagery of the great flood. The figure of the drowned giant, with his gaping mouth, hairless head without ears and distinctive almond-shaped eyes has an indisputable resemblance to *Guernica*'s dead soldier. The Surrealist Georges Bataille, Picasso's friend and sometimes collaborator, had written about this illustration in an issue of *Documents* in 1929, focusing particularly on the features of the giant's head, an essay Picasso may have either seen himself or had drawn to his attention by Maar, Bataille's former lover.

The left arm of the fallen soldier in *Guernica* is thrown behind his severed head, the fat fingers of his hand outstretched. From the position of its thumb it is clearly a right, rather than a left hand. In 1970, Picasso has a conversation with George Daskall, a Bulgarian journalist working for the BBC World Service. They talk about André Breton's idea of the 'tortured object', distorted by external events, and Picasso says the town of Gernika after the attack was 'the most tortured object in the world... All living creatures in that town, human and animal, were converted into tortured objects, decomposed, distorted and shrieking their agony to the sky. The painting is simply a symbolic representation of the horror as seen in my own mind – that is all.' At a second meeting he takes a large, right-hand leather glove out of his pocket and passes it to Daskall, telling him 'this is from Gernika. The man who wore it died in the destruction, his hands contorted in death. This is a tortured object found on the battlefield of liberty.'[22] We don't know who gave him the glove, but it was clearly important to Picasso; as well as providing the model for the fallen warrior's left hand it was an object charged with power – a little like the fetishes he had seen long ago in the Trocadéro – granting a visceral connection with Gernika and the events that took place there.

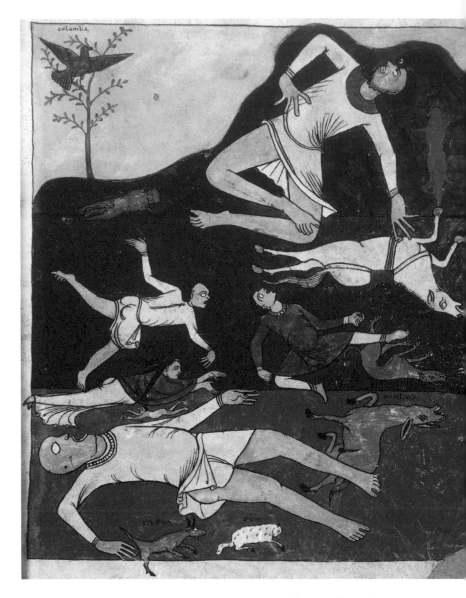

BEATUS DE LIEBANA, *Commentary on the Apocalypse of Saint-Sever* (detail), eleventh century

Like the bird, or dove, images of a mother and child tap directly both into the history of Western art, with its depictions of the Pietà, and into direct lived experience. The hands of the grieving mother in *Guernica* are enormous, by contrast making the infant's tiny feet even more poignant; one cradles her child, the other, with its lined, working mother's fingers, is spread in a gesture of helplessness. These hands were meant to protect her baby from harm, to hold it close, yet she has failed in her most primal task, unlocking an existential howl of grief. Her flung-back head, extended neck, open mouth, asymmetrical nostrils and teardrop-shaped eyes, separated by frown lines, are mirrored in the face of the woman falling from the burning building. The two figures provide what T. J. Clark has called the painting's 'rhyming agonies'. [23]

In the preliminary sketches for the painting, it is the woman entering from the right, looking up at the lamp, who carries the dead child, but by the 11 May, when Dora Maar records the first state of the painting sketched out on canvas, this female character has split into two distinct beings. They will continue to divide and subdivide, spawning a series of distinct works on the theme of 'the Weeping Woman' that extend beyond the completion of *Guernica*. In some of them, tears and the tracks they leave on skin become solid objects so that teardrops appear to dangle on strings like pearls, while in others, tear ducts themselves protrude from the eyes like gun barrels, signifying perhaps that tears can be weapons of attrition as well as the mark of passive suffering. Dora Maar is supposed to be the model for these women, which some critics have compared to religious images of the *Mater Dolorosa*, to the many depictions of weeping female saints and the Virgin Mary in Spanish art and to a religious sculpture in the Picasso family apartment in Barcelona, to which Picasso's father had attached glass tears. Only once does Maar become agitated during her conversation with Frances Morris, when asked if the paintings and studies

relating to the theme of the *Weeping Woman* for which she in some sense served as an archetype are rooted in religious symbolism. 'Certainly not, it is absurd,' she says. 'The disaster of *Guernica* is nothing at all religious. It is about the people who have lost everything at Gernika... the emotion of the tragedy of Spain, that's it.' A grieving mother is, after all, the most universal symbol of the horrors of war, the 'tortured object' par excellence. Maar acknowledges on the tape that yes, perhaps she was emotional as a young woman. However she insists the idea of portraying women in the act of crying was stimulated by news of the Spanish tragedy rather than any desire to make a personal comment on Maar's personality. 'He said it was the first time he had painted a weeping woman,' Maar tells Morris. 'He had never painted weeping women before.'

If the grieving mother and dead child in *Guernica* remind us of images of war from Vietnam to Aleppo, the falling woman at the right of the picture, suspended in the air between life and death, brings back more recent and specific nightmares: the 'jumpers' who leapt from the burning Twin Towers in New York, images of whom the news agencies initially suppressed and whose existence was questioned. Picasso's falling woman is no mirage; despite the cartoon simplicity of her outline her human physicality is established, not least by the whorls of hair in her exposed armpits. She falls amid a jumble of timbers licked by flames – is her hair already on fire? Maar is clear on the tape that she is the model for the falling woman – 'yes', she tells Morris, 'Picasso said "it is you".'

Picasso is not a Basque but knows the passionate commitment of the regions of Spain to gain self-determination, not least through first-hand experience gained during his teenage years in Barcelona and through his continuing friendships and connections with Catalans and Catalan culture. Like all Spaniards, he is aware of the rudiments of the Basque tradition and knows the story of the sacred oak that grows in Gernika and

PICASSO, *Study for a Weeping Head (1),*
Preliminary drawing for Guernica, 1937

Museo Nacional Centro de Arte Reina Sofia

which survived the flames. A central decision he must make in painting *Guernica* lies in the balance he selects between imagery of suffering and of resistance. The concept of martyrdom is central to Spanish culture and very present in accounts of the war: martyrdom is itself a weapon, like the gun barrel tear ducts of Picasso's weeping women. Four days before the attack on Gernika, a production opens in the Nouveau Théâtre Antoine in Paris of Miguel de Cervantes' sixteenth-century play *The Siege of Numantia*, directed by the former occupant of Picasso's studio, Jean-Louis Barrault, with a stage set by André Masson. The play tells of the siege laid by the Roman general Scipio Aemilianus to the sacred Celtiberian city of Numantia; unable to break the siege, the population decide they would rather die by their own hand or kill each other honourably than surrender, burning down their city to deprive Scipio of the spoils of victory. In Cervantes's play the allegorical figure of Fame declares that ruined Numantia will 'live on forever declaring the greatness of the Spanish people'. Such tactics persist in Spain into modern times. On 4 September 1936, anarchist *dinamiteros* blow up and torch the city of Irun rather than surrender it to the Nationalists; the day after the attack on Gernika, the Nationalist broadcast that denies responsibility for the bombing claims, 'We did not burn Gernika. The incendiary torch is the monopoly of the arsonists of Irun, of those who set fire to Eibar, of those who tried to burn alive the defenders of the Alcázar of Toledo.'

If Picasso is inspired by the symbolic victory of the Numantians, which was in reality a defeat, those responsible for the content of the Spanish Pavilion are engaged with a real and present war in which such a result is unthinkable. Doubtless they would have preferred the fallen soldier portrayed at the centre of the composition, with his clenched fist still defiantly aloft, as he appears in the first stage of *Guernica* captured by Dora Maar's camera. Instead that arm, with its knotted fist,

which also appeared in the sketch *The Studio: The Painter and his Model: Arm Holding a Hammer and Sickle*, has been severed and lies on the ground. (Cervantes, of course, lost the use of his left arm at the Battle of Lepanto, defending Christendom against the naval forces of the Ottoman Empire.) Nevertheless, among the tragedy, horror and abjection, Picasso implants a symbol of hope. Even in death the soldier's grip on the hilt of the shattered sword is unbroken; from its hilt, insubstantial yet defiant, springs a flower.

– v –

To the possible precedents and sources for *Guernica* mentioned so far, many more can be added: Rubens' *The Consequences of War*, a postcard reproduction of which Picasso keeps in his studio, its mourning female figure described by its creator as 'unhappy Europe, who has suffered for such long years from rape, outrage and misfortunes'; Édouard Manet's *The Execution of Emperor Maximilian*, with its brutal, close-up firing squad; Spanish religious and folk art; the various classical artefacts the artist may or may not have seen while in Rome or reproduced in magazines – the pursuit of such art-historical trails continues to generate talks, essays, papers, articles and books almost a century later. Picasso himself, of course, is not here to confirm or deny the latest theory and one suspects he would not do so if he was. A more interesting subject for research perhaps is the key to the development *Guernica* represents in his own artistic practice, not just in terms of scale and technique but in subject matter, psychology and emotion. How does an artist whose entire oeuvre has been built around his own individualistic vision alter his focus to address a collective tragedy on the epic scale required by the commission?

The clues are there in works made between 1925 and 1934, a period during which Picasso effects a jailbreak from the interior world of claustrophobic spaces populated with artists' models, wine bottles, mandolins, newspapers and other Cubist paraphernalia and into the open air.[24] During this time he produces some of his most powerful and disturbing explorations of the human – usually female – form, in which bodies assume aspects of monstrosity, gigantism and terror and the division between physical body, spectre, object and artwork is broken down. During the early 1920s Picasso, like many other European artists responding to the so-called 'Call to Order', appears to reject the avant-garde experimentation of the pre-war years, returning to classical forms for inspiration. But then, in 1925, a different spirit is unleashed in *Les Trois Danseuses* (*The Three Dancers*), a painting he himself considered more important than *Guernica*. It evokes a different kind of classicism, one plugged into the wild, Bacchic frenzies of Greek myth. This is neither an elegant evocation of The Three Graces, nor a 1920s nightclub Charleston. The dancer on the left in particular, her head reputedly inspired by a mask from New Guinea in Picasso's collection, is frightening in her abandon; one breast swung skyward by the velocity of her movements she grins menacingly at us, eyes glazed, red-lipped and open-mouthed. X-rays have revealed figures beneath those in the painting that are closer to the rounded, gentler contours of subjects from Picasso's neo-classical period: a change is underway, a rearrangement of the body allowing it to express new fears.

The figures painted during these years are not born out of war – unless, as T. J. Clark has suggested, Picasso's reaction to the 1914–18 conflagration was a delayed one, a kind of post-traumatic reaction. Instead they speak of domestic conflict, male paranoia, the strangeness of physical proximity; of women's bodies that are both vulnerable and threatening, passive and predatory. Mouths are armed with a few needle-like

PICASSO, *The Three Dancers*, 1925

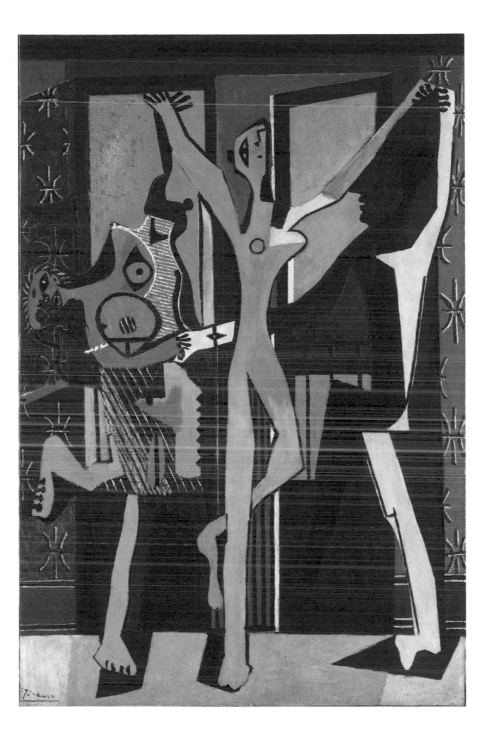

teeth, as in the Metropolitan Museum's *Head of a Woman* (1927); or turned sideways and lined with a full set to resemble a *vagina dentata,* the ultimate male fear, as in the *Nude on a White Background* (1927) from the Musée Picasso in Paris. The artist's model explodes the confines of the studio, escaping the prison of the male gaze to become a sculptural object, either installed on the side of a building, dwarfing her onlookers as in *Monument: Head of a Woman* (1929), or isolated at the edge of the ocean, her limbs turned to stone, as in *Nude Standing by the Sea* (1929).

There are clues here to the imagery of *Guernica* and its accompanying paintings and drawings, in which women's faces and bodies on the one hand express suffering and on the other are weaponized in their weakness, so that breasts become bombs, tears projectiles. The dagger-like tongue in the mouth of the horse and the weeping mother in *Guernica*, and in so many of the weeping women studies, is also present in Picasso's *Figures by the Sea* of 1931, redolent in this case of sex rather than suffering, and it reoccurs in *Nude Reclining by the Window* (1934) which prefigures the dismemberment of the dead soldier in *Guernica*. Some critics believe Picasso has chosen to exclude male figures from *Guernica* entirely, expressing the suffering of war purely through women, children and animals; this, Anne M. Wagner argues, is part of the 'biological politics' of the painting that have helped make it such an enduring icon, but which are often overlooked in discussion of its content.[25] In Wagner's view the soldier, with his hollow neck and severed arm, is not a male protagonist but merely a broken statue.

It is striking, certainly, that the male perpetrators of violence are entirely absent and Picasso's decision to depict events through the suffering of women, children and animals is key to our understanding. However, in works by Picasso from the twelve years before he painted *Guernica*, we repeatedly encounter figures that are both human and statue, monument and

PICASSO, *Nude Standing by the Sea*, 1929

monster; having escaped the usual laws of nature, they blur the boundary between animate and inanimate, still breathing despite undergoing their strange transformations. Few would deny the subject of *Nude Reclining by the Window,* with her sausage fingers and penile tongue, is vibrantly alive, although her body appears to have drifted apart into separate fragments; or that the solitary figure in *Nude Standing by the Sea,* despite her monumentality, is conscious in some way that is not entirely clear. In the same way, I would suggest, the figure at the foot of *Guernica* is both statue *and* dead soldier, dead bodies being the most fitting monument of war. Picasso went on record as saying he was a believer in the demonic, both in the supernatural sense and in terms of the demons that lurk within us all. These pictures record those inner forces very well. *Guernica* takes that story a stage further, showing what happens when the demonic takes on material form and is released into the world.

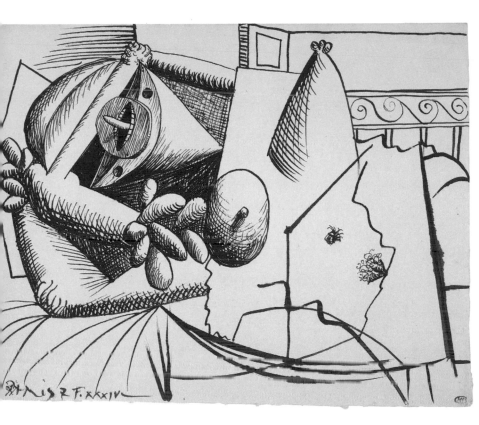

PICASSO, *Nude Reclining by the Window, 1934*

It Will Be Spoken Of For A Long Time

May this great meeting of peoples,
animated by the same desire to make
life more happy and full, give renewed
strength to the hope that lies in the heart
of them all and peace, long promised
to men of good will, reign for ever more.

OFFICIAL GUIDE
*Exposition Internationale des
Arts et Techniques dans
la Vie Moderne, Paris* 1937

The Spanish Pavilion finally opens to the public on 12 July 1937, seven weeks late, therefore missing much of the press coverage and reviews that surround the official inauguration of the exhibition. It is *Guernica*'s first public appearance and from the start one thing is obvious: the painting not only portrays conflict, it provokes it. Almost before the paint on its canvas has dried, it is caught up in a debate between the competing claims of aesthetics and politics that is being played out in London and New York as fiercely as it is in Paris. British critic Herbert Read, one of the painting's earliest champions outside Picasso's immediate circle, has predicted the reaction of many of those involved in organizing the content of the pavilion two years before the event. 'Communists', he explained to an audience in London, 'will tell you abstract art is dead, and that in any case it is incomprehensible to the proletariat and of no use to the revolutionary movement. Like the simple bourgeois of another generation, they ask for something they can understand, a "realistic" art above all, something that they can use in propaganda.'[1]

As Juan Larrea is forced to admit, many of those who have selected the Spanish display at the exhibition are disappointed that Picasso has created a generalized image of the sufferings of war, refracted through a Cubist lens, rather than a painting that will communicate more directly with the crowds passing through the space. The government of the Spanish Republic, after all, is not merely putting on an art exhibition: they are engaged in a fight to the death, waged in Paris through images and symbols as resolutely as it is in Spain with bullets and blood. Rarely can the competing claims of art and propaganda have been more intensely present in the gestation of a work later accorded the status of a masterpiece. It makes sense therefore to see Guernica in the context of the works that surrounded it on its first exhibition, yet strangely these are rarely mentioned in the literature, perhaps because many of them disappeared from view at the end of the Fair.

In 1986 a significant number of items bearing labels on their reverse reading 'Exhibition of Art and Technology, Paris 1937, Spanish Pavilion' are found in a storeroom of the Barcelona Museum of Art where they have remained undisturbed for half a century; the subsequent exhibition *Art contra la guerra** and its accompanying catalogue allow us to see something of the ambiance of the pavilion in which *Guernica* was shown. Certain images – such as Jesús Molina's watercolour *La España que no quieren conocer* (*The Spain They Refuse to Acknowledge*; 1937), acquired by the Reina Sofia in 2011, in which a civilian truck commandeered by Republican militia bumps along an unmetalled country track bristling with rifles and flagpoles like a porcupine– have been extensively exhibited in recent years and are relatively well known. Others, like Ramon Puyól's oil paintings *At the Front* and *Rest at the Front*, in which Republican soldiers, unshaven, bandaged and stupefied with exhaustion, achieve heroic status through their very ordinariness, are less so.

Many of the works found in Barcelona can be classified under one of two headings: Republican combatants, by artists including Teodoro Nicolás Miciano Becerra and Eduardo Vicente, or the victims of aerial attack. Alejandro Fernández Cuervo follows the second of these themes in his expressionist woodcut *Bombardeo* (*Bombardment*; 1937) featuring tumbled bodies, running and grieving figures, an explosion, flames and smoke rising to a sky stamped with the silhouettes of two aeroplanes. Horacio Ferrer de Morgado takes inspiration from a more specifically located bombing in his painting *Madrid 1937* (*Aviones Negros*) (*Madrid 1937* [*Black Aeroplanes*]), much as Picasso has done for *Guernica*. Although the subject matter of the two works is similar both show the innocent victims of

* The exhibition *Art contra la guerra: Entorn del pavelló espanyol a l'exposicío internacional de Paris de 1937* was held at the Palau de la Virreina, Barcelona, November–December 1986.

HORACIO FERRER DE MORGADO,
Madrid 1937 (Black Aeroplanes)
Museo Nacional Centro de Arte Reina Sofía

unseen airborne attackers – stylistically they could not be more different.

Of the three comely young women in Morgado's picture, one wears a red scarf and leads a toddler by the hand who is giving the Republican salute, one is caught with her breast exposed as she shakes her clenched fist at the sky and the third comforts a babe in arms, watched over by an older woman, noble in her suffering, wringing her hands. In its clumsy conflation of classical, religious and political imagery the painting fulfills all of Herbert Read's requirements for communist art. Sure enough, it is hailed as the critical success of the pavilion and at one point is suggested as a replacement for *Guernica* at its entrance.

Guernica's location and context are as charged on its first public appearance as they will remain over the decades that follow. Immediately behind the Spanish exhibit is the much larger Vatican Pavilion, which has agreed to provide a home for works by artists supportive of the Nationalist cause in Spain, including José María Sert's painting *Intercesión de Santa Teresa de Jesús en la Guerra Civil española* (*The Intercession of Saint Teresa in the Spanish Civil War*). Just to the north, on the central pathway through the gardens, is the modernist Norwegian Pavilion housing a dramatic, large-scale tapestry by Hannah Ryggen called *Etiopia*, a response to Mussolini's brutal Abyssinian war, featuring in its top right-hand corner an image of the dictator's head impaled on a spear.* Between the Spanish and Polish pavilions and the River Seine, next to the Pont d'Iéna, rises the monumental bulk of the *Deutsches Haus* with its 35-metre (117 ft) tower capped by the eagle and swastika emblems, the whole structure designed, as the official guide helpfully explains, by 'the eminent professor [Albert] Speer... whose reputation is

* This proximity has given rise to the erroneous but pervasive belief, widely circulated on the internet, that *Etiopia*, often compared in terms of scale and intention with *Guernica*, was hung 'next' to Picasso's painting, presumably in the Spanish Pavilion.

spread afar on account of his fine creations at Nuremberg for the annual congresses of the National Socialist Party.'[2]

The Spanish Pavilion at the exhibition is closer to the houses of its enemies than its friends, just as the Spanish nation finds itself increasingly isolated in Europe. The pavilion of the USSR, the only nation, apart from Mexico, that has given direct aid to the embattled Republic, lies the other side of the central pathway that runs through the gardens, separated from the Spanish Pavilion by illuminated fountains that dance and sparkle through the night. Described in the official guide as 'a monolith composition of sculpture and architecture', the Soviet Pavilion is topped by Vera Mukhina's six-storey-high statue of a heroic young worker and a peasant girl. The German and Soviet pavilions, face-to-face in Paris, are locked in artistic confrontation, while in Spain, German and Italian aircraft attack Spanish troops trained and equipped by the Russians. In the Trocadéro Gardens, the proxy war is expressed through architecture and sculpture, frozen into monumental form. Beside the Seine the Italian Pavilion announces itself with a giant equestrian statue by George Gori, 'symbolizing the genius of Fascism', as if cutting off all hope of escape.[3]

In the face of such powerful statements, many on the Republican side insist art has a duty to communicate with the widest possible audience rather than employ the hermetic language of an elite inner circle. Spanish film director Luis Buñuel, who has programmed the documentary films playing in the nearby courtyard, including his own *Madrid 36*, will later confess that he 'can't stand *Guernica*, which I nevertheless helped to hang. Everything about it makes me uncomfortable – the grandiloquent technique as well as the way it politicizes art. Both Alberti and Bergamín share my aversion. Indeed all three of us would be delighted to blow up the painting.'[4] More wounding perhaps for Picasso than the incomprehension of his artistic peers is the rejection by José Antonio Aguirre, the Lehendakari (President)

of the Basque government, of his offer to gift *Guernica* to the Basques. Basque muralist José María Ucelay, who has played his part in the painting's creation myth by being the bearer of news of the attack, is particularly scathing. In his view, *Guernica* 'as a work of art… is one of the poorest things ever produced in the world. It is just seven by three metres of pornography, shitting on Gernika, on Euskadi [the Basque country], on everything.'[5] Architect and arch-modernist Le Corbusier claims the public feel much the same and that the painting sees 'only the backs of the visitors because they [are] repelled by it'.

The first to drop their bombs on *Guernica*, then, are those who might have been supposed to be its natural allies: artists, filmmakers, architects and politicians of the left. More predictable is the reaction of the German contingent at the exhibition to the 'Red' Spanish Pavilion. It contains, the German language guidebook explains to its readers, nothing of importance; only one, unnamed painting is mentioned, apparently the dream of a madman, a hodgepodge of body parts that a four-year-old could have painted. If Picasso is in any doubt of his standing with the Third Reich, the *Entartete Kunst* (Degenerate Art) exhibition that opens in Munich just a week later than the Spanish Pavilion, on 19 July, makes things clear. He is included in its se lection of artists seized from the collections of German museums, in whose work, according to wall captions, 'madness becomes method', revealing the all-polluting 'Jewish racial soul'. To fascists, then, his art is dangerous: to Spanish Republicans, not dangerous enough.

The argument for the defence is launched by Picasso's friend the writer Max Aub, a cultural attaché for the Spanish Republican government in Paris who has assisted in the commissioning process for *Guernica*. The night before the pavilion opens to the public he makes a speech to the French construction workers who have built it, leading them through the pavilion's exhibits. 'At the entrance, on the right', he told them,

Picasso's great painting leaps into view. It will be spoken of for a long time. Picasso has represented the tragedy of Gernika. It is possible that this art will be accused of being too abstract or difficult for a pavilion like ours which seeks to be above all, and before everything else, popular manifestation... To those who protest saying that things are not thus, one must answer asking if they do not have two eyes to see the terrible reality of Spain. If the picture by Picasso has any defect it is that it is too real, too terribly true, atrociously true.

Leading authors, poets and critics – including Paul Éluard, Christian Zervos, Michel Leiris, Luc Decaunes, José Bergamín, Amédée Ozenfant and Juan Larrea – rally in support of the painting in a special double issue of *Cahiers d'Art* published in the summer of 1937, their language soaked in apprehension at the gathering darkness in Europe. The magazine reproduces the painting along with all the sketches and preliminary studies and Dora Maar's photographs, attacking the limitations of the communist party's 'correct thinking' on art which they characterize as incapable of capturing the 'grand, dramatic and dangerous' epoch which has given birth to *Guernica*. For Ozenfant, the painting is 'an appalling drama of a great people abandoned to the tyrants of the Dark Ages'. Far from being hard to appreciate, 'all the world can see, can understand, this great tragedy' in its presence. Luc Decaunes sees the Spanish Pavilion as a whole as 'a terrible indictment by a people face-to-face with their assassins'. Michel Leiris sounds an even more sombre, universal note. 'Picasso sends us our letter of doom,' he writes; 'all that we love is going to die, and that is why it is necessary we gather up all that we love, like the emotion of great farewells, in something of immense beauty.'

Despite its late opening, the Spanish Pavilion contains a constellation of artistic talent, one that will disintegrate when the exhibition closes in a manner that presages what is to come. Joan Miró's five-and-a-half metre high mural *El segador* (*The*

Reaper, or *Catalan Peasant in Revolt*), painted on Celotex panels and displayed by the stairs between floors, is disassembled and sent by sea to the seat of the exiled Republican government in Valencia; Alberto Sánchez Pérez's towering cement sculpture *El pueblo español tiene un camino que conduce a una estrella (The Spanish People Have a Path that Leads to a Star)* embarks on the same journey. While they are en route, pressure from Nationalist troops increases and the government is forced to move again; both works are lost.* If Picasso's offer to make a gift of his painting had been accepted by either the Basque or Republican governments in 1937, it is very possible that it also, like Miró's masterpiece, would have disappeared in transit, existing only as a black and white footnote in art history.

Instead *Guernica* makes its first public appearance outside Paris when it is included in a touring exhibition of masterworks of French modernism that opens at the Kunstnernes Hus in Oslo on 10 January 1938. It then continues to the Statens Museum for Kunst in Copenhagen, the Liljevalchs Konsthall in Stockholm and the Konsthallen in Göteborg. This first journey through Scandinavia provokes little controversy, perhaps because the painting is shown alongside works by Georges Braque, Henri Matisse and Henri Laurens; perhaps also because the political turmoil in Spain and rising tensions elsewhere in Europe have less urgency when viewed from northern latitudes.† Although *Guernica*'s debut outside France is relatively low-key, the painting leaves its trace on Scandinavian art. Danish artist Asger Jorn was just twenty-three years old when he set out for Paris on a motorbike with his wife Kirsten Lyngborg in

* Perez's lyrical column is recast years later and today stands outside the Museo Reina Sofía in Madrid, *Guernica*'s current home.

† Its sojourn in Oslo gives rise to the legend that the Norwegian National Gallery missed the opportunity of buying *Guernica* at a knockdown price. Despite its continued presence on the internet, the story appears to originate in internal politics at the gallery and controversy over the conservative acquisitions policy of the gallery's then-director.

ASGER JORN, *The Troll and the Birds*, 1944

1936, with the intention of enrolling in Fernand Léger's *Atelier de l'Art Contemporain*. There he meets another young painter, Roberto Matta; together they work on the exhibition the following year. Matta's role as 'painting assistant' on *Guernica* allows Jorn access to the mural while it is still in progress, an extraordinary position for such a young artist to find himself in and one that cannot fail to have an impact. Along with Matta, Jorn is employed as a painter on Léger's monumental mural *Le Transport des forces* (*Transport of Forces*) for the entrance of the *Palais de la Découverte* (Palace of Discovery) at the exhibition, as well as being hired by Le Corbusier to enlarge children's drawings to mural-scale for his *Pavillon des Temps Nouveaux*.

His chance to put what he learns in Paris into practice comes in April 1940 in Copenhagen, when German tanks roll across the Danish border. For Jorn and his friends in the *Helhesten* (Ghost Horse) group, *Guernica* provides an example of a modernist work able to engage in political critique without compromising its avant-garde language – exactly the opposite diagnosis of its effectiveness to the one given by the naysayers in Paris.* Picasso's painting has entered the consciousness of Danish artists just in time.

This is an early example of a phenomenon that is to attend *Guernica* as it travels: wherever it goes it is appropriated and put to use, serving as a mechanism that enables artists to make shifts and overcome problems, whether in technique, ambition or outlook. Once its fragility means it ceases touring in the late 1950s and becomes anchored at the Museum of Modern Art in New York, the dialogue artists have with the painting tends to be with its image in reproduction, its all-pervasive presence meaning that allusion to it can function as instant visual shorthand. What seems extraordinary is that this iconic status is suf-

* *Guernica* also impacts on artists in the Danish *Linien* group, including Richard Mortensen, who claims his anti-war painting *Vision: Painting for Arthur Rimbaud* (1944) is directly inspired by it.

ficiently established for Jorn to make use of it in 1944 in his painting *Trolden og fuglene* (*The Troll and the Birds*), a mere seven years after *Guernica*'s first appearance, via a quotation that is itself a challenge to the artistic *mores* of the occupiers of his country.

The painting deliberately makes use of awkward composition, expressionist brushstrokes and garish, childlike colour schemes, combining Nordic folk tales with high modernism, its exuberant spontaneity challenging all who would deem such work 'degenerate'. Beyond this purely stylistic provocation, in the lower left-hand corner Jorn inserts a brown rectangle, a 'painting within a painting' that makes quotations from *Guernica*, the most immediately recognizable of which is the floating light bulb eye.[6] Picasso's work is now sufficiently powerful that reference to it can act as a coded signal, *hommage* turned political act.

Guernica continues to haunt Jorn and helps shape one of his best-known works, the mutating anti-war masterpiece *Stalingrad*, painted over a fifteen-year period beginning in 1957. (Jorn exceeded even Picasso's dislike of finishing a painting – erasing, painting over and reworking *Stalingrad* in 1960, 1967 and finally in 1972, even, on one occasion, when it hung on the wall of a collector's private residence.) *Stalingrad* began simply as a large-scale abstract work with the title *Le fou rire* (*The Mad Laughter*); but, like Picasso when he struggled to come up with a subject for the Spanish Pavilion, Jorn is interrupted by an account brought to him from the field of battle. The caretaker of his Italian residence, Umberto Gambetta, fought in the Battle of Stalingrad and the horrors he relates to Jorn convince the artist to change tack and attempt his own *Guernica*. Unlike Picasso, he will later tell the author Guy Atkins, he 'wanted to make a painting that would *be* an action rather than portraying an action'. Jorn's relationship to visual imagery changes while he is working and reworking *Stalingrad*; the artistic language of

Guernica no longer seems valid to an age in which images are constantly manipulated in the mass media and the painting itself proliferates in reproduction, demoted to the status of kitsch souvenir. Yet Jorn's early encounter with *Guernica* remains electric in memory, a beacon showing what can be achieved in a face-to-face artistic struggle with history.

A number of British artists see *Guernica* in the Spanish Pavilion in Paris, none in more surprising circumstances than the painter John Craxton. A fourteen-year-old schoolboy, Craxton is on a Boy Scout summer camp on an island in the Seine when he is invited to accompany a school friend – whose father happens to be the Old Master dealer Mark Oliver – on a visit to the exhibition. 'What I remember of *Guernica*', he is later to recall,

> is not so much the violence and the tragedy but the marvellous architecture of it. It had this wonderful symphonic sense. Everything was contained within the room of the canvas, just like a Titian. It held up well with Renaissance paintings… Although he used an amalgam of earlier things, Picasso's formal invention was just incredible. I remember the electric light bulb very well; no one had put it in a painting before to represent the light of the sun. There's not a line wasted or out of place. And there was no sense of brushwork; I was already aware of the false admiration of 'beautiful passages of paint.'

John Craxton is a precocious teenager who is at the beginning of his journey as a painter when he encounters *Guernica*. Julian Trevelyan, already a working artist associated with both the Surrealist movement and the Artists International Association in London, is equally moved by *Guernica* at the Spanish Pavilion. 'Looking back at the lights of the exhibition along the Seine from the heights of Meudon,' he will write in his memoir *Indigo Days*, 'I felt that the non-fascist world, the world of the values in which we believed, was having, perhaps, its last fling.'[7] For many, *Guernica* encapsulates this sense of foreboding, a prophecy of things to come. It will fall to a mutual friend of Trevelyan's

and Picasso's, the Surrealist artist Roland Penrose, to arrange matters so that that the painting sounds its warning in London.

London has already witnessed a very public discussion of the merits of the painting, with two critics – Anthony Blunt and Herbert Read – split along very much the same lines as those who praise and denigrate the painting in Paris. For Blunt, who reviews the Paris exhibition for *The Spectator*, the painting is 'disillusioning... the expression of a private brainstorm which gives no indication that Picasso has realized the political significance of *Guernica*.' Picasso had, as he was to mockingly write in the same publication some months later, spent his life in the 'holy of holies of art', by implication cut off from the concerns of the working class and therefore unable to communicate with them.[8] In an article in *The London Bulletin* and correspondence in *The Spectator*, Herbert Read meets these charges head on. 'It has been said that this painting is obscure,' he writes; 'that it cannot appeal to the soldier of the republic, to the man in the street, to the communist in his cell; but actually its elements are clear and openly symbolical. The light of day and night reveals a scene of horror and destruction; the eviscerated horse, the writhing bodies... it is the modern Calvary, the agony in the bomb-shattered ruins of human tenderness and faith.'[9] The arguments deployed by Mr Blunt are, he witheringly asserts, typical of 'middle-class doctrinaires who wish to "use" art for the propagation of their dull ideas'.[10] The truth is that Roland Penrose in London and Picasso's supporters in Paris, although not shackled to socialist realism, are as keen to 'use' *Guernica* as any party cadre. 'We want the exhibition [in London] to happen with the maximum force and solemnity,' Juan Larrea writes to Penrose in February 1938, 'both for Picasso himself since the more admired he is the more useful he will be to the cause, and for the cause itself since this is one of the rare means we have to reach that sector of the public for whom this kind of argument may prove convincing.'[11]

Guernica sends an advance guard to London in the form of one of the studies for the painting – a drawing of a weeping woman holding a dead baby. The study is reproduced on the cover of the programme for the Grand International Meeting at the Royal Albert Hall in London on 24 June 1937, arranged by the National Joint Committee for Spanish Relief in aid of Basque refugee children. Picasso himself is billed as being 'in the chair', appearing alongside German novelist Heinrich Mann and the first director of the Courtauld Gallery, W. G. Constable, but in the end he is forced to send his apologies – he is still busy at work on *Guernica*. As will happen so often in the following years, particularly once war has broken out, he himself is physically absent but is represented either by *Guernica* or a work derived from it. In addition to the drawing for the programme, which in its caption is 'dedicated to the mothers and children of Spain', Picasso sends another drawing, entitled *Weeping Woman* and dated 16 June 1937, to be placed in the auction to raise funds for refugee relief. To the embarrassment of the organizers, despite Picasso's almost godlike status among the artistic community in London, the work struggles to find a buyer and is eventually sold for a mere £80.

Consolation for those who have come to the Albert Hall in the hope of hearing Picasso is provided by the surprise appearance of the equally stellar actor and singer Paul Robeson. Although the programme insists he will be joining the event via a live radio link from Moscow, Robeson flies to London instead, unsure whether he will be permitted to broadcast by his new friends in the Soviet Union. 'The artist must take sides', he rousingly declares in his speech to those assembled in the hall. 'He must elect to fight for freedom or slavery. I have made my choice. I had no alternative... For the liberation of Spain from the oppression of fascist reactionaries is not a private matter of the Spaniards but the common cause of all advanced and progressive humanity.'[12] The truth is that taking sides is not an is-

sue for the audience listening to Robeson either: the Spanish war has divided opinion more sharply than any other issue since the General Strike a decade earlier. Predictably the Nationalists are backed by Oswald Mosley's Blackshirts, but reports of the sacking of churches and murder of priests by Republican militia in the opening months of the conflict alienate many who might have been expected to have Republican sympathies. The painter Edward Burra will recall, in conversation with John Rothenstein, having lunch with Spanish friends in Madrid just before the outbreak of the war. Smoke drifts by the window and he asks them about it. '"Oh it's nothing", someone replied with a shake of impatience, "it's only a church being burnt"! That made me feel sick... Everybody knew that something appalling was about to happen.'[13] Such understandable queasiness, as well as the portrayal in much of the British press of the Republican government as completely communist, means that support for the rebels reaches well beyond the extreme right, into conservative middle England.

For all its diplomatic even-handedness, the Conservative government soon finds itself in conflict with the Reich over events in Spain. The first reports of German involvement in the bombing of Gernika to reach an international audience have been carried by *The Times* – the paper's name, Nazi propagandists point out, is *Semit* (semite) spelt backwards. Despite foreign secretary Anthony Eden's extreme caution under questioning in the House of Commons, Nazi denials that their forces are even present in Spain – an early example of the phenomenon we have since come to know as 'fake news' – have not been given sufficient airtime via British official channels for German tastes.

Meanwhile Franco's attack on a democratically elected government and his track record of suppressing organized labour have galvanized public opinion across the country. Two and a half thousand British men and women, from trade unionists

and communists to artists and intellectuals, have volunteered for the International Brigades. Many, including the poet Julian Bell and the artist Felicia Browne, have spilt their blood on Spanish soil already. The question of how to respond to the conflict – through artistic work at home or military or other service in Spain – has become of paramount importance to the artistic community. 'Until the Spanish Civil War started in 1936, there was an air of gentle frivolity about our lives in London,' Julian Trevelyan will remember later. 'For the next three years our thoughts and conscience [are] turned to Spain.'[14] Those who chose to stay at home make sure their voice is heard on the Spanish question. The stated aim of the Artists' International Association (AIA) is the 'Unity of Artists for Peace, Democracy and Cultural Development'. Founded in 1932, by 1936 it has 600 members, ranging from established figures like Augustus John, Stanley Spencer, Vanessa Bell and Duncan Grant, to a new generation of British Surrealists and others, among them Henry Moore, John Piper, Ben Nicholson, Roland Penrose and Eric Gill. Its response to the humanitarian crisis caused by the war takes the form of both exhibitions and more temporary works, including street murals, posters and hoardings. As Simon Martin has written, these visual campaigns take 'the work of modern British artists out of the elite galleries of the West End of London and into... direct contact with ordinary, working class people. In this respect... their very form represent[s] a kind of democratization of art.'[15] It also means the creators of those works often find themselves in direct conflict with black-shirted thugs from Sir Oswald Mosley's British Union of Fascists.

Guernica, in contrast, makes its first appearance in the United Kingdom at the New Burlington Galleries, in the heart of London's West End. Its arrival in Britain on 30 September 1938 coincides with the signing of the Munich Agreement by Hitler, Mussolini, British premier Neville Chamberlain and Édouard Daladier, prime minister of France. Picasso's artistic

expression of defiance is therefore overshadowed by a far greater one of appeasement. Nevertheless he has staged an invasion: the painting is accompanied, the exhibition poster tells us, by 'sixty preparatory drawings, sketches and studies for the composition', and these foot-soldiers will accompany *Guernica* on its travels ever afterwards; sometimes gathered around the painting, expanding its field and giving it context, at others representing it in places too small to accommodate it or too distant to reach. The painting is, if not unique, extremely unusual in that it is often its satellite studies and associated works that have drawn the highest praise from other artists. For Julian Trevelyan, who has attended the opening of the Spanish Pavilion, it is 'the intensity and pathos of the great sequence of drawings that led up to *Guernica*' that mark its unveiling 'as the greatest moment in Picasso's life, the moment at which his genius was raised to an unparalleled incandescence.'[16]

The New Burlington Galleries, located behind the Royal Academy, are no strangers to radical art: the previous year they hosted the International Surrealist Exhibition organized by Roland Penrose, David Gascoyne and Herbert Read, which included works by Picasso alongside those of artists including Salvador Dalí, Max Ernst, Francis Picabia, René Magritte, Paul Nash, Roland Penrose, Henry Moore and E. L. T. Mesens. The exhibition was a *succès de scandale*, with crowds flocking to evening events, which featured appearances by legendary Surrealist figures André Breton and Salvador Dalí among others. (Dalí, ever the showman, gives a public lecture in a diving suit and nearly suffocates in the process.) The exhibition attracts an average 1,000 visitors a day, and Penrose and Mesens have no difficulty securing the space again to display Picasso's already-notorious work, with all profits from the sale of the catalogue going to the National Joint Committee for Spanish Relief.

The galleries, with their high, curved ceilings pierced with windows and polished parquet floors, exude the elegance of a

GRAHAM SUTHERLAND, *Gorse on a Sea Wall*, 1939

bygone age; an extreme contrast to the surroundings of *Guernica*'s first exhibition in an avant-garde pavilion in Paris. It is not clear whether it is the apprehension generated by the Munich Crisis or the absence of Picasso himself that dulls the public's excitement. There are no events to rival Salvador Dalí's appearance – Paul and Nusch Éluard, who deputize for Picasso, have none of the Surrealist's showbiz razzmatazz – and the exhibition closes having attracted a mere 3,000 visitors, although it is safe to assume there are a high proportion of artists among them. Those who have not made the pilgrimage to see it at the exhibition in Paris have pored over *Guernica* and its studies in the special issue of *Cahiers d'Art* published in 1937, long before the painting arrives on British shores.

One of those who has already seen the painting in Paris is critic Myfanwy Piper. She is the first to reproduce *Guernica* in a British publication, in her book *The Painter's Object* (1937), in the form of one of Dora Maar's studio photographs. The force of Picasso's artistic vision, she will later recall, 'acted on us like rape just when we had settled for the Mondrian cloister.'[17] For Francis Bacon, the encounter with *Guernica* is one more stage in his life-long dialogue with Picasso. Like many of his contemporaries, he is struck by the way Picasso has morphed from an avant-garde artist into a spokesman for his time. He will claim later that he 'doesn't like' *Guernica:* that although allowing it is 'of considerable importance as an historical event', he doesn't think it is 'one of Picasso's best works'.[18] Nevertheless there have been suggestions that his major triptych *Three Studies for Figures at the Base of a Crucifixion* (1944) is marked by the influence of Picasso in this period, particularly by the studies for *Guernica* of the dying horse and mother and baby.[19]

Bacon's friend, the painter Graham Sutherland, is seeking a way in his own work to portray objects as both 'themselves and something else at the same time'; *Guernica* and its attendant studies at the New Burlington Galleries appear to offer a way

forward. 'Picasso's *Guernica* drawings seemed to open up a philosophy and to point a way whereby – by a kind of paraphrase of appearances – things could be made to look more vital and real,' he was to explain later. 'The forms I saw in this series pointed to a passionate involvement in the *character* of the subject whereby the feeling for it was trapped and made concrete. Like the subject and yet unlike... Only Picasso... seemed to have the true idea of metamorphosis whereby things found a new form through feeling.'[20] For Sutherland, the way forward *Guernica* offers is philosophical, rather than stylistic, although visual echo of Picasso's studies for *Guernica* may be present in Sutherland's pre-war landscapes, such as *Gorse on a Sea Wall* (1939) and *Midsummer Landscape* (1940), in which twisted organic forms recall the tortured horses with their bowed necks in Picasso's drawings.

His own depictions of the result of bombing, made as he wanders with his war artist's pass through devastated streets and factories, are devoid of people; instead he seeks expressiveness in twisted girders, collapsed roofs and eviscerated machinery. 'The conception of the idea of stress, both physical and mental, and how forms could be modified by emotion... was crystallized by my understanding of Picasso's studies for *Guernica*,' he recalls. 'Faces become distorted by tears and mouths open in fear... I had seen aspects of this idea in certain kinds of destruction. So did I, too, in the steel works.'[21]

Sutherland is thirty-five years old when he sees *Guernica*; Richard Hamilton, who will have a profound effect on the course of British art in the 1950s and 1960s, is less than half his age. He has already left school and is working in the Reimann studios, a 'slightly commercialized version of the Bauhaus' that has been forced to relocate to London because of the political situation in Germany. 'I was taken up by a stage designer called Professor Haas-Heye,' he will tell an interviewer years later. 'On one occasion he gave me a shilling and told me to go and see

the Picasso exhibition at the Burlington Gallery... There was *Guernica*, filling a wall surrounded by many *Guernica* studies and dozens of his weeping woman paintings. It was a life-changing experience for me, for a sixteen-year-old.'[22] Hamilton isn't the only teenager to visit the Burlington Galleries that October. Like John Craxton, John Richardson, whose multi-volume life of Picasso will do so much to shape the artist's legend, is a fourteen-year-old schoolboy when he comes face-to-face with *Guernica* for the first time. Recalling that encounter in his nineties, he remembers being 'overwhelmed by it. A meeting with Picasso thirteen years later would develop into a friendship which inspired a biography.'[23] *Guernica*'s first appearance in London might not be the sensation Penrose hoped for, but its presence nevertheless acts as an agent of change, not only on those who will go on to create significant art themselves but on those who will write its history.

Despite their initial disappointment, Penrose and Mesens are not ready to give up, either in their attempts to raise money for the Republican cause or to convert the British public to Picasso's greatness. *Guernica* must be put to work raising funds up and down the country. Where the painting itself cannot be accommodated, the drawings and studies can take the message. The first port of call for the works that have accompanied *Guernica* to Britain is the lecture rooms at Oriel College in Oxford in October, where a review in *The Oxford Times* describes the content of the exhibition as 'horses with maddened expressions, small ears and eyes, and cavernous mouths with bared fangs.'[24] Their arrival at Leeds Art Gallery in December is greeted in rather different terms in the *The Yorkshire Post* by Bonamy Dobrée, a distinguished member of the English faculty at the University of Leeds. 'Many of the drawings, from the point of view of pure art, leaving their content aside, are miracles of beauty, in form, in the way they occupy the frame or fill the space of the eye,' the professor tells his readers; 'in balance, in sheer lyricism

overleaf
Poster for an exhibition of Picasso's *Guernica*
at the New Burlington Galleries, London, October 1938

EXHIBITION *of*
PICASSO'S "GUERNICA"

at the New Burlington Galleries—October 4th—29th
under the auspices of the
NATIONAL JOINT COMMITTEE FOR SPANISH RELIEF

GUERNICA

THE TRAGEDY OF GUERNICA

Under this title, the London newspaper 'The Times' published the following, on April 28th, 1937:
"Guernica, the most ancient town of the Basque and the centre of their cultural tradition was completely destroyed yesterday afternoon by insurgent air raiders. The bombardment of this open town far behind the lines occupied precisely three hours and a quarter.......In the form of its execution and the scale of the destruction it wrought, no less than in the selection of its objective, the raid on Guernica is unparalleled in military history. Guernica was not military objective. The whole town of 7,000 inhabitants, plus 3,000 refugees, was slowly and systematically pounded to pieces.''

✿ ✿ ✿

The 'Morning Post' published the following article from Reuter's correspondent in Bilbao on April 28th 1937:—
"The ruthless destruction by insurgent aircraft of Guernica, the defenceless 'holy city' of the Basques, will rouse unquenchable hatred of General Mola and his men in the breast of every Basque in Spain, it is felt here German aviators are now officially charged with having perpetrated yesterday's terrible slaughter, in which, it is stated, 4,000 bombs and 100 aerial torpedoes were dropped The raid occurred on market day when the town was full of peasants. Like other Basque country towns it was absolutely defenceless''.

✿ ✿ ✿

On April 28th, 1937, the 'Daily Express' published the following from Mr. Noel Monks, its correspondent in Bilbao:—
"I have seen many ghastly sights in Spain in the last six months, but none more terrible than the annihilation of the ancient Basque capital of Guernica by Franco's bombing planes.

✿ ✿ ✿

On May 6th 1937 'The Times' correspondent in Bilbao stated:—
"The statement issued from Salamanca that Guernica was destroyed by 'Red' incendiaries is false'

✿ ✿ ✿

On May 1st 1937, Mr. Noel Monks stated in the 'Daily Express':—
"I will swear to it that Franco's German aviators bombed Guernica, and that they killed 1,000 civilians''.

✿ ✿ ✿

On May 6th 1937 'The Times' published a statement from the mayor of Guernica in which he said:—
"It was not our militia who set fire to Guernica, and if the oath of a Christian and a Basque *alcalde* has any value, I swear before God and history that German aeroplanes bombed viciously and cruelly our beloved town of Guernica until they had wiped it from the earth.''

A YEAR LATER

"The July itinerary (organised by the National Spanish Travel Service) will include a visit to Guernica, the town that figured in the Red's greatest slander against Franco's forces''
'Catholic Times' 24th June 1938

PICASSO

Pablo Ruiz Picasso was born in Malaga in 1881. He spent his youth in Barcelona. In 1901 he went to Paris where he has lived ever since. He has been one of the leaders of the modern movement in painting. Cubism, Dadaism and Surrealism owe much to his influence. He is well known for his stage settings for Serge de Diagilew's Russian Ballet. In 1936 he was appointed honorary director of the Prado by the Spanish Government.

THIS WORK WAS EXHIBITED IN THE SPANISH PAVILION

at the

INTERNATIONAL EXHIBITION IN PARIS 1937

EXHIBITION *of*

P
I
C
A
S
S
O
S'

Clichés "Cahier d' Art"

'GUERNICA'

of line, in analysis of planes.' By contrast *Guernica* itself, which has not travelled to Leeds, has been painted 'under the stress of overwhelming emotion... Thus one must not expect it to be an attractive, pleasant thing, any more than Shakespeare's *King Lear* is an attractive pleasant thing... [For] art is not a soothing syrup, it is an explosive to make us see afresh, to force us to readjust our preconceived ideas.'[25] His review runs next to a correspondence column in which one letter writer claims 'a million and more' Britons support Franco, while another suggests, 'the fact that our oldest ally, Portugal, is openly friendly with the Nationalist government and openly hostile to the Spanish Government', should give pause to those who back the Republic.

Guernica's second landing place in London, in January 1939, is very different to its first, exchanging the affluent surroundings of the West End for the impoverished working-class district of Whitechapel in the east. Historically, Whitechapel has long attracted immigrants; refugees from poverty, pogroms or political oppression, crowded together into slums and tenements that are hotbeds of political activism. The exhibition of *Guernica* at the Whitechapel Gallery is not part of its official programme; instead, members of the East London Aid Spain committee of the Stepney Trades Council (a front for the Communist Party), together with what Roland Penrose will describe as 'a strong committee of left wing artists, politicians, scientists and poets', hire space within the gallery for twenty-five guineas and publicize it themselves, with the aim of contributing to the Trade Council's 'Million Penny Fund' to send an East London food ship to Spain.[26] At Picasso's request, visitors are asked to donate a pair of boots in good repair that can be sent to Republican soldiers at the front.

The exhibition is opened by Clement Attlee, the leader of the Labour Party, for whom both the East End of London and the Spanish conflict have special significance. He had first come to know the area as a teenager, volunteering for a charity found-

ed in Stepney by his public school, which worked with boys and young men from deprived backgrounds. This eye-opening encounter with the realities of life for the poor in Britain led to a political awakening that will see him maintain close ties with the East End for much of his political life, serving first as mayor of Stepney, and subsequently, as an MP for Limehouse and for Walthamstow. In the weeks before *Guernica*'s arrival in Whitechapel his politics have been galvanized once more: this time through a visit to Spain, where he stays with Prime Minister Negrín, 'a distinguished scientist and socialist'; meets Basque leader Aguirre, 'a devoted Catholic and a very fine man'; and in 'an impressive scene by torchlight in a Spanish village' inspects the British contingent of the International Brigade, whose 'Number 1 Company' is named the Major Attlee Company in his honour.*

His presence in Spain is recorded by photographers and does not go unnoticed in the British press. 'On my return to England', he writes in his autobiography, 'I was criticized for returning the salute of the Spanish Forces with the clenched fist sign, on the grounds that I was thereby approving of Communism. This story constantly meets me on the public platform. In fact, at this time this salute was commonly used by all supporters of the Republic, whether they were Liberals, Socialists, Communists or Anarchists.'[27] Unlike Picasso, who has removed the clenched fist he originally placed at the centre of *Guernica*, he cannot recall the gesture. However, the change in his outlook is profound. Of the generation shaped by the horrific carnage of the First World War, he was an appeaser but now makes resistance to fascism and support for the Spanish Repub-

* After a meeting in Oxford where he spoke in support of the Spanish Republic, Attlee was carried shoulder-high down the High Street in front of huge crowds 'more or less against his will', all the while 'looking at his watch and pleading "please put me down: I shall miss the 9.34 to London"'. Elizabeth Longford, quoted in Chris Farman, Valery Rose and Liz Woolley, *No Other Way: Oxfordshire and the Spanish Civil War 1936–9* (The Oxford International Brigade Memorial Committee, 2015), p. 28.

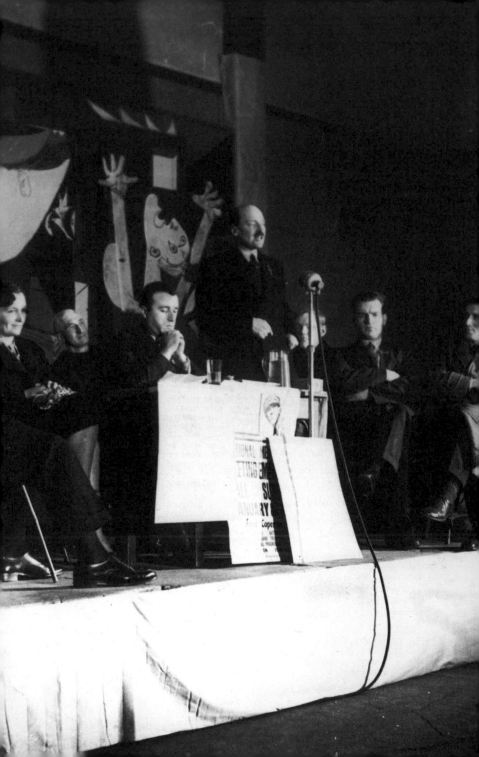

lic central to Labour policy, doing no harm to his standing with Labour Party members, or ultimately with the voters of Britain. 'If once fascism gets hold', he tells the opening night audience at the exhibition, 'the people who will suffer most will be the young. Fascism tries to make the younger generation in its own image, to make every boy and girl into the image of Hitler and Mussolini... Today fascism is weak. For they cannot fool all of the people all of the time.'

Within a fortnight, 15,000 people have filed through the entrance hall, past an International Brigade banner made by members of the AIA, raising £250 for Spanish relief. Educational films are shown in the evenings and Roland Penrose, Herbert Read, Eric Newton and Julian Trevelyan all give talks about the painting to local working people, Trevelyan reporting he finds them 'ready and eager to accept the various symbolisms' within it.[28] Public workshops are also held in the art of propaganda, ranging from effective organization to tips on typography for activists. The pile of boots beneath *Guernica* grows steadily, eventually reaching 400 pairs, a visible reminder of the reason for the painting's presence here. 'The misgiving of those who imagined that Picasso's work would mean nothing to the working classes have proved false', Penrose declares, in a clear repudiation of the assertions made in the press by Anthony Blunt. *Guernica*'s champions appear to have won at least a temporary victory in the aesthetic battle between modernism and socialist realism as well as making a worthwhile contribution towards relief in Spain where, as summer arrives, German planes will return to dropping incendiary bombs on fields of wheat, deploying their latest and most effective weapon against Republican supporters: starvation.

In February 1939, *Guernica* is once more taken off its frame and wound onto a roller to travel to Manchester, where it is exhibited, along with the studies, in a car showroom on Victoria Street. The exhibition is hung by students from Manchester

The Labour Party leader Clement Attlee opens the *Guernica* exhibition at the Whitechapel Art Gallery, January 1939. Roland Penrose, who has helped bring *Guernica* to London, is on the far right.

School of Art and local artists supportive of the Republican cause; one of them, Harry Baines, a communist well-known locally for his murals, will recall shortly before his death his own 'somewhat ham-fisted method of unrolling the large heavy canvas, banging some nails in it and attaching it to the wall'.[29] This is all far from the ambiance of the galleries in which Picasso's work is usually shown, and the painting will bear the scars. Although the exhibition is off the art world radar, it makes its own contribution to the labyrinth of myth around *Guernica*. An official bulletin from the organizers, the Manchester Foodship for Spain, claims Picasso 'was actually in Guernica at the time of its bombardment and ruin, and under the influence of its terrible doom he painted his picture... Its awful symbolism portrays the ruin of human intelligence and human kindness. It is a damning commentary on war.'

For two further months the painting and its satellite works remain in England until Penrose receives a terse message from their creator. 'As I told you', Picasso writes on 28 March, 'I want *Guernica* and the drawings and the other pictures which are in London to be sent to me in Paris as soon as possible and I do not accept that anyone else has the right to decide when these works should be sent.' On the same day, Madrid falls to the Nationalists. Franco declares victory on 1 April and in Paris there is a cold wind blowing. It is time for *Guernica* to depart, as so many artists and writers have already done, but as its creator will refuse to do, for the New World. It leaves Paris by train in the final week of April for Le Havre, where it is loaded aboard the transatlantic liner *Normandie*, bound for safety in New York. As if to underline that its diplomatic mission is not done, it is accompanied on its journey by the exiled premier of the Republic, Juan Negrín; it will dock in New York on 1 May, exactly two years after Picasso made his first sketch for the painting in his studio on the rue des Grands Augustins.

Manchester Foodship for Spain

40 DEANSGATE
MANCHESTER 2

Telephone BLA 5569

Hon. Secretary :
WINIFRED HORROCKS

An Exhibition of Picasso's "GUERNICA" and 67 preparatory paintings, sketches, and studies is to be shown at 32 Victoria Street (near the Cathedral) Manchester, from Feb: 1st to the 15th, from 10. a.m. to 8.p.m. each day. An entrance fee of 6d will be charged, and all proceeds are to go to the Foodship for Spain.

Pablo Picasso, one of the leaders of the modern movement in painting, was appointed honarary director of the Prado by the Spanish Government in 1936. He was actually in Guernica at the time of its bombardment and ruin, and under the influence of its terrible doom he painted his picture.

This huge canvas which dominated the Spanish Pavilion at the Paris Exposition in 1937, is now to be shown in a Manchester Motor Showroom.

It has been described as "A Monument to destruction", and its awful symbolism portrays the ruins of human intelligence and human kindness. It is a damning commentary on War.

Leaflet announcing the *Guernica* exhibition, distributed by the Manchester Foodship for Spain campaign, 1939

IT WILL BE SPOKEN OF FOR A LONG TIME

A Message
from One Age
to Another

Now the dove and
the leopard wrestle
At five in the afternoon.

FEDERICO GARCÍA LORCA
'Lament for Ignacio Sánchez Mejías'

Approaching New York by sea, immigrants come up on deck for a first sight of the petrified forest of the city's skyline; but they are also scanning the horizon for a work of art by Frédéric Auguste Bartholdi, *Liberty Enlightening the World*, the monumental figure that serves as America's one-person welcoming committee, embodying all the promise and grandeur of the continent. The Statue of Liberty itself arrived by ship in 1885, its sections packed in crates, to be met by vast crowds on the docks and a flotilla of small craft in the harbour. In 1903 the famous sonnet by American poet Emma Lazarus is inscribed around its base, allowing the statue to speak, issuing an invitation that resonates around the world and is not explicitly withdrawn until the second decade of the twenty-first century.

> "…Give me your tired, your poor,
> Your huddled masses yearning to breathe free,
> The wretched refuse of your teeming shore.
> Send these, the homeless, tempest-tost to me,
> I lift my lamp beside the golden door!"[1]

The torch-bearing arm of Bartholdi's Statue of Liberty displayed at the Centennial International Exhibition of 1876 in Philadelphia

On 1 May 1939 another work of art, securely stowed in the hold of the *SS Normandie* – the largest, fastest and most opulent ocean liner in the world – bisects the sightline of Bartholdi's female colossus. It too will become an icon, known worldwide and associated with certain key principles, although what exactly those principles are thought to be will alter depending on the time and context in which it is situated. Over the coming years, its arrival in North America is said to represent many different things: a transfer of cultural power from Paris to New York; the explosion that fires up Abstract Expressionism; part of a communist plot; the beginning of a new phase in Picasso's career; the end of Picasso's career. (The pithiest put-down will probably come from critic Clement Greenberg, who describes *Guernica* as a classical relief flattened by a defective steam-roller.)

Although Picasso will never visit the United States he is familiar with the Statue of Liberty, as much of the world is, through reproduction; as an elective Parisian he also knows it through the miniature version that stands on a plinth in the River Seine, near the Eiffel Tower. In any case, its woman's arm, bearing a torch, finds an echo in his painting.* Much of the statue's symbolic force is concentrated in the limb that, in Lazarus's words, ends in a 'beacon-hand' from which 'Glows worldwide welcome'. It is exhibited separately, along with Liberty's head, in the last years of the nineteenth century before the rest of the statue reaches America.

Picasso will be reminded of the power vested in such objects when his old friend Ambroise Vollard suffers a bizarre accident in France less than three months after the ship docks in New York. His chauffeur-driven car skids on a wet road and somersaults, causing a bronze statue by Aristide Maillol on a

* The rays emanating from Liberty's head may also be echoed in the arrangement of flames in the building to the right of the painting, above the falling woman.

shelf behind the back seat to break free and strike him a death blow with its arm.*

Guernica is not merely paying the United States a cultural visit: first and foremost it is still at work, raising money to ease the suffering of refugees from Spain, particularly those held in internment camps in the South of France, a cause Picasso works for with commendable energy, often contributing significant amounts from his own funds. Its tour of the United States is organized with the help of the American Artist's Congress Against War and Fascism, who in the autumn of 1936 set up the Spanish Refugee Relief Campaign. Picasso has allied himself with the AAC by agreeing to address their Second Annual Congress at Carnegie Hall in December 1937 by telephone link from Switzerland, where he is searching for a safe location for artworks moved out of the Prado Museum. In the event he is prevented by illness from speaking himself but his statement is read down the line by a nurse, giving it added dramatic impact. After expressing his regrets that he cannot be with them in person and reassuring them that the democratic government of Spain is making every effort to protect its art treasures from the effects of war, he makes a powerful statement of belief. 'It is my wish at this time to remind you that I have always believed, and still believe, that artists who live and work with spiritual values cannot and should not remain indifferent to a conflict in which the highest values of humanity and civilization are at stake.' Despite the AAC's communist roots, their campaign has attracted a broad base of supporters, including prominent names from the arts and sciences such as Ernest Hemingway, Lewis Mumford, Dorothy Parker, Thomas Mann and Albert Einstein.

Once again the challenge for *Guernica* is to make its message heard in a city buzzing with the excitement of hosting an

* In an alternative if no less colourful explanation, Picasso's biographer John Richardson has suggested that Vollard's death was murder; a result of his association with a Corsican art dealer with links to organized crime.

international exhibition. The official opening of the New York World's Fair is on 30 April, the day before the SS *Normandie* docks, an unusually hot Sunday afternoon. While the exhibition in Paris celebrated the achievements of modern life in the present tense, the organizers of the fair in New York look towards the future with their slogan 'Building the World of Tomorrow', a strategy they hope will attract not only a large number of visitors but also corporations eager to sell the public new labour-saving devices. The fair, dominated by the 186-metre-high (610 ft) Trylon and the vast globe of the Perisphere, which contains a scale model of a futuristic metropolis called Democracity, is laid out in Flushing Meadows, Queens. Tickets are relentlessly promoted through advertising and public events; the official opening is announced on television by President Franklin D. Roosevelt, on the first day public broadcasts are made on this new medium in New York City. The fair even has its own song, 'Dawn of a New Day', written by George and Ira Gershwin and recorded by Horace Heidt and his Musical Knights for the Brunswick label.

A time capsule is buried in the fair's grounds containing a summary of mankind's achievements, to be left in the soil for 500 years as 'a message from one age to another'. The fair itself however is unable to evade the impact of world events. Once again a Spanish pavilion is planned, making use of some of the same photomontages and art works that have been displayed at the Paris exhibition as well as a panel containing key demands for a negotiated peace; but by the time the fair opens the Republic has fallen and the pavilion's doors never open. Instead Spain is unofficially represented by Salvador Dalí, an artist whose political leanings many find dubious. His Dream of Venus Pavilion, its bulging, biomorphic exterior a contrast to the clean, functionalist architecture that provides the dominant aesthetic at the exhibition grounds, includes two swimming pools and an aquatic dance show. When the fair is extended for a sec-

ond season from May to October 1940, in order to alleviate its losses, many other pavilions, rather than being celebrations of vibrant cultures and economies, have become memorials to vanished or invaded nations. Forty-four million people attend the fair over its two seasons. During the next five years, rather more – around fifty million – will die in the global conflagration.[2]

Art is at the centre of the expo in the form of the 'Masterpieces of Art Exhibition of American and European works from 1500–1900'. Many famous works are borrowed from European museums, including Jean-Antoine Watteau's *The Judgement of Paris* from the Louvre and Johannes Vermeer's *The Milkmaid* from the Rijksmuseum, although the onset of war in Europe will mean such loans become impossible for the second season of the fair in 1940. Visitors are also invited to an exhibition drawn from American museums called 'American Art Today', in which, a critic will later conclude, 'regionalism and a tame social realism predominate'.[3] Many of the younger and more avant-garde artists in the city, some of whom will emerge as key figures in Abstract Expressionism, have been sponsored through the WPA (Works Progress Administration) and FAP (Federal Art Programme) to create murals for the fair. Arshile Gorky is allocated a wall inside the Aviation Building and Willem de Kooning the exterior walls of the Trylon Hall; to the artists' chagrin, their designs have to be executed by members of the Mural Artist's Guild of the AFL's* United Scenic Artists, but even such setbacks do not dampen the utopian atmosphere.[4]

All the muralists share studio space on site, preparing sketches in the WPA's workshop; the painter Anton Refregier excitedly declares in his diary that the studio is 'the closest to the Italian Renaissance of anything, I am sure, that has happened in the United States.' In words that reveal the aspirations and the influences at play on artists about to come face-to-face

* AFL: American Federation of Labor.

with *Guernica,* he declares, 'We are the mural painters. We hope we are catching up with our great fellow artists in Mexico. We will show what mural painting can be.'[5] In fact none of the artwork at the fair has the impact of murals like Léger's *Le Transport des forces* at the exhibition in Paris; it will be an artist not even present in the city who will suggest new possibilities for the form.

The city is full of visitors during the World's Fair and full of exhibitions to greet them. The Museum of Modern Art (MoMA) celebrates its tenth anniversary and its move to a new building on West 53rd Street with a massive show called 'Art in Our Time', which ranges across painting, sculpture, graphic art, photography, architecture, industrial art and film. One artist dominates, with eleven paintings included, ranging in date from 1902 to 1938. His uniqueness is emphasized through his placement in the accompanying catalogue: 'Pablo Picasso. Spanish, born 1881. To Paris, 1901, where he now lives. With Braque, invented Cubism. For this reason he is placed at this position in the catalogue although his incalculably protean art cannot be classified.' At the heart of the painting section of the exhibition lies *Les Demoiselles d'Avignon,* which has made the transatlantic crossing on the *Normandie* the year before and which, until the arrival of *Guernica,* is the museum's key Picasso holding. *Les Demoiselles* is, the catalogue explains, 'like many transitional masterpieces... inconsistent and imperfect – but in no other painting has the most influential artist of our time expressed more powerfully his formidable and defiant genius.'[6] Words that some might feel could be applied just as aptly to the painting that has arrived at the New York docks.

Guernica is not bound for the Museum of Modern Art – at least not yet – but its first port of call is quite close by, at a private gallery on East 57th Street. Set up in 1926 by F. Valentine Dudensing in partnership with Pierre Matisse, dubbed 'a Temple of Modernism' by critic Henry McBride, the Valentine

Gallery has long championed Picasso's work. *Guernica,* the studies and 'afterthought' spin-off works are installed in the gallery's large main room. The preview night for the exhibition on 4 May attracts a blue-chip crowd of 100 invitees, each paying five dollars towards Spanish relief, eager to finally see the picture they have read so much about, among them Eleanor Roosevelt, off a train from Washington, and the collector Peggy Guggenheim. A representative of the United States government is present in the shape of the Secretary of the Interior and the defeated and fragmented Spanish Republic is represented by Juan Negrín, in one of his last diplomatic assignments. *Guernica* is immediately connected to the electric networks running through the city, from the trustees at MoMA to the desks of politicians and the boards of banks. Over the next three weeks it will attract a different crowd, willing to pay fifty cents admission to the gallery: young artists, convinced Picasso is either the man to learn from or to beat; gallery-goers who have already seen 'The Art of Our Time', hungry for more Picassos; left-wing activists involved in money-raising for Spanish refugees; even first-time visitors to the city drawn by the World's Fair, wandering in off the street. Arshile Gorky, the Armenian artist whose career up until this point has followed Picasso's almost to the point of imitation, earning him the nickname 'the Picasso of Washington Square', gives an impassioned lecture in front of the painting to – in the words of artist Lee Krasner – an audience 'of nobodies' who listen with rapt attention, seated on the floor. Throughout the talk, according to Krasner, he does not smile. Krasner is 'floored' by her first sight of the work, forced to go out and walk around the block three times before returning to look again.

Another artist who is deeply affected by his first sight of *Guernica,* this time at the Picasso retrospective at the Museum of Modern Art, is the Mexican painter Rufino Tamayo, who has himself been exhibited at the Valentine Gallery. Tamayo is seek-

ing to create an art that reflects his pre-Columbian heritage and Mexican identity, yet rejects the didactic social realism of the mural painters that dominates the discourse in his home country. *Guernica* seems to offer the possibility of expressing the terror and turmoil of the times without sacrificing ambiguity and complexity: it also prompts him to rethink his approach to the human figure, which moves in his works to a more monumental scale, and to animals, the subjects of several important paintings from the 1940s. Other Mexican painters borrow more directly from *Guernica's* imagery, particularly focusing on the figure of the tortured horse, which is explored in works by artists including Alfonso Michel and José Moreno Villa. The Mexican public is particularly well informed about the conflict in Spain, not least because of the steady stream of Spanish exiles arriving at the port of Veracruz between 1937 and 1939. They include artists, architects, doctors, agronomists, artisans and a number of leading Spanish intellectuals, including the philosopher José Gaos, who sat on the commission for the Spanish Pavilion in 1937 and who goes on to play a vital part in the intellectual life of the country.

Guernica has touched down in America at a very particular moment in art history. Artists, museum directors, curators and critics alike are engaged in heated debate over many of the same themes that are being argued over in London and Paris – figuration pitted against abstraction, the personal versus the political, classical tradition as opposed to modernism – but with the addition of one further question unique to this side of the Atlantic: what shape or form might a distinctively North American art take, free of the suffocating weight of European culture and the sense of cultural inferiority it engenders? Both those associated with figurative traditions and the emerging schools of abstraction in New York believe that the physicality and scale of the American landscape holds one of the keys to a new visual vocabulary. But where is the art that can encapsulate both the

myth of the West and the vibrant energy of the American Dream, the capitalist thrust of which results in the vision of the future laid out in the Perisphere?

Separated from Paris by an ocean, artists in the city that will receive *Guernica* have kept in touch with the latest developments in the European avant-garde through the exhibition programme of MoMA and the pages of magazines like *Cahiers d'Art*, available in selected New York stores and highly prized even by those who lack the linguistic skills to understand it. ('I didn't read French, so when I had a copy of *Cahiers d'Art* I didn't know what it was all about,' sculptor David Smith will later tell David Sylvester. 'I learned from the pictures, just as though I was a child in a certain sense... Gorky didn't read French and I don't think de Kooning read French either.')[7] Marxism is a key influence in artistic circles, along with its aesthetic offshoot, socialist realism, although many will become increasingly disillusioned with the Soviet Union following the Stalinist show trials of 1936 and the German–Soviet Non-aggression Pact of 1939. Interest in 'primitivism' is also very current, fed by the Museum of Modern Art exhibition of African art in 1935. For left-leaning painters, the figurative tradition is best exemplified by the holy trinity of Mexican muralists, Diego Rivera, José Clemente Orozco and David Alfaro Siquieros, who are especially influential with those called to make public works on the WPA programme. Thomas Hart Benton, who teaches at the Art Students League of New York until 1935 and who embodies both a muscular regionalism and suspicion of the European avant-garde, is also a powerful influence. Abstract painters, as well as homegrown expressionists who cannot find galleries willing to show their work, create their own support networks, magazines and exhibition spaces. New York is home to the American Abstract Artists, whose early members include Ad Reinhardt, Jackson Pollock, Lee Krasner and Bauhaus exile Josef Albers. While Alfred H. Barr, director of the Museum of

Modern Art, believes abstraction to be the ultimate destination of modern art, James S. Plaut, director of the Boston Museum of Modern Art, sees the theorizing of abstractionists as a 'cult of bewilderment'; their disagreement will be formalized in an institutional name-change almost a decade later.*

While few young American painters can afford to make a trip to Europe, by the end of the 1930s much of Europe has come to America. Increasing numbers of Dadaist and Constructivist artists arrive on American shores during the decade, including Marcel Duchamp, Amédée Ozenfant, László Moholy-Nagy, Jean Hélion and Hans Hofmann. As the fate of Paris looks increasingly uncertain, they are joined by others including André Breton, Marc Chagall, Salvador Dalí, Max Ernst, Roberto Matta and Piet Mondrian. Seldom has any city had such an infusion of artistic talent in so short a period; yet the greatest of all among the European modernists remains in the city New York critic Harold Rosenberg will christen 'The Holy Place of our Time'.[8] Despite Picasso's absence, the arrival of *Guernica*, the 'Art in Our Time' show and the Picasso retrospective exhibition at the Museum of Modern Art at the end of *Guernica*'s American tour provide a unique opportunity to put the Old Master of modernism under the microscope. For American painter William Baziotes, *Guernica*'s combination of monochrome and myth, religious and psychological symbolism 'all too vividly demonstrate the limitation of representational art to express modern experience'.[9] He studies Picasso's retrospective until he can 'smell his armpits and the cigarette smoke on his breath'.† Picasso is not about the figure, he decides, or plasticity, but something internal. He has 'uncovered a feverishness in himself and is painting it – a feverishness of death and

* The Boston Museum of Modern Art will be rechristened the Institute of Contemporary Art in 1948.

† The great satirist and purist abstract painter Ad Reinhardt's response: 'Study the old masters. Look at nature. Watch out for armpits.'

beauty'.[10] By turning inward, according to this analysis, Picasso prefigures what will become a defining characteristic of much of the most celebrated art produced over the next two decades in the city that is to be *Guernica*'s new home.

What American art needs is a figure who can achieve a similar feat, internalizing and resolving the conflicting forces operating on the art of the American continent to forge something new. The man who most closely fits the bill, unknown to himself, comes to see *Guernica* at the Valentine Gallery in May and returns several times, 'sometimes... alone, sometimes with others, to make sketches, to exchange hushed comments, or just to stand and be overwhelmed by the great grey monolith of it'.[11] On one occasion, overhearing a fellow artist speak disparagingly of the painting to a companion, he invites him to 'step outside and fight it out'. The young painter in question is Jackson Pollock. Born in Wyoming, raised in Arizona and California, Pollock has been exposed to Native American art (which he continues to explore at the American Museum of Natural History) and the vastness of the landscape; he hides his shyness and insecurity behind a taciturn manner and a prodigious consumption of booze, peddling a cowboy *shtick* that goes down well with East Coast sophisticates. To this combination of biography and brain chemistry he brings a hunger to learn from, and surpass, the great figures of twentieth-century art. He has been largely shielded from Picasso's influence – he studies under Thomas Hart Benton, something of a mentor to the young painter, who is vocal in his disdain for Picasso's work. When Benton leaves New York, Pollock falls under the influence of another older painter, the eccentric Ukrainian refugee John Graham. Graham regales Pollock with stories of having met Picasso, drunk with him, watched him at work, and Pollock is transfixed. Yet none of Graham's stories will have the impact of his first encounter with *Guernica*.

The artist who steps through the door of the Valentine

Gallery is still searching for direction. The power of the impression *Guernica* and its accompanying sketches make on him is borne out in the drawings he shares with Joseph L. Henderson, the Jungian therapist who is treating him for depression and alcoholism. Several images drawn direct from *Guernica* are present – the collapsed figure of a horse and another with its neck twisted towards the ground, a bull, a woman with her eye swinging at the end of a string. Pollock may have had little direct connection with the conflict in Spain but *Guernica*'s bestiary speaks directly to his psyche, still stalked by the animals that terrified him as a child on the family farm.

Social Realist painters like Benton, Pollock realizes, caught up with parochial and regional subject matter, cannot represent the future. In contrast, Picasso offers a model of painting that is international and speaks a universal language, offering an escape route from the political issues that have dominated Pollock's work in the 1930s. Uniting myth, symbol and suffering, *Guernica* is, as Kirk Varnedoe will write, 'a huge machine for reconciling opposites. In a way that ma[kes] Orozco look stagy and didactic, its violence roar[s] off the canvas without any compromising bow to standard forms or allegory.'[11] That violent

No. 507 in *Jackson Pollock : a catalogue raisonné of paintings, drawings, and other works*, vol. III

No. 537 in *Jackson Pollock : a catalogue raisonné of paintings, drawings, and other works*, vol. III

energy will be channelled by the all-American artist the critics have been looking for, a 'ring-tailed roarer' from the American West who likes 'to go to saloons and play at busting up the joint'; an artist who can turn a canvas into a landscape and then enter it himself by putting it on the floor and treading on it.[13]

Initially there is little mixing between the somewhat insular, French-speaking European exiles in the city and the American artists of the emergent New York School – the art critic Irving Sandler recalls parties where the two factions congregate on opposite sides of the room – but one artist who had attended the birth of *Guernica* in Paris will act as a connector, allowing modernist energy to flow into the American grid. The Chilean-born Surrealist Roberto Matta is now in New York, his linguistic skills, youth and restless ambition setting him apart from the other exiles. He is friendly with Robert Motherwell, later to become the self-appointed spokesman and theorist for the New York abstract painters, who will remember Matta as 'the most energetic, enthusiastic, poetic, charming, brilliant young artist' he has ever met.[14] Matta is eager to forge alliances with American artists willing to experiment. 'Are there any guys on the WPA who are interested in modern art and not all that socialist realist crap?', he asks William Baziotes.[15] Motherwell too acts as a link between worlds, his fluent French allowing him to become an interpreter for the Surrealists in New York, 'for things as small as where you get the best olive oil, and as large as society's various and ongoing connections with the endlessly spreading world of art.'[16] Motherwell occupies a strange position in art history, perhaps because his Harvard education and upper-middle class background mean he fails to live up to the ideal of authenticity beloved of certain art critics and academics; or alternatively because, as well as being an artist, he himself is a writer on art, in critics' eyes the equivalent of a dog walking on its hind legs. European novelists and poets are as important to Motherwell as artists; Federico García Lorca in

particular is a totemic figure, particularly his poem 'Lament for Ignacio Sánchez Mejías' which serves as an inspiration for his painting *The Little Spanish Prison*. Once more Matta provides a connection; in 1934, the author of the *Lament* had given him a copy of the poem.

Motherwell's alliance with Surrealism doesn't last; the movement does nothing to address what he sees as a central dilemma: the artist's role in modern society. The collapse of religion and the more recent discrediting of politics of both left and right following the Depression, the Stalinist show trials and the rise of fascism have left artists isolated and without a social function. For Motherwell, it is this fundamental problem that *Guernica* and the semi-mythical figure of its creator address. 'The weakness of socialists derives from the inertness of the working class,' he writes in *The Modern Painter's World*. 'The weakness of artists derives from their isolation. Weak as they are it is these groups who provide the *opposition*.' Picasso is 'cut off from the great social classes, by the decadence of the middle class and the indifference of the working class'. Nevertheless in *Guernica*, which 'expresses Picasso's indignation, as an individual, at public events' and which Motherwell describes as a '*tour-de-force*', he has, to some extent, overcome these problems and is therefore worthy of admiration. Yet the painting hangs in 'an uneasy equilibrium, between political engagement and formal aesthetics'.[17]

If the artist exists in solitude, his or her work must still find an audience. The ideal place for them to do so might be on a ceiling or wall rather than the rarefied space of the gallery, Motherwell suggests in 'The Painter and the Audience' in 1954. Once again, *Guernica* is a model. 'How many walls have been turned over during the past fifty years to the most celebrated and esteemed painters? So far as I know, to Matisse thrice... [and] to Picasso once, a temporary pavilion, for which he painted *Guernica*... What a triumph these four commissions repre-

sent as efforts to reach beyond that solitude! A solitude that has become traditional in modern society.'[18] The critic Elizabeth McCausland, who had called for *Guernica* to come to the United States in an article in the *Springfield Republican* in July 1937, was equally clear that *Guernica* demonstrated a shift in Picasso's relation to the world. To go and see it on display at the Valentine Gallery will be, she tells her readers, 'a half dollar well spent for it symbolizes the passage from isolation to social identification of the most gifted painter of our era'. Motherwell, it is clear from his later writings, remains rather more conflicted about how successful the painting is; rather than providing him with a solution, the 'huge machine' of *Guernica* sets him a puzzle, albeit a fruitful one, that he will struggle with throughout his career, most notably perhaps in the series of over 100 paintings called *Elegy to the Spanish Republic* on which he works between 1948 and 1967.

Despite his experiments with Surrealist techniques, Pollock remains locked in an Oedipal struggle with Picasso. In a famous anecdote, his wife Lee Krasner recalls hearing a loud sound from his New York studio, followed by Pollock shouting 'God damn it, that guy missed nothing!' When she rushes in to see what has happened she finds Pollock staring into space with a book of Picasso's work thrown on the floor. On another occasion, in a bar, Pollock yells, 'There's me and Picasso! The rest of you are whores!' *Guernica*'s imprint can most clearly be felt in a breakthrough painting he creates for the narrow hallway to the apartment belonging to his new dealer, Peggy Guggenheim, called *Mural* (1943). This is a difficult space, even if his audience are simply hanging their hats on the way to one of Peggy's glamorous salons rather than visiting a pavilion at a world's fair. Pollock has understood one important practical thing, thanks to advice from Marcel Duchamp: although he is painting at mural scale he will do so on canvas, as Picasso has done; this means his work too will be able to travel and be exhibited else-

where, rather than remaining in a space where it is vulnerable to the decorator's brush that stalks such fashionable Manhattan apartments. This lesson will stay with him and be expressed in the application he writes for funding to the Guggenheim Foundation some five years later:

> I intend to paint large movable pictures which will function between the easel and mural... I believe the easel picture to be a dying form, and the tendency of modern feeling is towards the wall picture or mural. I believe the time is not yet ripe for a full transition from easel to mural. The pictures I contemplate painting would constitute a halfway state, and an attempt to point out the direction of the future, without arriving there completely.[19]

Pollock has not yet fully embraced abstraction; to stand in front of *Mural* is to see all manner of forms lurking among its vividly coloured undergrowth, some of them familiar from the pages of his sketchbook: a face, limbs, even an extended arm in its top-right corner. Spectral figures, similar to the Native American-inspired pictographs of his earlier paintings, march from right to left across the canvas. He will later claim the canvas captures, 'a stampede... [of] every animal in the American West, cows and horses and antelopes and buffaloes. Everything is charging across that goddamn surface.' For the first time he is experimenting with house paint, similar to the Ripolin Picasso has used, in addition to oils, and there are areas of loose, expressive brushwork and pink paint that has been flicked onto the canvas – a sign of things to come.

Like *Guernica*, Pollock's *Mural* will accrue its own legends, specifically one disseminated by Lee Krasner. Having done so much to support his art practically she intervenes in his burgeoning myth by claiming *Mural* was painted in a blaze of energy during the course of a single night before Peggy Guggenheim's deadline, and delivered on foot, presumably rolled and still wet, by Pollock with only hours to spare – a Herculean task

given the painting's size. The story enters the canon via the writings of Clement Greenberg and Peggy Guggenheim's autobiography *Out of This Century,* published in 1946. In her version, she and her new lover are 'preoccupied for weeks trying to think of fantastic ways of decorating the entrance hall' until she thinks of asking 'the genius she has just discovered' to paint a mural. Pollock finds it 'difficult to settle down to anything as big as this mural', she writes. 'After weeks of hesitation he began wildly splashing on paint and finished the whole thing in three hours.'[20] The story of paralyzed indecision followed by a burst of activity of course recalls Picasso's struggles with *Guernica*. It is only conclusively debunked in 2014 by researchers and conservationists from the J. Paul Getty Museum, who make an extensive examination of the painting, concluding from a study of its surface that it has been completed over a period of time.*

– II –

Before *Guernica* can take up residence in the Museum of Modern Art, where it will reside semi-permanently until 1981, it must fulfil its duty as a fund-raiser and tour America. For the next twelve years it will travel between the major museums of the United States, visiting New York, Los Angeles, San Francisco, Chicago, St. Louis, Boston, Cincinnati, Cleveland, New Orleans, Minneapolis, Pittsburgh, Cambridge and Columbus, Ohio, before crossing the ocean once more to São Paulo in Brazil and back to Europe for a tour of eight cities once peace is restored. It is an extraordinary itinerary, packed into a few years,

* Pollock's *Mural* can be seen on the website of the University of Iowa Museum of Art (uima.uiowa.edu/collections/american-art-1900-1980/jackson-pollock/mural/).

enough to make any conservator blanch. Alfred Barr's worry can be heard in a letter in the collection of the Reina Sofía. 'I am somewhat surprised... that you are willing to have us lend the *Guernica*,' he wrote to Picasso, before the painting was dispatched for the biennial in São Paulo in 1953, 'though of course we are very willing to do so, even though it means dismantling the permanent installation that we had set up last fall in the belief that you would not want to move the picture for many years. I should also remind you that the canvas around the edge is rather delicate because of the frequent stretching and unstretching of the picture during its tour in the years 1937–41.'[21]

As well as the physical challenges of life on the road, *Guernica*'s tour of the US in 1939 will garner reaction from American newspapers, critics and even politicians for the first time. To say it divides opinion is an understatement. In Los Angeles, the opening on Wilshire Boulevard is as star-studded as the one in New York, attracting Hollywood names including Bette Davis, the director George Cukor and Edward G. Robinson, who combines tough-guy cinema roles with anti-fascist activism in his private life; his movie *Confessions of a Nazi Spy*, the first anti-Nazi movie released by Hollywood, opens around the time *Guernica* lands in New York. Dashiell Hammett and Dorothy Parker are also present; any hard-boiled comments on the painting that may have passed between them and the star of *Little Caesar* are sadly lost to history. At the San Francisco Museum of Art, *Guernica* is exhibited alongside *The Dream and Lie of Franco* and other anti-war works by artists ranging from Goya to Käthe Kollwitz and Otto Dix. Tensions around the painting are already high enough for the curator of the show, Charles Lindstrom, to compose a special message to place beside it, one of few such site-specific texts to float off the wall and into art history.[22] 'It is no part of wisdom to slay the bearer of ill tidings,' he writes, 'the horrid facts remain, and it is they, and not the report of them, which deserve abhorrence... This is

the last judgement of our age, with a damnation of human manufacture, and nowhere the promise of a paradise.'

The artist Leon Golub recalls encountering the painting for the first time at the Arts Club of Chicago: 'It was a shocker, colossal! Like *Les Demoiselles d'Avignon*, a revolutionary act.' Revolutionary acts are exactly what certain journalists and newspaper proprietors are worried about: the *Chicago Herald-Examiner* describes the painting as 'Bolshevist art controlled by the hand of Moscow'. While an artist in New York like Jackson Pollock can use *Guernica* to free himself from politics, for much of the American establishment it is political above all, a work that has taken sides, aligning itself with church-burning Spanish anarchists rather than those upholding traditional values. A glowing review in *The New York Sun* at the beginning of the tour has provided reactionary critics with a hostage to fortune by erroneously stating Picasso is a communist who is 'fighting Franco with might and main'. Although he will not join the party until 1944 Picasso's alleged membership is justification enough for The Society for Sanity in Art, a right-wing organization with branches all over the United States, to demonstrate noisily at venues on the tour. Despite such grandstanding – which so often has the opposite effect to the one such protestors intend, turning an exhibition into a sensation – *Guernica* does not draw the crowds the organizers of the tour hope and the money raised for the Spanish cause is modest.*

The Picasso retrospective that opens in November 1939 at the Museum of Modern Art in New York is the most comprehensive presentation of the artist's oeuvre so far assembled, as the foreword to the catalogue points out; one that Alfred Barr has been working towards for at least the last eight years, with

* Fifty years later, in 1999, Rudy Giuliani, then mayor of New York City, will attempt to cut off funding to Brooklyn Museum over the inclusion of Chris Ofili's painting *The Holy Virgin Mary* in the *Sensation* exhibition, succeeding only in turning it into a major success.

many frustrations along the way. Even with more than 300 works in the exhibition there are disappointments: a number of sculptures that were being cast in Europe for the exhibition, as well as a number of other loans from European museums, have not arrived due to the outbreak of war. Neither will Picasso himself, understandably, be present, although plans are already being made to offer him sanctuary in the United States. Alfred M. Frankfurter leads the critics in their praise in *Art News*. 'Here', he writes, 'in full retrospect, is the master of the modern age, the painter who, even by the admission of his antagonists, has influenced the art of his time more than any other man. Here is the most fertile and the most advanced painter of the twentieth century, whose art at fifty-eight is still as revolutionary and again as generally misunderstood as was once that of his twenties.'

For the first time at the Museum of Modern Art, *Guernica* is presented embedded within a lifetime's work – inevitably, given its chronology and scale, as something of a summation. There is no equivocation in the brief note to the painting in the catalogue regarding its creator's motivation. 'On April 28, 1937 the Basque town of Guernica was reported destroyed by German bombing planes flying for General Franco. Picasso who had already taken the Loyalist side in his 'Dream and Lie of Franco' immediately *prepared to take an artist's revenge* [author's italics].' This then is the official line in 1939 from the holy of holies of modern art in America, in a text either written, or at least approved, by its director: *Guernica* is an act of resistance and accusation, connected to a specific outrage. Fifty-nine studies and postscripts are exhibited alongside the painting, which the catalogue advises 'cumulatively make it possible to study how Picasso has proceeded in composing one of the most important paintings of recent years'. In addition, visitors are advised it is 'interesting to compare' the painting with earlier works, all in the exhibition, notably *Dream and Lie of Franco*;

two bull fight scenes of the 1930s; the *Crucifixion* of 1930; and the *Minotauromachy* of 1935 (all of which comparisons are still made by those writing on the painting today). *Guernica* is 'important', the catalogue wishes us to know, both in art-historical terms and within Picasso's oeuvre, and therefore worthy of our study.

Despite the museum's definition of *Guernica* as an act of artistic revenge, the ties between the painting and the event that inspired it are beginning to loosen. It no longer presents a conundrum that can be solved – the Republic is a lost cause – and on its American tour it is put to work pleading for bread instead of guns. With the retrospective, another realignment occurs; rather than being linked to a single issue, the painting is displayed within the entirety of Picasso's output for the first time and viewers are invited to consider the artistic rather than political themes that connect it to works of other periods. From an act of protest, it mutates into a work of art in a museum: remarkably swiftly it will become a cornerstone of MoMA's collection. As the bombing of Gernika begins to recede into the past, the picture moves into the future; a future that will see a conflagration to dwarf the one unleashed on the Basque town in 1937.

Once the prophecy embedded in *Guernica* of a coming conflict with fascism is fulfilled, its politics might be expected to become uncontroversial. Instead, confronted and ultimately defeated on the battlefield, fascism changes shape and re-emerges much closer to home. The House Un-American Activities Committee (HUAC) will monitor those who have campaigned for the Republican cause, including the Spanish Refugee Relief Committee who brought *Guernica* to New York. 'Today the fascist threat has come full circle,' the American Artists' Congress states in 1941, in words foretelling the era that will be shaped by J. Edgar Hoover and Joseph McCarthy, and in which Picasso will earn the distinction of an FBI file that is 187 pages long. 'In a traditionally free and liberty-loving America,

fascism comes in the name of anti-fascism. All the enemies of progress suddenly become defenders of democracy. Our liberties are destroyed to defend liberty and the policies to which our people are committed by their government, in the name of peace, border ever closer on overt war.'[23] Voices hostile to the Museum of Modern Art, criticizing it for harbouring communist-inspired works, grow louder. A defence is called for. All specific references to the Spanish Civil War are removed from information panels; a new text by Alfred Barr explains that 'there have been numerous, but contradictory interpretations of *Guernica*. Picasso himself has denied any political meaning whatsoever, simply establishing that the mural expresses his hatred of war and brutality.' In this way a condemnation of a fascist atrocity is released from its historical anchor and begins its journey towards becoming a global symbol of peace. On West 53rd Street, if only temporarily, the dove has wrestled the leopard into submission.

More or Less
True

Even the most perfect
reproduction of a work of art
is lacking in one element: its
presence in time and space, its
unique existence at the place
where it happens to be.

WALTER BENJAMIN
*The Work of Art in the Age
of Mechanical Reproduction,* 1936

War has broken out in Europe, an opportunity for commanders on all sides to put into practice the military theories trialled in Spain. After an initial sojourn in Royan, on the southwestern coast of France, the painter of *Guernica* sits much of it out in his studio in Paris, separated from his creation by five and a half thousand kilometres of ocean. Or is he? Myth swirls down the rue des Grands Augustins like fog off the river. Picasso's continued presence in the city during the German occupation is either a sign of his great bravery or of his corrupt relationship with the occupying forces. According to some he is a collaborator, to others a leader in the resistance. Of course, he is neither; he is an artist, whose fame affords him some degree of protection but also makes him a target, his decision to stay, according to his own account, the result of inertia.*

Has *Guernica* really left Paris at all? Not according to one of the most persistent legends that cling to the painting. It is a story everyone knows: one as likely to be found on an amateur's art blog as in Theodor Adorno's seminal essay *Commitment*, published in 1962.

> An officer of the Nazi occupation forces visited the painter in his studio and, pointing to *Guernica*, asked: 'Did you do that?' Picasso reputedly answered, 'No, you did.'

The veracity of this account, which in a few words encapsulates so much, is slightly undermined by the facts: *Guernica* left Paris in April 1939, while German troops didn't arrive in the city until June 1940. Nevertheless, within a few years Picasso's reported witticism has travelled as far as the painting itself; in 1945 a French journalist confronts him with a version rather different

* Other authors have dealt at length with Picasso's wartime experience and there is plenty of evidence of his routine bravery, which included supplying moral and financial support to Spanish refugees and others, and meeting with wanted members of the resistance at his studio.

to Adorno's, in which the German soldier is referring to a post-card reproduction of the painting.* Is the story true, she asks him? ' "Yes", Picasso laughs, "that's more or less true. Sometimes the Bosches would come to visit me, pretending to admire my paintings. I gave them postcards of my *Guernica* picture saying: "Take them along, souvenirs! souvenirs!" '

The myth Adorno recycles in his essay is important not just as fuel for his argument regarding the independent life of the artwork, but for what it can tell us about *Guernica*. Firstly, the painting has dematerialized, acquiring the magical ability to tour America's principal art museums while remaining in the artist's studio in Paris. Secondly, the different tellings of the story conflate the painting and a version of it at postcard size, perhaps one of those made for the Spanish Pavilion; either is equally able to provoke the pithy exchange between Picasso and a representative of fascist rule. *Guernica* will retain this ability: to invest reproductions of itself – posters, tapestries, reworkings by other artists – with something of what Walter Benjamin calls, in *The Work of Art in the Age of Mechanical Reproduction*, the 'aura' unique to the original artwork, as well as the meaning the public have attributed to it. (Benjamin's seminal text, still a staple of art history students' reading lists, is first published the year the Spanish Civil War breaks out.) *Guernica* has reached a fork in the road. It will continue to exist as an artwork in the physical realm; at the same time it will intervene in and comment on world events as it makes appearances in different forms. Countless thousands across the globe will take on themselves the right to appropriate, quote and refashion its likeness, recontextualising it for different times as a slogan, a brand, a totem to be brandished in the face of the oppressor, shorthand for numberless atrocities, a dozen wars. Once attended only by its retinue of studies and oils,

* Yet another variation casts the questioner as the German ambassador to France, Heinrich Otto Abetz.

Guernica now sits at the centre of an endlessly multiplying constellation of replicas, refractions and reworkings in physical and digital form. To all of which, if asked, 'Did you do that?', the ghost of Picasso would no doubt reply, 'No, you did.'

As the meta-*Guernica* continues to multiply and expand, pervading the world, the painting, once little more than a touring protest banner, becomes a static art object, embedded within a museum collection, too fragile and valuable to be moved. At the Museum of Modern Art its new status is demonstrated by its hang in a room of its own, empty except for the painting and a wooden bench where, as one visitor in 1946 recalls, 'hundreds of people came and sat to eat their sandwiches and look... And there was *Guernica*, all by itself, absolutely filling the back wall.'[1]

Guernica has generated merchandise from the moment of its first exhibition in Paris in 1937. From the postcards on sale at the Spanish Pavilion it will proliferate over the course of eight decades to encompass the posters, postcards, framed prints, jigsaws, placemats, memory games, fridge magnets, notebooks, t-shirts, magnetic bookmarks, pencil cases and key rings, all bearing its image or details from it, that are for sale in the gift shop in the museum where it is now located. None of these are likely to have the impact of one of the three tapestry reproductions of *Guernica* made in Cavalaire in the Var department of southeastern France. Tapestry workshops have played a significant role in promoting the modernist aesthetic in the first half of the century, existing in a symbiotic relationship with the art world that is now relegated to a footnote in art history. Many of the great names in the canon, including Léger, Miró, Braque, Raoul Dufy, Sonia Delaunay, Max Ernst and Marc Chagall, have entered agreements with skilled artisanal weavers allowing the creation of tapestries of some of their best-known paintings. Picasso had made the mural movable by painting it on canvas; modernist tapestries, able to be rolled and unrolled without sustaining wear or damage, take portability to the next stage. The new, rationalist

architecture that is springing up around the world requires art that suits its geometric spaces; Le Corbusier christens tapestries 'nomadic murals', going on to create more than twenty designs himself.

The studio at Cavalaire is small, overseen by master weaver Jacqueline de la Baume Dürrbach and her husband René. Her atelier has already produced a cartoon of *Guernica* on its own initiative, initially based on a poster reproduction. When the painting comes to Paris in 1955 and is shown at the Musée des Arts Decoratifs (Museum of Decorative Arts), Jacqueline is able to gain access for three hours a day before the exhibition opens to correct the cartoon, eventually presenting it to Picasso for approval at Antibes. Picasso has already been sufficiently impressed with the Dürrbachs' work to agree to a number of collaborations; he makes some corrections and allows them to go ahead with the production of three tapestries of *Guernica*, on the condition that he receives ten per cent of the proceeds of any sale in advance. Word of the creation of the first of these* reaches the ears of an American collector who is both an avid admirer of Picasso's work – he has already made approaches to see if he can buy *Guernica* – and has a strong connection with tapestry as an art form. Nelson Rockefeller has grown up surrounded by fifteenth-century Flemish textiles in his parents' apartment in Manhattan, posing in his early twenties with his family as subjects for a tapestry by Marguerite Zorach.[2] His friend Wallace K. Harrison, the architect of the United Nations building, tells him of the existence of a tapestry version of *Guernica* at the Dürrbach studio and he travels there himself to investigate. It is love at first sight and he buys it immediately. (The atelier will go on to produce a total of twenty-seven

* The second version of the tapestry was created in 1978 and purchased by the Musée Unterlinden. The third tapestry, made in 1983, was purchased in 1996 by the Gunma Museum of Modern Art in the Japanese city of Takasaki.

tapestries 'after' Picasso, and Rockefeller will commission them a further sixteen times.) This is no facsimile: slightly reduced in size, Rockefeller's tapestry of *Guernica* has also changed its colour spectrum, grey and white morphing into sepia tones of light brown and cream, in keeping perhaps with contemporary trends in interior design.

For a period beginning in 1955 the city of New York therefore has two *Guernica*s in its orbit: the painting, located at the Museum of Modern Art, of which Nelson Rockefeller becomes President in 1939,* and the tapestry, owned by Rockefeller himself, who will go on to hold office as Governor of New York (1959–73) and Vice President of the United States (1974–7). *Guernica*'s image has thus travelled from the fringe, where its first viewings in the United States have been organized by left-leaning campaigning groups, to the very centre of establishment power, into the protection of a family that connects the worlds of art, big business and politics. Yet the woven version of *Guernica* will not remain hidden in the baronial splendour of Kykuit, the Rockefeller family estate close to Sleepy Hollow in Westchester County. After Nelson Rockefeller is elected to office in New York in 1959, it is moved to the Governor's Mansion in Albany where, thanks to its incumbent's aristocratic largesse, it is put on public view. It too, will travel, and like the painting bear witness to world events.

Perhaps inevitably the proximity of these two versions of Picasso's work generates interference, not least between the different power-centres in which they reside. At the Museum of Modern Art, Alfred Barr is sceptical about tapestry as a medium for reproducing art – wool, after all, is a poor substitute for printer's ink in terms of matching colour, and weaving completely changes the picture surface. Nevertheless, he must do nothing to threaten the museum's relationship with such an important pa-

* Rockefeller's mother Abby Rockefeller was one of the founders of the museum.

tron and member of the board; one for whom he often finds himself acting as an adviser regarding acquisitions for the Rockefeller private collection. His unease is clear in a letter he sends to the artist Nelly van Doesburg, who has acted as a go-between to facilitate the purchase of the tapestry, in February 1956. 'Did Picasso actually decide upon the colors used, and if not, did he approve them? That is, was he satisfied after he saw the final tapestry?'[3] Van Doesburg is somewhat curt in her reply. 'Dear Alfred, Picasso finds the tapestry a "Masterpiece". He finds the tapestry nearer to the colors of the "original" because the colors in the original are more or less gone!'[4] Picasso, she goes on to say, has insisted on having his photograph taken in front of the tapestry. The word 'masterpiece' is written in red ink, for added emphasis.

As well as triggering anxiety in Barr, the letter pinpoints several of the most pertinent questions surrounding *Guernica*. How can a woven copy, in which the artist has played a minimal role, be deemed 'nearer to' the original – especially by the artist himself? Barr's relationship with Picasso has at times been fraught; to the conscientious curator the artist has seemed cavalier about the safety of his own work, both in continuing to allow *Guernica* to be toured and in his casual attitude to its reproduction, and he has been challenging to deal with when arranging major exhibitions. At the same time he is the ultimate authority on the painting's future, the one who will decide how long *Guernica*, arguably the centrepiece of MoMA's collection, remains at the museum.

Picasso's reported comments on the colour of the tapestry are especially worrying. The painting has suffered during its extended tours of the 1940s and 1950s and has had to undergo emergency conservation to prevent further deterioration in its condition. The canvas has been impregnated with wax-resin and put under vacuum pressure to try to fix flaking paint back to its surface, loosened by its continual rolling and unrolling

during its travels; meanwhile the application of varnish has darkened it, heightening contrasts in a way the artist never intended. Is this what Picasso means by saying the original colours are 'more or less gone'? This would be a criticism of the custodial role the Museum of Modern Art has played in caring for *Guernica*. 'It is simply not true that the colours of the tapestry are in any way nearer the original,' Barr responds a week or so later. While the painting is 'somewhat dirtier and slightly worn around the edges… it has not changed color in any serious way. It was originally and remains predominantly black, white, and gray.'*

If the tapestry calls the authority of both the original painting and its custodians into question, it also has implications for its owner. While *Guernica* was birthed in the heady politics of the 1930s, the tapestry has landed in the very different atmosphere of Cold War America. Despite his progressive tendencies in domestic policy, Rockefeller is a hawk when it comes to opposing communism and is a supporter of increases in military spending; positions in marked contrast to Picasso's well-publicized dalliance with the Communist Party, his links to the peace movement and his opposition to American involvement in Indo-China, expressed in the painting *Massacre in Korea* (1951). Picasso has even been named as a dangerous subversive in the House of Representatives by George A. Dondero, a congressman and right-wing media pundit from Michigan, whose views on the avant-garde chime with the paranoid suspicions of Senator McCarthy and J. Edgar Hoover. It is not only artists who are under attack; art institutions have also felt the heat. The presence of *Guernica* at the Museum of Modern Art continues to attract the vitriol of conservative critics such as Arthur Craven. The muse-

* Barr revised his opinion of the tapestry once *Guernica* became too fragile to tour, realizing it could fulfil a useful role as a surrogate. In the early 1960s it travelled to universities in New York and Maine and four cities in Japan, again touring sites in North America after Rockefeller's death in 1979.

um, he writes in 1948, is 'a Rockefeller plant riddled by cultural sicknesses. Its top intellectual, Alfred Barr, master of a style that is one part mock erudition and nine parts pure drivel, writes books on the red idol deified by the Parisian Bohemia which he rules, and other such deadly phenomenons [sic].'[5]

If association with a 'red idol' is not enough to give Rockefeller pause, the family already have a history with left-leaning artists. In 1933 they had approached Picasso to paint a mural for the ground floor of the Rockefeller Centre, John D. Rockefeller's grand project, then under construction. When he refuses, concerned about the setting, they turn to the Mexican muralist Diego Rivera, who accepts. They have chosen a title – *Man at the Crossroads Looking with Hope and High Vision to the Choosing of a New and Better Future* – but have no say in how Rivera will interpret it. When he includes the unmistakeable figure of Vladimir Lenin among what the *World Telegram* newspaper calls 'scenes of communist activity', it is too much for his patrons. Nelson Rockefeller writes to him on 4 May, asking him to remove Lenin's likeness in view of the mural's public location. He refuses and is dismissed, although paid in full. Despite widespread protests from New York's artistic community, the unfinished mural is hidden behind drapery as work continues on the building and at the beginning of the following year is unceremoniously hacked off the walls and disposed of in dumpsters outside the entrance.

How then does a republican governor explain the meaning and content of *Guernica*? His thoughts come down to us in a television interview recorded in 1964 at the Governor's Mansion. The journalist narrating the programme pauses in front of the tapestry, calling it a 'major work of Governor Rockefeller's collection' and 'perhaps the key to his taste and his distinction'. Rockefeller responds by calling *Guernica* 'one of the great revolutionary paintings of our times'. While admitting his version is only 'a tapestry made from the painting', he goes on to claim that

'today, I think, tapestries are coming back as a form of artistic expression.' Seeking to further legitimize his reproduction he exaggerates Picasso's involvement, claiming he has supervised its making and 'actually changed the colours, introduced very subtle colours here, which I think enhanced the composition itself, particularly in the tapestry form.' Finally, the journalist brings up the interpretation of *Guernica*'s imagery, asking, 'It's against all war, I suppose?' To which Rockefeller replies, 'it is, and one of the most powerful expressions of opposition to war.'[6] This interpretation is the one now most commonly attributed to the painting, which has moved from being an anti-fascist statement linked to a specific atrocity to a protest against war in general. Despite the fact the tapestry is owned by a prominent figure in the American establishment, *Guernica*'s 'meaning' has apparently migrated from one object to the other unchanged. In reinforcing the tapestry's claim to be a pacifist totem, Rockefeller is storing up trouble ahead.

If Picasso remains a communist bogeyman for the right wing in America, how is he viewed by the 'red' hordes with whom he supposedly associates? Picasso's relationship with the left is an uneasy one: his joining of the Communist Party in 1944 gives rise to what Jean-Paul Sartre memorably describes as 'the nausea of the Communist boa-constrictor', which is 'unable to either keep down or vomit up the enormous Picasso'.[7] The trouble is he will not stay on message, aesthetically or politically. At first much is overlooked in view of the propaganda value of having him in the party fold, but towards the end of the 1940s the message from Moscow hardens. 'When Picasso wanted to portray the suffering of the Spanish people in the war against Italian and German fascism,' writes Soviet critic Vladimir Kemenov in 1947,

> he painted his *Guernica* – but here, too, instead of heroic Spanish Republicans, he showed us the same wretched pathological and deformed types as in his other paintings. No, it is not in order to

expose the contradictions of reality nor to rouse hatred for the
forces of reaction that Picasso creates his morbid, revolting
pictures. His is an aesthetic apologetics for capitalism; he is
convinced of the artistic value of the nightmares called into
being by the disintegration of the social psyche of the capitalist
class.[8]

Under attack from right and left, both for its stylistic quali-
ties and its politics, *Guernica* is also out of step with the prevail-
ing current in North American art. Politics has been rendered
bankrupt, first by the economic collapse of the 1930s and then by
the catastrophe of war. American painting must be liberated
from politics, the champions of Abstract Expressionism insist,
from the tyranny of European art history and from links to spe-
cific events or causes. Above all, it must be freed from rep-
resentation. In Clement Greenberg's view, any historical content
Guernica may have 'doesn't necessarily make it a better or richer
work than an utterly "non-objective" painting by Mondrian.'[9] Pi-
casso's stubborn refusal to give up on figurative elements in his
famous anti-war painting is the result of 'his desire to answer
current history with an art whose evocation of violence and ter-
ror will be unmistakeable'; this urge is in opposition to 'the in-
herent logic of his course as an artist [which] draws him towards
the abstract.'[10] In a withering and well-argued attack in *Art Fo-
rum,* abstract painter and critic Walter Darby Bannard singles
out *Guernica* for its 'many extreme exaggerations, particularly
size and theatricality, because it is so familiar to so many, and
because of all paintings of this century it is specially, and in a
very modern way, meretricious'. His criticism extends to those
who appear in its thrall. 'Go any time to The Museum of Mod-
ern Art to see the reverent group before the painting', he con-
cludes, 'or read its praises in a dozen books. Then go see the
empty floor before another mural-size painting – Monet's *Water
Lilies* – which is as fine and true in feeling as *Guernica* is coarse
and dissembling.'[11]

Despite being under attack from the avant-garde in America, *Guernica's* influence continues to spread beyond the borders of the Western art world. From Latin America and the Middle East to Asia, Picasso's painting is present, suggesting ways of commenting on contemporary events. *Guernica* has special meaning for the Japanese, for whom the aftermath of the nuclear strikes on Hiroshima and Nagasaki is very real: curators at two of the country's leading art galleries, in Kyoto and Tokyo, petition for a decade to secure the release of the painting for a Picasso exhibition marking the fiftieth anniversary of the bombing in 1995. In the end *Guernica* speaks by its absence, represented by a full-size photographic reproduction.

Perhaps the most exquisite irony in the painting's history as a nomadic icon occurs in September 1990, three weeks before the re-unification of Germany. Five national dailies in the Federal Republic carry a two-page advertisement placed by the *Bundeswehr* (Federal Army), featuring a reproduction of *Guernica* under the headline 'Hostile Images are Fathers of War'. Its purpose is to argue for the continued need for vigilance (and therefore state funding of the military) as 'insurance against hazards nobody can predict' after the end of the Cold War. West German liberal opinion is outraged that the very armed forces that bombed Gernika in 1937 have co-opted the painting for their own purposes; Günter Grass writes a scathing attack on the *Bundeswehr* in *Die Zeit*, one the newspapers that had run the advertisement, sparking a national debate.

In India, a generation of modernist painters coming of age in the 1940s, including Francis Newton Souza, Maqbool Fida Husain, Ram Kumar, Krishen Khanna, Paritosh Sen and Tyeb Mehta, are very aware of the European avant-garde in general and of Picasso in particular, his membership of the Communist Party giving him added credibility in a country with strong communist traditions.

Professor Upamanyu Pablo Mukherjee, now a professor at

the University of Warwick, remembers *Guernica* as a constant presence in leftist circles in Kolkata in the 1970s.

> In many of the houses I visited in my childhood there were cheap posters of *Guernica*. I do not remember anyone explaining to me what *Guernica* was about until I had grown a little. But I did not need the story to feel the painting in my very bones. The screaming horse, the skeletal humans with knobbly arms and legs, the weeping mother holding a baby – I had seen them all around me in the streets and for a long time I thought Picasso had grown up in my city and put on canvas all those things we children were not supposed to talk about or notice – suffering, anger, death – even though they were the very stuff our lives were made of. Later, when I read about the Spanish Civil War and Franco and Hitler, I therefore had no trouble thinking of Kolkata as a part of Republican Spain and I have to this day not abandoned that impression.'[12]

Neither, for their part, have Indian artists abandoned using *Guernica* as a starting point for works commenting on the state of their own nation.*

As the 1960s unfold, *Guernica*'s location in the Museum of Modern Art takes on new significance. It now resides in a principal museum in a nation that is itself at war, a war that divides its population almost as bitterly as the civil war divided Spain. Details of the painting are regularly appropriated to appear on anti-war protest banners and placards, and the room in which it is displayed becomes a place of vigil against the Vietnam War.

Does *Guernica*'s presence in New York make Picasso complicit in America's foreign policy? Some appear to think so. In 1967, 400 artists and writers petition him to take *Guernica* out of the country. 'Please let the spirit of your painting be

* For instance, Maqbool Fida Husain's series of *Mahabharata* paintings begun when he was invited, along with Picasso, to exhibit at the 11th Bienal de São Paulo in 1971, and Yusuf Arakkal's *Gujarnica*, created in response to the Hindu–Muslim riots in Gujarat in 2002.

reasserted and its message once again felt, by withdrawing your painting from the United States for the duration of the war,' they write, pointing out that what 'the United States is doing in Vietnam far exceeds Guernica'. Others believe that the painting's long incarceration in a museum, combined with its ubiquity as a reproduction, has robbed it of all power, turning it into just another decorative object for the entertainment of the bourgeoisie.

One artist at least is determined to awaken *Guernica* from its slumbers. Iranian-born Tony Shafrazi is deeply affected by the constant drip-feed of information about the Vietnam War in the American media; by racism, the Watts riots in Los Angeles and corruption in government. On 28 February 1974 – the day after the release on bail of Lieutenant William Calley, the American soldier who committed the massacre of Vietnamese women and children at My Lai in 1968 – Shafrazi enters the Museum of Modern Art and joins the 'reverent group' before *Guernica*, which that day includes a class from a high school in Scarsdale. Instead of standing in silent contemplation he approaches the painting and daubs the words 'Kill Lies All' across it in foot-high red paint.* 'We couldn't move; we were all stunned,' one of the sixteen-year-old school students tells a reporter, recalling that as a museum attendant moves towards Shafrazi he turns round and shouts 'I'm an artist'.[13] The incident won't stop Shafrazi going on to have a long career as a successful gallerist in New York, representing some of the biggest names in contemporary art. His intention, he explains to a reporter from *Interview,* 'was to put that painting on the front page of *The New York Times* and of every other newspaper in the world – and that did happen. So it wasn't a hit-and-run, cowardly prank. The critical factor is to realize that the burning, the rage, the inhumanity, and the hatred that is rampant in American culture was really coming to the

* The paint was water-based and easily removed, doing no permanent damage.

surface. In a climate like that, nobody pays attention to pretty paintings. The role of art was, I felt, very important and being neglected.'[14]

Shafrazi's action will spawn a series of interlinked pieces over the next four decades, each in dialogue with both *Guernica* and reactions to it. German artist Felix Gmelin is fascinated by artworks that have been destroyed or vandalized; by remaking them himself he attempts to interrogate their true histories. His 1996 painting *Kill Lies All After Pablo Picasso (1937) & Tony Shafrazi (1974)* recreates a detail of *Guernica* bearing Shafrazi's heretical text, the words of which are themselves sampled from James Joyce's *Ulysses*. Like his predecessor, Gmelin is questioning the role of the gallery in framing the artwork. 'I wanted to bring the art absolutely up to date, to retrieve it from art history and give it life,' he tells an interviewer. 'By turning Picasso's *Guernica* into a masterpiece the museum helps to make the picture historic, thereby rendering it invisible in the present.'[15] But the chain doesn't end there. In 2010 an artist named Guillaume

RUDOLF BARANIK, *Stop the War in Vietnam Now!*, 1967

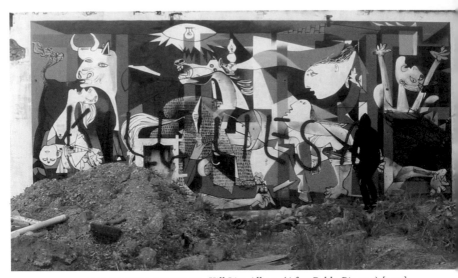

MATTHIEU TREMBLIN, *Kill Lies All 2.0*, (After Pablo Picasso) [1937], Tony Shafrazi [1974], Felix Gmelin [1996], Guillaume Pellay [2010], 2012

Pellay creates a life-size mural version of *Guernica* entitled *Tuerie (Killing)* in the Place Sané in Brest, in northwestern France, a location he describes on his website as a 'hollow tooth and its walls'. In 2012 a figure armed with a red aerosol, his head hidden beneath the black hood of the anonymous street artist, is videoed climbing over the rough ground in front of the mural and spraying Tony Shafrazi's words across it, his swift movements capturing the graphology of the original.[16] Matthieu Tremblin, whose practice focuses on re-painting existing tags and street art, demonstrates he is aware precisely of the nature of his intervention in art history by the title he chooses for this 2012 work: *Kill Lies All 2.0* (After Pablo Picasso) [1937], Tony Shafrazi [1974], Felix Gmelin [1996], Guillaume Pellay [2010]. In this way *Guernica* journeys from the gallery space, where writing on someone else's painting is regarded as sacrilege, to the

street, where adding to or erasing another's artwork is a regular occurrence, albeit subject to its own particular codes and tensions.

America is at war with communism in Indo-China in the 1960s and 1970s, but it is also at war with itself. In 1967 Martin Luther King Jr. is still alive but John F. Kennedy and Malcolm X have both been assassinated and American cities are riven by race riots. A seven-year-old boy named Jean-Michel Basquiat is brought to the museum to stand in front of *Guernica* with his Puerto Rican mother, who will later succumb to a mental breakdown while separating from his domineering Haitian father. The scene is captured in the film *Basquiat,* based on his life and directed by another New York artist, Julian Schnabel. In Schnabel's version of events, Basquiat's mother weeps in front of the painting as a golden halo gradually appears around Basquiat's head, perhaps indicating his future as a world-famous artist, represented by one Tony Shafrazi. The painting has another significant visitor. Since 1963, American painter Faith Ringgold has been working on what she calls the *American People Series*, but she is struggling to get her work exhibited: even the black art scene, she finds to her disappointment, is male-dominated. A visit to an exhibition where she sees large paintings by Larry Poons and Robert Goodnough is a revelation. In her autobiography *We Flew Over the Bridge*, Ringgold remembers that she

> came away with the idea that there was more to a big canvas than its size; that there had to be a good reason for taking up so much space if the painting was to be more than merely expensive wallpaper. I had also recently visited The Museum of Modern Art yet again to see my favourite Picasso – the huge *Guernica*. It is a canvas that one first 'sees' as a whole flat image, and only later does one become aware of its parts. Everything happens up front. Perspective can be the enemy of the mural, creating holes in the composition instead of distance.[17]

Ringgold's best-known work, *American People Series #20: Die,*

now hangs in the museum where she used to contemplate *Guernica*. Like Picasso, she is painting a catastrophe: instead of aerial bombardment, her subject is what Shafrazi calls 'the burning, the rage, the inhumanity, and the hatred' that has erupted onto America's streets during the 1960s. At almost 4 x 2 metres (12 x 6 ft), *Die* is roughly half the size of *Guernica* but is still a very large painting, its impact not so much a matter of scale as of its visceral imagery; a blood-spattered, Tarantinoesque take on interracial conflict played out by well-dressed professionals; the struggle between black and white, it is clear, reaches all the way from the ghetto to the boardroom and beyond.

Not for Ringgold Picasso's Cubist distortion or reliance on archetypal myth; her parable of modern life is depicted in brutally realistic terms, yet the open-mouthed horror of her subjects, caught in a flashbulb moment of extreme violence, is every

bit as desperate. Certain quotations from *Guernica*'s composition are evident: its central triangular section is echoed in the legs of the white female character who has lost a shoe; an outstretched arm reaches in from the right bearing a gun instead of a lamp, and a woman enters from the same direction in a similar crouching posture to that of the woman entering from the right of *Guernica*. But *Guernica*'s relevance to Ringgold is more than a matter of lessons in structure and composition. As she explains to an interviewer in 2016, as a young artist she came to MoMA 'on a weekly basis almost, just to see *Guernica*'. When she is contemplating how to approach the subject of *Die*, Picasso's painting 'immediately came to my mind. And I said, "Oh how wonderful to be able to think of imagery that interprets something you are trying to express, like a riot...".'[18]

FAITH RINGGOLD, *American People Series #20: Die,* 1967

At Some Point
in the Near Future

All the superlatives that one hears at the merest mention of Picasso's *Guernica* suddenly vanish when one describes the actual surface of the painting… In its current condition, it might be wondered if it hasn't all but disappeared, if what we now see isn't the mummification of the work that was once painted to shock the world… hardly more than its cadaver. However, as history has demonstrated, the dead don't necessarily lose their power. Occasionally they continue to grow.

ANDREA GIUNTA
'Picasso's *Guernica* in Latin America'[1]

If some left-leaning artists in New York in the late 1960s see *Guernica*'s location on West 53rd Street as collusion with imperialist warmongering, its coordinates are read very differently on the other side of the Atlantic. The fact that the most famous painting by Spain's most famous artist has never been shown in the country of his birth is a permanent rebuke: Picasso has made it clear he will not send it there until democracy is restored. While Picasso's work is constantly on exhibition in the world's great museums, in Spain its presence is more intermittent, a flickering signal from the outside world, often only present in the press to be decried by right-wing critics. Its beam is strongest in Barcelona, his adopted home city, which has received a large donation of works from Picasso's secretary and old friend Jaime Sabartés.

In the early 1960s, the city has a hugely energetic mayor, Josep María de Porcioles i Colomer, whose determination in pushing through his modernizing agenda in the face of official reluctance is commemorated in the local nickname given to the ovoid water towers above the city – *los cojones de Porcioles*.* He is determined to see Sabartés' collection installed in a museum dedicated to Picasso that will act as a focus for a new cultural quarter, and successfully woos the artist in long-distance telephone calls, playing on his enormous affection for the city and his desire for his work to be seen in his home country. A building is acquired – the Palacio Aguilar in the city's medieval district – and in March 1963 the Donación Sabartés opens its doors.† At the last minute the regime seems to wake up to the implications of giving Barcelona's adoptive son such public recognition; the museum opens under a media blackout, all mention of it disappearing from the press.

* Porcioles remains a controversial figure; hand-picked as mayor of Barcelona by Franco, his achievements were arguably won through collaboration with the regime.

† Known today as the Museu Picasso; a choice of name that would not have been prudent until after the death of Franco.

Despite restrictions on the mention of its name, the painting *Guernica* cannot be buried as easily as the shattered town itself, rebuilt five feet above its original position on the rubble of the past. On 20 January 1967, the streets of Barcelona, the first city in Spain to create a museum dedicated to Picasso, fill with students and intellectuals paying homage to the artist. The image of *Guernica* is everywhere, held aloft, demonstrating that the 'Picasso effect' cannot be contained safely within the wall of the Palacio Aguilar. The painting is a continual irritant, a thorn in the hide of Franco's regime. Every time the painting travels to another country to be exhibited during the 1940s and 1950s, representatives of the Spanish government abroad report receiving protests about the bombing of Gernika and the lack of civil liberties in Spain. The borders of the nation itself are porous; Spanish tourists travelling north to France for holidays bring back posters of *Guernica* to hang in their homes, discrete domestic symbols of resistance. It also infiltrates in other forms; on the fortieth anniversary of the civil war, Czechoslovakia issues a postage stamp commemorating the International Brigades, featuring a reproduction of *Guernica*. Any letters arriving in Spain bearing the stamp remain undelivered.

Increasingly, moderate elements within the regime recog-

Postage stamp, Czechoslovakia, 1967

nize some kind of rapprochement with Picasso is necessary if Spain is to be seen as a modern nation, integrated with the rest of the world. The success of the Picasso museum in Barcelona demonstrates the artist's potential as a magnet for cultural tourism; why should Catalonia be the sole beneficiary? The painting, after all, *belongs* to Spain; wasn't Picasso commissioned and paid to create it by the then Spanish government? On the other hand *Guernica* still presents officials with an apparently intractable philosophical problem; in their version of history the event it depicts never took place. Maintaining such a position is complicated, a battle fought on many fronts, from the constantly adjusted accounts of revisionist historians to the censorship of Spanish editions of biographies of Picasso. But Spain in the early 1970s isn't North Korea in the last decades of the twentieth century – it isn't possible to control what people think and at the same time open your doors to mass tourism. A nation's frontier is easier to defend against tanks than a foreign newspaper casually dropped in an airport or a paperback left in a hotel room. A growing number within the regime think *Guernica* would be most effectively neutralized by being brought to Spain; before it is, another radical reinterpretation of its meaning and message will be called for.

An early attempt is made in, of all places, the right-wing newspaper *El Alcázar*, better known as a mouthpiece for the Falange than as a purveyor of modernist art criticism. '*Guernica* (given by Picasso to the Spanish people) is part of the cultural patrimony of this people,' an editorial, accompanied by an illustration, argues in 1969, 'and should be put on exhibition in Spain as proof of the definitive end of the contrasts and differences aroused by the last civil conflict.' On the surface this is a strange proposition: the exhibition in Spain of a painting that accuses its rulers of mass murder will be 'proof' that all divisions resulting from the war are ended; an artwork inspired by an historical event will help in its forgetting. What is clear is

that Franco, Spain, Picasso and his most famous painting are engaged in a dance, a matter of advances and retreats, invitations and rejections, as perilous as any at the *corrida*. Like a bullfight, it can only end in the death of one or more participants. The elderly artist is deeply affected by *moriña* (homesickness); the circus of Spanish friends and acquaintances that assembles at his studio in southern France for his entertainment is unable to satisfy his longing, and he repeatedly asks his driver to take him to a place on the border from where he can see across into Spain. Franco, too, is old, an increasingly frail and remote figure, affected by Parkinson's disease; rival factions of progressives and conservatives within the regime jostle for position as the question of succession becomes more pressing. In October 1969, Spain's Director General of Fine Arts, Florentino Pérez Embid, who is engaged in plans for the development of a new national museum of modern art in Madrid, startles those attending a press luncheon in Paris by announcing that 'General Franco deems Madrid the right place for *Guernica*, Picasso's masterpiece.' Rumours and hints continue to emerge from the Spanish side: of a place for *Guernica* in the Prado, of recognition and honours. Picasso is not easily bought: he has already turned down a *Légion d'honneur* in France, insisting such a decoration should only come from his own country, by which he does not mean the Francoist state.

Clarification comes in a letter from Picasso to the Museum of Modern Art, drawn up by his French lawyer Roland Dumas on 15 November 1970. In it he reminds them that it has always been his wish to see 'this work and its accompanying pieces return to the Spanish people', and stating that it will be the 'duty' of the museum to release them 'to the qualified representatives of the Spanish government *when public liberties are re-established in Spain.'* As to whether or not these liberties are satisfactorily established, the counsel must be sought of Maître Roland Dumas... and the museum must comply with the advice he

gives.' A codicil is later added, explaining that *Guernica* and its accompanying studies have been 'entrusted' to the Museum of Modern Art in New York and are 'intended for the Government of the Spanish Republic'. In a few words and with a flourish of his *muleta*, the ageing matador ties the museum, the Spanish negotiators for the 'return' of *Guernica* and his family and heirs in a complicated knot it will take years to unravel. Picasso's ninetieth birthday on 25 October 1971 is celebrated throughout France, where museums that own Picassos open their doors free for a week to allow the public to appreciate them. In London, ninety racing pigeons are released on the steps of the Tate Gallery. There are no such ceremonies in Spain. In Madrid at least the occasion is marked, when a full set of the *Vollard Suite* etchings is put on display in the private Galério Theo; on 5 November eight masked men from the ultra-right group *Guerrilleros de Cristo Rey* (Warriors of Christ the King) enter the gallery, smashing display cases and destroying some etchings. If the negotiations over *Guernica*'s eventual resting place are a bullfight, these men represent the 'brutality and darkness' the artist alluded to in his conversation with Jerome Seckler at his studio after the liberation of Paris (see page 87).

Picasso is first to leave the ring, on 8 April 1973, at the age of ninety-one; he is followed shortly afterwards in November 1975 by his archenemy Francisco Franco Bahamonde, when the dictator dies at the age of eighty-two. In an extraordinary historical twist, Nelson Rockefeller, owner of the *Guernica* tapestry, attends Franco's state funeral in his role as vice president of the United States; one can only imagine the thoughts passing through his mind during the ceremony.

Why should *Guernica,* among his thousands of other artworks, matter so much to Picasso that he words his instructions for its return so uncompromisingly? Partly perhaps because its fate mirrors his own. Picasso had applied for French citizenship at the beginning of the Second World War and been rejected on

account of his political views. He in turn rejected the offer of French citizenship in 1944, while also refusing to apply for a Spanish passport, condemning himself to a lifetime of complications when travelling outside France. The painting, too, is just a guest in New York, its residence a temporary arrangement, as its creator has made clear. As his own dream of returning to Spain recedes, aware his death grows closer, Picasso may imagine the painting making the journey he cannot in his place: if it does, he is determined it will be on his own terms.

The death of Franco begins the period of transition towards democracy, one of the first signs of which is an explosion of appreciation for the visual arts, literature and film as restrictions on what can be seen and read lessen. Regard for Picasso grows as the public familiarize themselves with his work in Barcelona and elsewhere, and with gallery-going in general. An explicit link is made between *Guernica* and the state of the nation in the United States Senate's resolution of October 1978, which praises Spain for its progress towards democracy. An additional section suggests that 'the masterpiece *Guernica*', which, despite its universal appeal, 'has special significance for the people of Spain by its representation of the tragic civil war which destroyed democracy in Spain', should 'at some point in the near future and through appropriate legal procedures... be transferred to the people and government of a democratic Spain.'[2] Spanish politicians become regular additions to the pilgrims gathered before *Guernica* in New York. Not everybody in Spain is overjoyed, however, that Picasso – even from beyond the grave, via the medium of his Parisian lawyer and his heirs, who are themselves divided – has the ultimate say in deciding when Spain's democracy is sufficiently complete to allow *la vuelta a España* ('the return' of the painting to Spain), as it is misleadingly known. The painting, of course, had no more been in Spain than Picasso had ever set foot in Gernika.

One fast-approaching landmark adds urgency to the ex-

tended negotiations between national government, artist's family, New York museum and Parisian lawyer; 1981 will be the centenary of Picasso's birth. Increasingly, voices in the Spanish press express astonishment that no firm plans appear to be in place to honour the anniversary, while countries around the world are lining up to do so: Spain's inability to come to terms with its most famous modern artist promises nothing short of national humiliation for the nascent democracy. To hasten discussions along, Javier Tusell, Director General of Artistic Heritage at the Ministry of Culture, together with diplomat Rafael Fernández-Quintanilla, is engaged in a seemingly endless quest to track down paperwork that will give substance to the claim that the Second Spanish Republic had purchased *Guernica*. The smoking gun is found in the archives of the Spanish Republican ambassador to France, Luis Araquistáin, removed for safety to Switzerland at the end of the civil war. The files contain a letter, dated 28 May 1937, in which Max Aub, the cultural attaché of the Republican Embassy in Paris, records payment by the Republic of 150,000 francs to Picasso, ostensibly for running costs while working on *Guernica*, but effectively a purchase of the painting. A ledger of the Spanish Embassy in Paris, countersigned by Aub and Araquistáin, records the same amount as *gastos* (expenses) *Guernica*; below Araquistáin's signature he has written *a la cuenta propaganda* ('to the propaganda account'). Another letter from Araquistáin to Picasso acknowledges the artist's wish to donate *Guernica* to the Republic. At least one historian has suggested this correspondence was conveniently 'forgotten' by exiled Republicans, who recognized it might give credence to Franco's claims on the painting.[3]

There is another complicating factor. The civil war has been buried twice: first in an enforced silence imposed from above and then by the *Pacto del olvido* (Pact of Forgetting), the voluntary, collective amnesia intended to ease the post-Franco transition. Now the country is convulsed by another internal conflict,

between the state and ETA (*Euskadi Ta Askatasuna*), the military wing of the Basque National Liberation Movement; expressed on one side by military repression and imprisonment and on the other by terrorist attacks in the form of bombings and assassinations, the conflict claims hundreds of lives in the five years following Franco's death. The tragedy of Gernika is a Basque tragedy, one chapter in a continuing litany of persecution and denial of self-determination: surely if the painting is to return it should be to Euskadi, not Madrid? For Madrid to 'steal' *Guernica* while not admitting culpability for the atrocity that inspired it is seen by many as yet another insult. On 26 April 1977, the fortieth anniversary of the bombing, a full-size replica of the painting is unfurled in the street in Gernika, where the town council proposes erecting a custom-built museum to house the painting, in front of a chanting crowd. Yet the Basques are not alone in believing they have a unique claim to *Guernica*. Others feel equally strong connections with Picasso, particularly Barcelona, which already has a Picasso museum, and Málaga, the city of his birth. Then there is the widely reported, though anecdotal, wish of Picasso himself that his painting be shown in the Prado in Madrid, alongside his favourite artists from the past. In Spain, the most appropriate home for *Guernica* becomes a subject for television debates and magazine polls, as work begins in secret on the place already assigned for its reception.

The news that *Guernica* is on the move creates ripples around the world. In London in 1980, the young director of the Whitechapel Gallery, Nicholas Serota, is gripped by the idea that its journey will present an opportunity for the painting to come to the East End a second time. He petitions Roland Penrose, by letter and by telephone, in the hope his connections with the Picasso family will help in securing a visit from what is now Picasso's most famous painting. When I speak with him at the end of 2016, shortly before he steps down as director of the

Tate, I ask him to explain what the significance of *Guernica* was to him personally and why it seemed so important at that moment that it should come to the Whitechapel once more. '*Guernica* meant an enormous amount to me as a painting commemorating an atrocity in the Spanish Civil War', he tells me.

For someone in their teens, both the romance and also the futility of the Spanish Civil War had a huge impact. Unlike Germany, a country awakening after the war, Spain in the 1960s still felt like a really closed country to someone living in London. I remember my parents feeling they wouldn't go to Spain while Franco was alive, but they did go to Germany in spite of the fact they were Jewish and had feelings about Germany... Of course *Guernica* had hung on the back wall of the Whitechapel in 1939... It hadn't been there for long but it had been a very critical moment and the idea of in some way recovering that experience in 1980 or 1981 was at least worth a try! It was probably a vain and naive hope, but I was callow enough to believe not everyone would think it was an absurd idea... There was a feeling that once *Guernica* went to Spain it would never travel again. It's difficult now to remember the degree, five years after Franco had died, to which Spain was still a country that was ruled by a military sensibility. Their only objective really was to get the painting to Spain.

How, I wondered, was *Guernica* perceived by the generation of artists then working in London?

Towards the end of the 1970s, about the time Margaret Thatcher was elected, was one of those moments when either artists who dealt with political issues came to the fore, or artists who had not really thought about their position in society suddenly began to do so. So Picasso, with the statement he made with *Guernica*, felt like the quintessential example of an artist who had been able to use his art without compromise to make a very strong political statement. The idea of bringing this exemplar to London seemed very important. At the same time a new generation of younger artists, painters principally, whose immediate predecessors had perhaps thought Picasso had got

stuck somewhere back in the 1930s or 1940s and hadn't made much interesting work in the post-war period, suddenly recognized that his late work was extremely interesting and free and bold. It was like a slow-breaking wave really. In 1978, '79 and '80, going into artist's studios I became aware that Picasso was once again a figure that artists wanted to talk about.[4]

One of the artists active in London at the time Serota is describing operated in ways largely independent of the established art world. Peter Kennard has made some of the most memorable politically motivated art of the past four decades, ranging from photomontage, drawings and paintings to digital imagery spread via the internet. 'Seeing reproductions of *Guernica* in books when I was an art student helped instil in me the need to explore ways of making art that could communicate directly on political events,' he recalls.

> I learnt that one simple image placed in conjunction with another creates a third meaning that rips apart our seamless corporate image-bank. *Guernica* is like a giant painted snapshot of human imbecility and cruelty seen in a mirror that Picasso smashed in fury. Then he rendered the fragments in black, white and grey paint. It is highly composed, but feels as if all its elements could collapse at any minute and then be reconstructed, as if the bloody dictatorship of Franco had been defeated. This is what makes it revolutionary, both in its form and its content.[5]

As it turns out, those organizing *Guernica*'s journey to Spain do not detain themselves long with the possibility of altering its itinerary to allow a detour to the Whitechapel Gallery in London. On 1 April 1981, representatives of the Spanish government make a formal request for *Guernica* and Picasso's lawyer, Maître Dumas, agrees that the Museum of Modern Art can release the painting in August.[6] Its destination will not be the Prado itself, despite the reported wish of its creator, but instead a temperature-controlled sanctum at the Casón del Buen Retiro,

formerly a museum of nineteenth-century Spanish art. On 9 September, *Guernica* is lowered from the wall at the Museum of Modern Art by staff – some of whom are reported to be weeping – rolled, crated up and 'in deep secrecy and with no opportunity for farewells', as *The New York Times* will put it the following day, driven under police escort through heavy traffic to the airport. As news breaks of its leave-taking, art historian Mary Ann Caws recalls that 'many New Yorkers, including this author, wore black armbands to lament its departure, even as we saluted the reason for its going'.[7] The painting is accompanied on its journey by Iñigo Cavero, the Spanish minister for culture, and Javier Tusell, one of the chief architects of its repatriation. The following day Iberia Airlines put an advertisement in the Spanish daily newspaper *ABC*, the text of which conveys in shorthand much of the dialogue following the plane's arrival. 'New York–Spain. Without a return ticket. Only one Way. To stay here. Because Guernica has made its last flight. It has flown for the last time as a symbol of peace between men. And as a symbol it will stay. Because it doesn't have a return ticket.'

'Symbol of Peace' it may be, but *Guernica* is still considered threatening enough to be exhibited at the Casón del Buen Retiro behind a steel frame fitted with bomb- and bullet-proof glass, protected by armed members of the *Guardia Civil*. Whether this is to prevent attacks on the painting or contagion from the unanswered accusations it contains is not clear. The cast that assembles at the inauguration ceremony on 23 October connects *Guernica*'s present with its past. Josep Renau is there, visiting from his home in exile in East Germany, as is Josep Lluís Sert, the architect of the Spanish Pavilion: the contrast between the open, light-filled setting he created for *Guernica* and the isolation ward set up within the heavy, ornate decoration of the Casón del Buen Retiro could not be more marked. From something 'completely modern', as Dora Maar had described it to Frances Morris, the painting to some observers takes on the

aura of an ancient, venerated and fragile object in a museum of antiquities, or even a hospital. 'Here [*Guernica*] is now,' Sert remarks, 'in the Neolithic Casón, just like a primitive cave painting trapped in intensive care.'[8]

The political dignitaries who are present seem especially anxious to prevent infection. The attempted coup earlier in the year – when soldiers from the same *Guardia Civil* that now protects *Guernica* stormed the parliament building and held parliament and the cabinet hostage – proves just how fragile democracy in Spain remains. In New York *Guernica* had been successfully repositioned as a generalized symbol of peace; bringing it to Madrid risks reigniting its latent powers in ways Tony Shafrazi could only dream of. As Rafael Alberti tells *El País* in advance of the painting's arrival, '*Guernica* has millions of enemies in Spain', and an assault by rightist paramilitaries is far from impossible.[9] In his speech at the inauguration ceremony, Iñigo Cavero lays out the ways in which the work should now be viewed. '*Guernica* is a battle cry against violence, against atrocities, against the horrors of war,' he tells his audience, 'against the denial of civil rights involved in armed conflict. Let nobody interpret this work as a banner for either side. We shall see *Guernica* as a pure and simple rejection of brute force. From now on *Guernica* will be the heritage of all the Spanish community.' The awkward matter of its name remains, perplexing President Leopoldo Calvo-Sotelo, whose election had been so rudely interrupted on 23 February. In a demonstration that politicians are perhaps not always as expert in matters of art as of state, he suggests changing its name from *Guernica* to *Los horrores de la guerra*.

The official position on *Guernica* is captured, as it has been before and will be again, in the catalogue to the exhibition, its essays tiptoeing around Franco's culpability for the destruction of the Basque town. The indirect approach it will take to history – nationalistic pride in the painting's return combined with

caution at naming the barbarism that inspired it – is encapsulated by a quote from Joan Miró. 'I remember when I was in Gernika years ago, in the shade of the Gernika tree,' the great artist recalls. 'And I feel great emotion now that *Guernica*, the great work of Picasso, is received in Spain with all honors. I also remember the days when I visited Pablo in his workshop on the Rue des Grands Augustins and the passion that he, the man, put into painting it. And I see with pride that our young democracy is entering a stage of fruitful creation.' Josep Renau writes of his involvement with the Spanish Pavilion and gives an account of his last meeting with Picasso, at which he tells the artist he hopes one day to see *Guernica* hang in the Prado along with Velázquez's *Las Meninas* and Goya's *The Third of May*. He also reveals how Picasso supported him financially on his release after years of internment in the camp at Argelès-sur-Mer, and how he came to the aid of many other Republican refugees in a similar fashion. In this way, he argues, Picasso has already repaid the 150,000 francs he received from the Republican government for the *Guernica* commission – by implication making clear the painting's presence in the Casón is entirely voluntary, its glass and steel containment in no way a debtor's prison.

Although Renau openly refers to the Spanish Republic and describes the painting as a premonition of the Second World War, he baulks at engaging with *Guernica*'s anti-fascist message. Veteran art historian Herschel B. Chipp is similarly circumspect. For the most part he concentrates on decoding the content of the painting, analyzing its evolution through the preparatory sketches and declaring, regarding the bombing of Gernika, that Picasso 'never intended to represent the event'. Instead, he argues in conclusion, the return to Spain of this 'powerful and personal picture' is 'in multiple levels of meaning, both human and artistic', symbolic of the return that Picasso could not make in person.[10]

Any message embedded in *Guernica* could therefore be

summarized, according to these diplomatic messengers, as: *No to War!* And: *Picasso is back in town.* Yet Iñigo Cavero's desire to detach the painting from any connection with those who commissioned it, so it belongs equally to both sides in a still-divided Spain, is undermined by a final *nota editorial* in the catalogue. It concludes with thanks and acknowledgements 'especially [to] those who rendered their services to the second Spanish Republic, who have intervened in this historic work'. *Guernica* remains an irresolutely awkward object. Despite the best efforts of politicians, its history cannot be so easily erased.

Beauty
and the Beast

I detest the miracle of the
multiplication of the
loaves and fishes of
Guernica.

ANTONIO SAURA
Contra ol Guernica, 1982

Even in the most unprepossessing museum settings, entangled in contradictory interpretations, artworks still work on their viewers. Picasso discovered this, we remember, as a young man unable to tear himself away from the 'magical' African masks in the Trocadéro, later explaining that, in their presence, 'something was happening to me, wasn't it?' Now *Guernica* too is making something happen among those gathered to welcome 'the last exile to return'. Another venerable icon is present at the inauguration, in the shape of Dolores Ibárruri, better known as 'La Pasionaria'; a secular saint whose image Republican women wear around their necks in place of the Virgin Mary. Ibárruri's fiery rhetoric and gift for coining slogans played a vital part in the Republican war effort. After the bitter disappointment of defeat she has lived in exile in Soviet Russia, only gaining permission to return to Spain two years after Franco's death. Together with Sert, Renau, Calvo-Sotelo and others of the select gathering, she is invited by Javier Tusell to step beyond *Guernica*'s protective screen, where she evidently feels the painting's force field to full effect. After listening to Iñigo Cavero's speech, she says, simply, 'the Civil War has ended,' a sentiment echoed on the front page of *El País* the next day. Within a year of its arrival at the Casón del Buen Retiro, one million visitors will come to stand in *Guernica*'s presence; at least some of them appear to be seeking a similar resolution.

The lacuna *Guernica* leaves in New York's leading modern art gallery is slightly mitigated by the arrival of its tapestry reproduction at an equally significant location in the city. The tapestry's owner, Nelson Rockefeller, leaves the stage in 1979, four years after attending Franco's funeral. In 1985 his widow, Happy Rockefeller, loans the tapestry to the United Nations building in New York, on the understanding it will hang outside the Security Council chamber as a permanent disincentive to war, returning Picasso's image, which Spanish cultural institutions are working so hard to depoliticize, to the centre of global

politics. The loan permanently connects the twin strands that have run through Rockefeller's life – art and power – as well as marking the Rockefeller family's investment in the building and the United Nations project. Nelson was instrumental in choosing a site for the building and his father in purchasing the land for it and donating it to the city, the utopian aspiration of the gesture echoed in the modernist architecture of New York's first glass curtain wall skyscraper. The decision of the United States to use the UN for a purpose that is far from peaceful will soon make the tapestry's presence there as awkward as that of its owner at Franco's funeral.

Antonio Saura is one of the most significant Spanish artists of his generation, unusual for being equally gifted in the plastic arts and the written word; his writings often combine acute insight with scatological humour. Picasso is important to him, especially the monstrous nudes of the late 1920s, which Saura references in works of his own in the 1950s. As a child he has lived through the civil war in Madrid and elsewhere, and his own works have been subjected to attack from extreme right-wing activists during Franco's rule. He chooses to respond to the shock of *Guernica's* accommodation in a country that has not yet come to terms with its past in a polemical pamphlet entitled *Contra el Guernica* (Against Guernica), which he publishes in 1982, aiming to puncture the air of national self-congratulation surrounding the painting's 'return' with his well-aimed jibes. The pamphlet causes outrage, the public failing to note the considered nature of its critique; nevertheless it is reprinted in 1992 when *Guernica* moves again, to the Museo Nacional Centro de Arte Reina Sofía, along with Saura's further writings on the painting. Its text is formed from a brilliant sequence of 280 aphoristic statements, each explaining why Saura hates, detests or despises the 'black and white scarecrow *Guernica*', as well as the cast of imbeciles, cretins, pedants, imposters, journalists, politicians, museum conservators, art critics, professors, writers and

censors he identifies in its orbit and the various systems that would appropriate the name or work of an artist for their own ends. 'I hate *Guernica*,' he writes:

> It is a giant poster and, like all vulgar posters, one can copy and multiply it infinitely... I hate *Guernica*: for years it has been the only painting in the home of numerous Spanish intellectuals... I hate *Guernica*: whereas it could have remained in penitence in a Basque village it has preferred to reside in Madrid in a vast hotel with air-conditioning... I hate the glass prison that turns *Guernica* into a piranha tank rather than a ghostly phantom.[1]

In a subsequent text, published in 1992, his sights are turned on the painting's creator. 'I detest Pablo Picasso who, instead of offering *Guernica* to the town from which he has usurped the name, has bequeathed his mishandled and decrepit work to the Reina Sofía hospital after a stay at the Prado central clinic.'[2] In 1997, a year before his own death, his critique is more measured and can be read as a response to the way the painting will be exhibited at the Reina Sofía in the twenty-first century, firmly contextualized in terms of a specific historical moment, adjacent to a room containing a scale-model of the Spanish Pavilion of 1937. 'To reclaim this work for political or propaganda purposes is immoral in my eyes,' he writes. 'Accepting its autonomy would set a precedent with considerable consequences, above all being a true attack on culture.'[3]

A year later, on the other side of the Atlantic, Kofi Annan is using the presence of the tapestry version of *Guernica* at the United Nations building to make a very different argument. Addressing the International Council of New York's Museum of Modern Art, the UN Secretary-General reminds them that

> the world has changed a great deal since Picasso painted that first political masterpiece, but it has not necessarily grown easier. We are near the end of a tumultuous century that has

witnessed both the best and worst of human endeavour. Peace spreads in one region as genocidal fury rages in another. Unprecedented wealth coexists with terrible deprivation, as a quarter of the world's people remain mired in poverty.[4]

War and injustice, in other words, have not ended: both the UN and the tapestry, placed here to remind delegates that their primary aim is to increase understanding and prevent conflict, have failed in their mission.

Just how far is only revealed on 5 February 2003, when Colin Powell, the American secretary of state, takes up his position outside the Security Council Meeting Room to brief the assembled press corps on the imminent American assault on Iraq. Within the chamber, Powell has worked his way through a theatrical presentation, the climax of which comes when he produces, from among his papers on the tabletop, a small glass vial. He holds the object carefully between thumb and forefinger while telling his audience, 'less than a teaspoon of dry anthrax, a little bit, about this amount – this is just about the amount of a teaspoon – less than a teaspoon of dry anthrax in an envelope shut down the US Senate in the fall of 2001,' and goes on to suggest that Saddam's regime may have produced thousands of litres of the material. The vial, of course, holds no such thing: it is more likely to contain sand, which is what, mainly, those in search of weapons of mass destruction will discover. With his conjuring trick, Powell converts the distant threat of weapons in the Middle East into visceral fear inside the United Nations building, conflating secular Ba'athism with Islamist terrorism by sleight of hand.

The answer proposed to this challenge is the same that Wolfram von Richthofen and General Mola applied to the obdurate Basques: for *blitzkrieg,* read Shock and Awe. Before operations can begin, a last obstruction must be surmounted. How can he announce the bombing of the city of Baghdad to television crews in front of an image of a woman cradling a dead baby, while another falls from a burning building? When Powell takes his place

before 200 reporters it is in front of a blue cloth bearing the symbol of the UN which completely occludes the tapestry, the second time a work owned by the Rockefeller family has been covered up to protect public sensibilities. The effect of this decision is the opposite of what the administration desires. Shrouding *Guernica* seems merely to add to its power, its absence providing a more telling comment on the announcement than its over-familiar image ever could.

Faced with a barrage of media comment and protestors holding up images of *Guernica* in the streets, spokesmen for the administration immediately claim the cover-up is at the request of broadcasters, worried 'the wild lines and screaming figures on the tapestry' would make a confusing background and that in close-ups 'a horse's hindquarters would appear above the head of the speaker' – risking making the secretary of state look like a horse's ass, perhaps?[5] New York's *Newsday* tells a different story, claiming, 'diplomats at the United Nations, speaking on condition they not be named, have been quoted in recent days telling journalists that they believe the United States leaned on UN officials to cover the tapestry, rather than have it in the background while Powell or other US diplomats argued for war on Iraq.'[6] It falls to the conservative *Weekly Standard* to decry this suggestion as 'fake news', a left-wing conspiracy it links to the work of art itself. 'So suspicion trumps knowledge in the name of political art', Claudia Winkler writes in an article titled 'The *Guernica* Myth', 'and falsehood morphs into history. It happens every day, such playing fast and loose with truth, since so many would rather indulge their passions than go to all the bother of reckoning with the outside world.'[7]

Within weeks an artists' collective in Los Angeles has created a replica of *Guernica* on a billboard at the junction of Sunset and Hollywood boulevards, lit at night by black light that reveals parting curtains and the UN logo rendered in ultraviolet paint. The debacle even allows a *New York Times* reporter to

utilize the language of modern art to critique the administration's arguments for war, claiming it has 'shifted in a dizzying Cubist cascade over the last months'.[8] Such tactics are not enough to halt the slide into a conflict resulting in hundreds of thousands of deaths, the consequences of which are still playing out as I write these words.

The role played by Picasso's image in international politics in 2003 will lead to the creation six years later of an artwork that ties up some of the historical threads we have followed through the course of *Guernica*'s journey. In 2008, the Whitechapel Gallery in London closes for extensive renovations, including an expansion into the Whitechapel Public Library next door. The gallery invites Polish-born, London-based artist Goshka Macuga to make the first Bloomberg Commission in a space that had formerly been the reading room of the library. The task is one for which she is uniquely qualified; her practice combines art making with archival research and curatorial interventions in art spaces, often deploying the work of other artists in ways a conventional curator would not envisage.

Immersing herself in the rich history of the Whitechapel Gallery contained within its archives, Macuga discovers the story of *Guernica*'s brief visit to the gallery in 1939 – something she has previously been unaware of – and also correspondence relating to Nicholas Serota's failed attempt to gain permission for the painting's return in 1981. She is also fascinated by the history of the library, which has earned itself the nickname the University of the Ghetto for the number of East End Jewish writers and intellectuals nurtured within its walls. 'I thought it was a great shame that the library would be lost', she tells me when I visit her studio in Walthamstow. 'The library that served local communities, and all the amazing people who used it. My concern was if anyone who had used the library were to walk in off the street to an exhibition in the old Reading Room, they would have no active interaction with the work.'[9]

The other element she brings to her installation is the memory of *Guernica*'s ghostly presence, hidden behind a blue cloth at Colin Powell's press conference. If the voice of reason can be silenced in this way – and the library reading room turned from a place of active engagement and community to a sterile space for the display of contemporary art – both these negations can also be reversed. Picasso's tapestry will be reactivated by bringing it back to the community that encountered the original painting in 1939, and the reading room made once more into a place where people meet and talk about ideas. Macuga's vision is essentially for the creation of a mini-UN in the heart of London's East End for the twelve-month duration of the installation; all that is necessary to complete it is the presence of *Guernica* itself. Macuga hesitates for two weeks before daring to suggest the idea to the gallery's director, Iwona Blazwick, who takes up the story.

'Goshka was fascinated by this early moment of activism, when one of the greatest history paintings of the twentieth century arrived in the East End,' Blazwick tells an audience at the Whitechapel Gallery.[10]

> When we invited her to inaugurate the newly expanded Whitechapel Gallery in 2009, she said to me, 'Iwona, I would like you to bring for me *Guernica*…' So I said, 'I will get right on that!' [Laughter]. There was an amazing happenstance, that a friend had just got a job in New York working for the Rockefeller Foundation. I got in touch with her and said, 'We're trying to get hold of this tapestry,' and she said, 'as it happens tonight there's a cocktail party, I'll be there and so will the curator of the Rockefeller Collection.' She makes the contact, calls me the next day and says, 'OK, come over'; so I get on a plane and I meet the curator for the collection. She says, 'Do you want to get into the UN?' She gets me a pass, we go in and there it is, this astonishing tapestry. As we walked up to it the head of maintenance for the whole of the UN building happened to be passing; I was introduced and I said to him, 'We want to borrow this tapestry

and we want to borrow it for a year,' and he said, 'Well, as it happens we are about to close the whole building for two years, so it's yours!' This was so exciting, this was like the highpoint of my curatorial career!

In Macuga's installation, entitled *The Nature of the Beast,* a deliberately ugly blue curtain is placed behind the *Guernica* tapestry, alluding to its covering during Powell's press conference. In front of it stands a glass-topped oval table, echoing both the horseshoe-shaped table at the United Nations and Alexander Calder's *Mercury Fountain,* the sculpture positioned in front of *Guernica* when it was exhibited in the Spanish Pavilion, further eliding the separation between painting and tapestry. To one side, on a pedestal, stands a Cubist-styled bronze bust of Colin Powell, brandishing his mysterious vial. A film programme runs, as it did in 1939, bringing images from the Spanish Civil War, Fallujah, Hebron and Vietnam into the gallery. Beneath the glass of the tabletop, elements from the gallery's archive relating to *Guernica*'s original exhibition in Whitechapel are on display, and this mini-exhibition is updated with new material as it is gathered. The table can be booked as a meeting place by anyone, free of charge, on the condition that the public are able to observe and that minutes of proceedings are passed to the archive, thus making up for the lack of documentation of the original exhibition resulting from its unofficial nature. Over the course of the exhibition, art students, artists, community groups, historians, educationalists, filmmakers, pacifists, anarchists, Marxists, archivists, curators, conservators, former members of the International Brigades and others utilize the space, ensuring it is constantly full of life.

'What was very striking', Macuga remembers,

overleaf
GOSHKA MACUGA, *The Nature of the Beast,*
tapestry, 2009

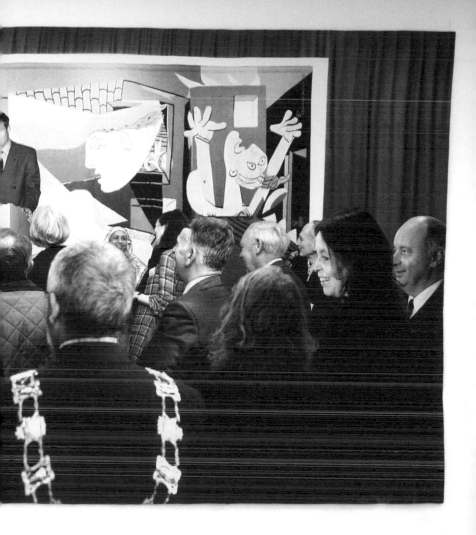

was this complete and utter respect for the image, for what the image represents. When you go to Madrid to see the original *Guernica* there are great restrictions as to what you can do in front of the image. So the work's greatness has now created a scenario where you cannot act on your feelings on seeing it, you have to be completely still and passive. The space I created allowed people much more freedom: so you would see old people coming and sitting and just being in the aura of this image and it was completely humbling to see what the work opened up to people, how they really enjoyed being there and meditating on its whole history. So I felt it was very successful in what it generated: it talked to completely different generations of people who weren't necessarily from the art world, people that were concerned with history, that were beyond art; it's very hard sometimes to reach out to people like this – I think this is the only work that has allowed me to go to that place.

Although the *Guernica* tapestry at the Whitechapel Gallery in 2009 is not bearing witness to the outbreak of a war, its presence still speaks to uncomfortable issues that have always muddied the art world – concerning sources of funding, the independence of the artist and the possibility of making an independent political statement through a medium so closely allied with capitalist market forces. Macuga feels these conflicts deeply and they serve as inspiration for her new tapestry, also called *The Nature of the Beast,* a machine-woven jacquard created at a tapestry workshop in Belgium, which replaces *Guernica* when it returns to America while her own artwork continues to tour to other venues.

The reopening of the Whitechapel Gallery is a major event in London's cultural calendar, marked by a series of events to which prominent figures are invited, including a representative of Britain's least democratic institution. Prince William arrives by helicopter on the roof of the nearby Whitechapel Hospital and then drives to the venue, the first member of his family to

visit the gallery for a quarter of a century. 'He started his speech by making a joke,' Macuga remembers – 'this was all he knew about contemporary art – saying "my name is Banksy". I think it was a disgrace he was even invited. In the current situation, where there is not enough public funding, institutions need people who are prepared to support them and these supporters don't necessarily come from the best context; some of them are criminals or oligarchs... As an artist one should be able to speak one's mind about who one wants to be affiliated with.'

Macuga's tapestry is based on a photomontage of press images from the opening of the exhibition. Prince William, speaking in front of *Guernica,* replaces Clement Attlee from the famous photographs taken at the Whitechapel opening in 1939. The figure of Iwona Blazwick is clearly visible at the centre of the composition, among a sea of suits, as representatives of business, politics and the local community congregate, apparently unaffected by the tortured images on the wall before them. To the left of the composition, one figure, the artist herself, has turned away from the proceedings, her haunted face a sign she is ready to flee. By including herself, Macuga acknowledges the contradictions inherent in her own position as an artist working within a system with multiple connections to power, the art market and institutional ambition. Once again, *Guernica* is engaged in saying the unsayable.

Picasso's painting continues to be cited in the first decade of the twenty-first century as a referent for very different calamities, as if only a work of its stature will be able to encapsulate each new horror. 'Is there a *Guernica* for 9/11?' asks photographer Joel Meyerowitz, embarking on the nine-month task of documenting activities at Ground Zero in his book *Aftermath: World Trade Center Archive.* 'Where is the *Guernica* of climate change?', asks the *Guardian* blog in 2008. In 2003, the Cuban artist José Fuster is interviewed in Havana, where a large billboard reproduction of *Guernica* with the caption, 'here will

stand a monument to anti-fascist Spanish culture', dominates a main highway in the city. Fuster, for whom Picasso is a key influence, tells his interviewer, 'the current US blockade of Cuba is the *Guernica* of Cuba.'[11] As if to comment on attempts to stifle the painting's continuing ability to act as a political provocation, Robert Longo creates *Guernica Redacted (After Picasso's Guernica, 1937)* (2014–15), a meticulous charcoal facsimile in which parts of Picasso's image are blocked out with vertical black stripes, reminiscent of those that censor official documents when they are produced for public enquiry.

Guernica also functions in different settings as a focus for

Photograph of Havana by DAVID CRAVEN, November 2003

collective art making. Women in Hamburg, a coastal town in the Eastern Cape region of South Africa greatly affected by AIDS, collaborate on making a tapestry based on the painting, *The Keiskamma Guernica* (2010). While incorporating Picasso's imagery, the tapestry also introduces specifically African elements to comment on the catastrophe visited on the local community by the AIDS and HIV epidemic. A similar motivation lies behind the work of the group of activists and artists known collectively as Remaking Picasso's Guernica, originally from Brighton, who have created versions of *Guernica* as banners that can then be used both in exhibitions and on protests 'to deploy the power of art against fascism, militarisation and war'. For this collective it is the act of making itself that brings about empowerment. 'As we cut, pinned and tacked, we discussed the historical correspondences between the mid 1930s, when Picasso created *Guernica*, and today', they write on their blog. 'We recognized similarities between aerial bombardment in the Second World War and the present use of drones; between old and new fascisms; between anti-semitism and Islamophobia.'[12]

In this way artists continue to translate *Guernica* from one medium to another, acting as self-appointed custodians of what they interpret to be its legacy. Examples of such works proliferate across the globe, making a representative selection almost impossible: instead I have chosen one. It falls to Mexican artist Denise De La Rue to complete the circuit between Picasso's painting and Rockefeller's tapestry version, separated by the Atlantic Ocean, and in doing so complete the journey of this book.

De La Rue first encounters *Guernica* as a ten year-old in Madrid, where it makes such 'a tremendous impact on [her] psyche' she decides that someday she will 'do something' with the painting.[13] Her path back to *Guernica* takes three decades, culminating in the film-based work *A Cry for Peace* (2014). The connection she feels with Picasso is partly through the fascination they share in bullfighting, reflected in her portrait

series *Matador*. 'I see a parallel between the matador and Sophocles' tragic hero', she tells me, 'and also with the warrior or the soldier. In the figure of the matador you can see the dichotomy of human existence – beauty and cruelty, life and death, parallels with Greek tragedy.'

When the idea comes to her to make a video work with a matador, using *Guernica* as a backdrop, it is possible she doesn't realize quite what she is attempting. The Succession Picasso has never allowed *Guernica* to be used in a piece of contemporary art in this way before, and it takes a year-and-a-half to get their permission, but her persistence finally wins through. The place of the film's first showing will equally require extraordinary diplomacy.

The film begins with a black screen, its darkness punctuated with the guttural grunts of a bull. Then the left-hand section of the painting appears, with the matador standing facing us, in front of the mother and child and below the head of the bull, his red *muleta* (cape) gathered in his left hand, the front of his elaborate black and white bullfighter's costume, the *traje de luces* (suit of lights), stained with what appears to be blood. He unfurls the cape and as he swings it across and around his body in 'a pass', the next section of the painting is illuminated. The matador's progress across the painting is accompanied by music by Argentine composer Gustavo Santaolalla and a soundscape De La Rue creates with Mexican sound artist Martín Hernández, featuring the bull's hot breath, the sound of planes, a sudden swell of a church organ and a final warning peal of bells. The third and final section of the painting is also released from darkness with a flourish of the cape, the three stages of the film echoing the three acts of a bullfight: the prosecution, sentencing and execution of the bull.

Despite the precision and elegance of his movements, the figure in the film is a real bullfighter, Javier Conde, one of the most famous to emerge from Picasso's birthplace of Málaga in

recent years. 'Yes, he is a matador, not a dancer,' De La Rue tells me.

> He is dancing with death. These choreographed movements are what they do, the way they practise before going into the ring. It is called *toreando de salon,* salon bullfighting. I didn't tell him 'move like a dancer', I told him to do the *toreando de salon* in front of the painting, parallel to it and from this spot to this spot: because the painting is long he could play with it; the movements are his, you know, it is his creation.

What about the red stain on his costume?

> The blood on his jacket is real; we were working within a very particular timeframe and dates and he had used that jacket in a bullfight the previous day – I asked him not to wash it. When he makes a downward movement with the cape, you hear record ings of the same kind of planes that bombed Gernika that Martín found in a sound archive from the 1940s; we included them because there is this connection between war and *tauromaquia.* The matador is a metaphor, he is the one taking us on a journey through the devastation of war.

Rather than arrange a conventional exhibition in a gallery or museum, De La Rue decides the right place for its first showing is somewhere completely different. 'I thought, ideally, the place to make a statement with the film, to honour the victims of war and also Picasso himself, would be the United Nations in New York, reinforcing the statement that Picasso made in *Guernica,*' she says. Once again it is a friendship that provides the contact that gets De La Rue, and her film, inside the United Nations building, this time with Muna Rihani Al Nasser, the Chair of UN Women for Peace. So it is De La Rue finds herself making a statement to hundreds of delegates at the United Nations, feet away from where the tapestry was covered up in 2003, befor screening *A Cry for Peace.* 'I show you this film hoping that we may reflect upon our own light and our own darkness,' she tells them, 'hoping that we will reawaken to our own violence and

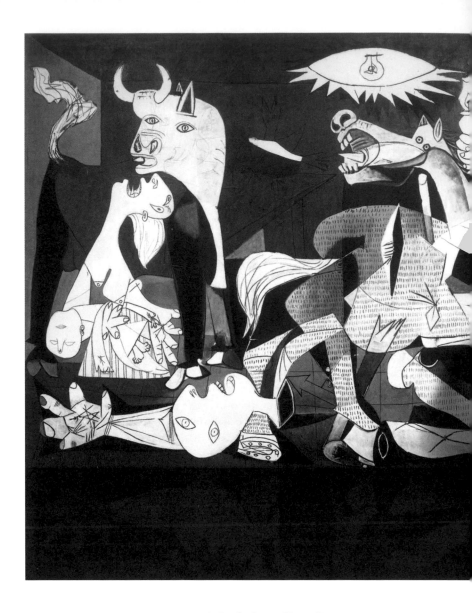

DENISE DE LA RUE, *A Cry for Peace,* film still, 2014

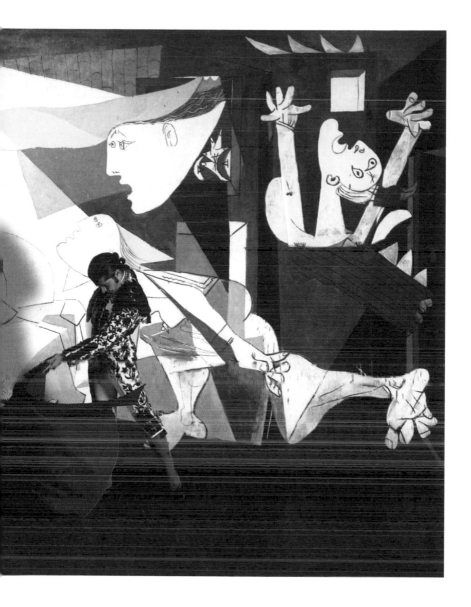

our own peace and by embracing that contradiction we may transcend it.'*

Through her action Denise De La Rue reconnects both the painting and the tapestry to the anti-war message attributed to them in the mid-twentieth century, reconciling their divergent histories. Picasso's work is seen in the context of an elemental, blood-soaked Spanish heritage loved by its creator, embodied by a dancing Malagueño matador who is married to a flamenco singer from Granada, the city where Lorca was murdered. In the bullfight, the opposing forces of beauty and violence are held in balance, each essential to the other: as Lorca tells us, 'the *duende* does not come unless he sees the possibility of death'.

In 1937 *Guernica* was not only a denouncement of an act of terrorism, it was seen by many as a warning of what awaited Europe if the balance tipped and fascism was allowed to continue unchecked. It may be La Pasionaria was wrong and the struggle that began with the civil war in Spain did not end when the painting arrived in Madrid. Perhaps it is just beginning – many seem to think so. If that proves to be the case, people will continue to be drawn back to the painting that, more than any other, seems to express their deepest fears.

* In 2014, when De La Rue showed the film, the tapestry was still on tour, returning to its original position at the UN in March 2015.

AFTERWORD
Picasso, Baby!

To me there is no past and future in art. If a work of art cannot live always in the present it must not be considered at all.[1]

PABLO PICASSO, 1923

My own travels in Spain have taken me both to where *Guernica* is and where it is not. To Gernika-Lumo itself, where its absence is marked by a piece of public art, a mosaic set among municipal planting that spells out the town's claim to the famous image that has stolen its name, and that both commemorates its link to a tragic event and somehow prevents it from ever leaving it behind: *"Guernica" Gernikara*, the inscription beneath it reads – *Guernica* to Gernika. As a spokesman for the Basque National Liberation Movement succinctly put it in the 1990s, 'we gave up the bodies and they got the painting'. Outside the Peace Museum a Spanish guide asks a group of English schoolchildren who have just descended from a coach what they know about the place they have arrived in. A boy raises his hand hesitantly, before saying: 'It was… bombed?'

I travel back to Bilbao by train. A mist has blown in from the sea, similar to the one the Nationalists claimed would have prevented aircraft taking off on 26 April, 1937, obscuring the wooded hillsides around Gernika. On my headphones I am listening to Jay-Z perform *Picasso Baby*, effortlessly skewering the connections between art, money, greed and status that disturb Macuga. He wants a Picasso for his *casa*, he tells us, as well as some Jeff Koons balloons, a Basquiat for his kitchen and a house like Tate Modern, along with the predictable mountains of cash. How long will it take us to realize that he is the modern day Pablo Picasso, baby?[2] Frank Gehry's titanium battleship, the Guggenheim Bilbao, is moored beside the River Nervión. The museum has transformed the fortunes of the post-industrial city, justifying the considerable investment placed in it by the Basque regional authorities. It has, however, failed in one of its key ambitions: Gehry, it is well known, allocated a space within his original design to accommodate *Guernica* and the museum's director general, Juan Ignacio Vidarte, was always clear he hoped a temporary loan of the painting would mark the museum's inauguration. Twenty years later, exhibiting *Guernica* is

one the 'dreams' of his directorship that remains unrealized; he still considers the refusal of the Guggenheim's request 'a mistake... it would have been a great gesture and a very special moment if *Guernica* had been present at the opening of the museum'.

At the information desk I try to establish where I might encounter the space within the Guggenheim that *Guernica* was intended to inhabit, setting off a flurry of discussion. 'I will have to ring someone', a woman tells me, 'because we have a difference of opinion.' As we wait, she tells me about her own grandmother, who survived the bombing of Gernika, but wasn't particularly concerned about Picasso's painting. 'Most of the people in Gernika at that time were farmers or fishermen, they weren't interested in modern art or the Parisian avant garde,' she explains. 'It was very different to the globalized world we now live in.' This reminds her of her own first encounter as a fourteen-year-old with *Guernica,* in its tapestry form, in the United Nations building when she visited New York on a school trip; the fame of the work's creator was not quite as ubiquitous as might have been expected. 'The guy there at the United Nations, who

Gernika, 2016

showed us around, who was meant to be knowledgeable, told us, "Here we have *Guernica,* by the artist Goya"! So my grandmother didn't know about Picasso, but neither did the guy in New York.'

Finally I am directed to room 208, on the second floor. The museum is showing an extensive survey of works by Francis Bacon, who was transfixed by seeing his first Picasso exhibition at the age of seventeen; the floating wall within the curved space of the room which could well accommodate *Guernica* instead bears Bacon's late *Triptych* of 1987. The left and central panels show details of wounded bodies, both with dressings and bleeding wounds; the right a lowered bull's head, with one horn dipped in blood. However hard one tries to leave behind the romanticism, the mythology, the braggadocio of the Picasso legend, it is impossible to escape the *corrida,* it seems. On the opposite wall hangs Bacon's last painting, *Study of a Bull* from 1991, in which he has glued dust from the floor of his studio to the canvas beneath the hooves of the almost immaterial, ghostly animal, as though the space of the studio and the bull-ring are one.

Returning to the ground floor, I am summoned by urgent signals to the information desk, where, they tell me, there is 'still a little bit of controversy'. They have spoken with a curator, who has told them that the space allocated to *Guernica* was in fact room 304, on the third floor. Once more I ascend, to find the room hung with a display of works by the generation of abstract painters, including Mark Rothko, Clyfford Still and Robert Motherwell, who usurped Picasso from his throne in the 1950s and 1960s, at least in America. Here, for the moment, Clement Greenberg has triumphed. A large, blue abstract, 'Anthropometry' by Yves Klein has taken the interior wall, possibly the position Gehry intended for *Guernica.*

According to the linear logic of the formalist critics who initially championed works like these, Picasso's painting should

long since have been relegated to the status of historical object. New conflicts deserve new means of expression: bullfighting, eternally suffering women and warriors bearing swords seem metaphors from a past so distant as to be only discoverable through a process of art-historical archaeology. But modernism, we now know, was wrong; history does not proceed in a straight line, but in a series of loops that condemn us to confronting the same monsters, again and again. *Guernica* not only mourns the victims of war, but the greater historical failure of both modernity and the Enlightenment to deliver on their promises. Technology, instead of bringing an end to back-breaking labour and emancipating the masses for a life of leisure, delivers death from the air; just as in our own age the internet, alongside its great benefits, has spawned conspiracy theories, voter manipulation and propaganda, threatening democracy itself.

Back in Madrid, the painted object refuses to stay still, continuing to mutate and reveal new aspects of its identity. At the press view of an exhibition marking its eightieth birthday, I find myself standing in front of *Guernica* with Manuel Borja-Villel, the director of the Reina Sofía Museum, contemplating its lunar surface. 'When *Guernica* left The Museum of Modern Art in New York to come here,' he tells me, 'they put varnish on it to protect it. Picasso never wanted that. Now the varnish is getting oxidized so we're thinking of removing it.' He chuckles at the uproar such a suggestion has caused, despite the sophistication of the latest, non-invasive techniques. 'Now there is a slight cartoonish element to the painting because the problem with varnish is that it flattens everything; once we remove it, the restorers think that in that leg' – he points to the back leg of the bull, on the extreme left of the canvas – 'you will be able to see all kinds of nuances, because varnish is not only opaque it makes those nuances disappear.' He nods, 'because Picasso was the master of the macro *and* the micro'.

Guernica may appear to have come to rest at the Reina

Sofía, but it has not relinquished its position on the world stage. Painted at top speed using a visual language evolved in Paris almost a century ago, it seems the painting still connects with our sense of outrage and our terror, a lens that penetrates the fog of disinformation clouding contemporary events. British and French politicians call the bombing of Aleppo by Russian forces a modern-day Guernica; civilian deaths in Mosul after a raid by Iraqi government forces are claimed to be the result of ISIS soldiers dynamiting the building. Crude, cartoon versions of Picasso's painting, with the heads of those responsible inserted, circulate online. Despite all our technological advances, the human body remains as fragile as ever, whether under bombardment in the Middle East or struck by weaponized vehicles in London, Nice or Barcelona.

For this reason, if for no other, *Guernica* continues to speak to our condition.

Acknowledgements

I would like to acknowledge the generous support of The Society of Authors' Authors' Foundation towards travel while writing this book. Heartfelt thanks to all those who have helped and encouraged me on this project, welcomed me into their homes, museums and studios, agreed to be interviewed, picked up the phone or replied to correspondence; as well as to the authors, art historians and scholars who have trodden these paths before and on whose work I have depended.

Especial thanks are due to
Nicola Ashmore, Lutz Becker, Soheila Benlevi, Manuel Borja Villel, Iwona Blazwick, David Breuer, Mohamed Bushara, Amina Darwish, the enthusiastic staff on the information desk at the Guggenheim Bilbao, Peter Kennard, Goshka Macuga, Malitte Matta, Ramuntcho Matta, Richard Milbank who commissioned and Georgina Blackwell who edited this book, Frances Morris, Upamanyu Pablo Mukherjee, Ian Nixon, Concha Iglesias Otheo de Tejada and David Cossi Muñoz at the Museo Reina Sofía Madrid, Denise De La Rue, the ever-patient librarians at the Sackler Library Oxford, Katherine Salahi, Amitava Sanyal, Andrea Schlieker, Sir Nicholas Serota, Tate Library & Archive, Roger Thorp & the Thorp Collection (Hitchin), Francesca Vinter, Pamela Sepulvada and Nayia Yiakoumaki at the Whitechapel Gallery Archive, and Wes Williams

 … and of course Charlotte, my family and friends, without whom none of this would be possible.

Notes

3 Quoted in Hugh Thomas, *The Spanish Civil War* (Penguin, 1989), p. 35.

MATERIALIZING A
DREAM

1 Barr, *Picasso*, p. 272.

2 From a transcript in the Alfred H. Barr Jr papers, The Museum of Modern Art archives.

3 Conversation with the author, Epaux-Bézu, France, 2016.

DEATH AND GEOMETRY

1 Translation by Martin Minchom, from his Spain's Martyred Cities: From the Battle of Madrid to Picasso's Guernica (2015), a detailed survey of international press accounts of the Civil War and their possible influence on Guernica.

2 André Malraux, *La Tête d'obsidienne* (Gallimard, 1974), p. 42.

3 See Lutz Becker, *Cut and Paste: European Photomontage 1920–45* (Estorick Collection, 2008).

4 Conversation with the author, London, December 2016.

5 Frances Morris, unpublished interview with Dora Maar, Paris 1990 © Tate. Courtesy of Frances Morris.

6 Stephen Spender, '*Guernica*', *New Statesman and Nation*,

PRELIMS

1 Alfred H. Barr Jr, *Picasso: Fifty Years of his Art*, (The Museum of Modern Art, New York, 1946), p. 250.

INTRODUCTION

1 Antonio Saura, *Contra el Guernica* (La Central/ Fundación Archives Antonio Saura/Museo Reina Sofía), 1992.

THE DISINTEGRATION OF THE WORLD

1 T. J. Clark, *Picasso and Truth: From Cubism to Guernica* (Princeton University Press, 2013), p. 25.

2 Simone Gauthier, 'Picasso, The Ninth Decade: a rare interview', Look 20 (November 1967): 87–88, cited by Lydia Gasman, in *Picasso and the War Years 1937–45*, ed. Steven Nash (San Francisco: Fine Arts Museum of San Francisco, 1988), p. 55.

vol. 16., No. 339 (London, 1938), pp. 576–8.

7 Malraux, *La Tête d'obsidienne*, pp. 17–19.

8 John Richardson, 'A Different *Guernica*', review of Xabier Irujo, *Gernika, 1937: The Market Day Massacre*, New York Review of Books, May 12, 2016.

9 *Life*, vol. 3, no. 4, July 26, 1937, p. 64.

10 Robert Rosenblum, 'Picasso's Disasters of War: The Art of Blasphemy', in *Picasso and the War Years: 1937–45*, (Thames & Hudson, 1998), p. 50.

11 Jerome Seckler, 'Picasso Explains', *New Masses* (New York), LIV, 11: March 13, 1945, pp. 4–7.

12 Pablo Picasso, message to Alfred H. Barr at the Museum of Modern Art, conveyed by his dealer Daniel Henry Kahnweiler, quoted in Alfred H. Barr, *Picasso: Fifty Years of his Art*.

13 Theodor W. Adorno, *Aesthetic Theory* (1970), trans. Robert Hullot-Kentor (London: The Athlone Press, 1997), p. 150.

14 Theodor W. Adorno, *Philosophy of New Music* (1949), trans. and ed. Robert Hullot-Kentor (University of Minneapolis Press, 2006), p. 32.

15 Rosenblum, 'Picasso's Disasters of War', p. 49.

16 Françoise Gilot, as translated by T. J. Clark in

Picasso and Truth: From Cubism to Guernica, p. 225.

17 John Berger, *The Success and Failure of Picasso*, (Granta Books, 1992), p. 169.

18 Barr, *Picasso*, p. 202.

19 Christian Zervos, 'Picasso: Between Two Charnel Houses', in *Picasso and Matisse*, (Victoria and Albert Museum, 1945).

20 Vernon Clark, 'The *Guernica* Mural – Picasso and Social Protest', *Science & Society* 104, (Winter 1941), pp. 72–8.

21 Richardson, 'A Different *Guernica*'.

22 Quotes taken from Brian Sewell, 'The Glove that Changed *Guernica*', *Evening Standard*, London, Thursday 7 May, 2009.

23 Clark, *Picasso and Truth*, p. 245.

24 I am indebted to the work of T. J. Clark in arriving at this understanding, not just through his writings (already cited) but in the extraordinary exhibition *Pity and Terror: Picasso's Path to Guernica* he curated with Anne M. Wagner in 2017 at the Reina Sofia Museum in Madrid

25 'Mater Dolorosa: The Women of Guernica', Anne M. Wagner in *Pity and Terror: Picasso's Path to Guernica* (Museo Nacional Centro de Arte 2017), p. 109.

IT WILL BE SPOKEN OF FOR A LONG TIME

1 Herbert Read, *What is Revolutionary Art?*, written for the Revolutionary Art Symposium organized by the Artists' International Association, London, 1935.

2 *Exposition Internationale: Arts and Crafts in Modern Life, Paris 1937: Official Guide* (English Edition), Editions de la Société pour le développement du tourisme, 1937.

3 Ibid.

4 Quoted in Richardson, 'A Different *Guernica*'.

5 Quoted in Gijs van Hensbergen, *Guernica: The Biography of a Twentieth-Century Icon* (Bloomsbury, 2004), p. 74.

6 For a further explanation of the painting's imagery and connection to *Guernica*, see Karen Kurczynski, *The Art and Politics of Asger Jorn: The Avant-Garde Won't Give Up* (Ashgate, 2014), pp. 54–5.

7 Julian Trevelyan, *Indigo Days* (MacGibbon and Kee, 1957), p. 79.

8 Anthony Blunt, 'Picasso Unfrocked', *The Spectator*, 6 August 1937.

9 *London Bulletin* no 6, October 1938, p. 6.

10 Herbert Read letter, *The Spectator*, 15 October 1937, p. 20.

11 Juan Larrea to Roland Penrose, 12 February 1938, Roland Penrose Archive,

Scottish National Gallery of Modern Art, RPA 717, in Simon Martin, *Conscience and Conflict: British Artists and the Spanish Civil War* (Lund Humphries, 2014), p. 121.

12 *Manchester Guardian*, 25 June 1937.

13 John Rothenstein, in William Chappel (ed.), *Edward Burra: A Painter Remembered by his Friends* (André Deutsch, 1982).

14 Quoted in Tom Buchanan, *The Impact of the Spanish Civil War in Britain: War, Loss and Memory* (Sussex Academic Press, 2007), p. 84.

15 Martin, *Conscience and Conflict*, p. 82.

16 Trevelyan, *Indigo Days*, p. 79.

17 Myfanwy Piper, *Back in the Thirties*, in Frances Spalding, *John Piper Myfanwy Piper: Lives in Art* (OUP, 2009), p. 119.

18 Michel Archimbaud, *Francis Bacon: In Conversation with Michel Archimbaud* (Phaidon, 1992), p. 34.

19 See Martin Hammer, *Bacon and Sutherland: Patterns of Affinity in British Culture of the 1940s* (Yale University Press, 2005), p. 202.

20 Quoted in Douglas Cooper, *The Work of Graham Sutherland* (Lund Humphries, 1961), p. 17.

21 Graham Sutherland in 'Images Wrought from Destruction', *Sunday Telegraph Magazine*, 10 September 1971.

22 Hans Ulrich Obrist, *Lives of the Artists, Lives of the Architects* (Penguin, 2015), p. 572.

23 John Richardson, 'A Different *Guernica*'.

24 *The Oxford Times*, 22 October 1938. Oxford residents will have another chance to see the exhibition the following year, in a show organized by the New Oxford Art Society and a young student called Denis Healey, who will later become Deputy Leader of the Labour Party.

25 *The Yorkshire Post*, 13 December 1938.

26 Roland Penrose, 'Picasso's Angriest Painting Goes Home', *The Times*, 18 September 1981.

27 Clement Attlee, *As it Happened* (Heinemann, 1954), p. 95.

28 Trevelyan, *Indigo Days*, p. 88.

29 Cited in research by Helen Little, curator of the exhibition 'Picasso & Modern British Art', on the Tate website: http://www.tate.org.uk/context-comment/articles/guernica-car-showroom, retrieved 31 January 2017.

A MESSAGE FROM ONE AGE TO ANOTHER

1 From 'The New Colossus' (1883) by Emma Lazarus, inscribed on the base of the Statue of Liberty in 1903.

2 Figures for attendance at the World's Fair vary considerably. Gijs van Hensbergen reports attendance of 'an estimated 60 million visitors' in *Guernica: The Biography of a Twentieth Century Icon*, p. 106. Helen A. Harrison claims that attendance 'fell far short of the expected 50 million' in *Dawn of A New Day: The New York World's Fair 1939/40* (New York University Press, 1980), p. 1. Arthur Herman specifies that over 44 million people attended its exhibits in two seasons, *Freedom's Forge: How American Business Produced Victory in World War II* (Random House, 2012), p. 58.

3 Helen A. Harrison, *Dawn of A New Day: The New York World's Fair 1939/40* (New York University Press, 1980).

4 Diary entry, January 1939, cited in Harrison, *Dawn of A New Day*, p. 65.

5 Ibid, p. 65.

6 'Art in Our Time' (The Museum of Modern Art, 1939).

7 David Sylvester, *Interviews with American Artists* (Chatto & Windus, 2001), p. 8.

8 Harold Rosenberg, 'The Fall of Paris', *Partisan Review* VII (1940), p. 440.

9 William B. Scott and Peter M. Rutkoff, *New York Modern: the Arts and the City* (The Johns Hopkins University Press, 1999), p. 295.

10 R. Blesh, *Modern Art U.S.A.* (Alfred A. Knopf, 1956), pp. 268–9.

11 Steven Naifeh and Gregory Smith, *Jackson Pollock: An American Saga* (Barrie & Jenkins, 1990), p. 350.

12 Kirk Varnedoe, 'Comet: Jackson Pollock's Life and Work' in *Jackson Pollock* (Museum of Modern Art, 1998), p. 34.

13 Harold Rosenberg, 'The Search for Jackson Pollock', *Art News*, February 1961, p. 35.

14 Robert Motherwell, interview with Sidney Simon, January 1967, 'Concerning the Beginnings of the New York School 1939–43', in Stephanie Teranzio (ed.) *The Collected Writings of Robert Motherwell* (University of California Press, 1992), p. 158.

15 Ibid., p. 160.

16 Mary Ann Caws, 'Robert Motherwell and the Modern Painter's World', in *Artists, Intellectuals, and World War II: The Pontigny Encounters at Mount Holyoke College 1942–44* (University of Massachusetts Press, 2006), p. 116.

17 Robert Motherwell, 'The Modern Painter's World', *Dyn*, 6 November 1944, reproduced in Dore Ashton (ed.), *The Writings of Robert Motherwell* (University of California Press, 2007), pp. 27–36.

18 Robert Motherwell, 'The Painter and the Audience', from *The Collected Writings of Robert Motherwell* p. 105.

19 Jackson Pollock, Application for Guggenheim Fellowship, 1947 © the Pollock-Krasner Foundation, Inc., cited in Pepe Carmel (ed.) *Jackson Pollock: Interviews, Articles, and Reviews*, Museum of Modern Art, 2002, p. 17.

20 Peggy Guggenheim, *Out of This Century: The Informal

Memoirs of Peggy Guggenheim (Dial Press, 1946), p. 344.

21 Letter from Alfred H. Barr to Picasso, 15 June 1953.

22 The wall text was reproduced in the pages of *Art Digest*, 15 October 1939.

23 *A Call to a Congress of American Artists in Defence of Culture,* June 6–8 1941, New York City. Archives of American Arts, Smithsonian Museum, Washington DC.

MORE OR LESS TRUE

1 Malitte Matta, conversation with the author, Epaux-Bézu, France, 2016.

2 Marguerite Zorach, *The Family of John D. Rockefeller Jr. at their Summer Home, Seal Harbor, Maine.*

3 The originals of Alfred H. Barr's correspondence related to the *Guernica* tapestry from February 1956 are held in folder 239, box 28, Nelson A. Rockefeller Papers, Rockefeller Family Archives, Rockefeller Archive Center, Sleepy Hollow, NY, and are cited in K. L. H. Wells, 'Rockefeller's *Guernica* and the Collection of Modern Copies', *Journal of the History of Collections*, vol. 27, issue 2, pp. 257–77. I am indebted to K. L. H. Wells' extensive research.

4 Ibid.

5 Cited in Marcia R. Pointon (ed.), *Art Apart: Art Institutions and Ideology Across England and North America* (Manchester University Press, 1994), p. 233.

6 *The Art of Collecting,* narrated by Aline Saarinen, broadcast 19 January 1964 on NBC, cited in Wells, 'Rockefeller's *Guernica*'.

7 Jean-Paul Sartre, 'The Artist and his Conscience', in *Situations* by Jean-Paul Sartre, trans. Benita Eisler, (Fawcett Crest, 1966).

8 Vladimir Kemenov, 'Aspects of Two Cultures', 1947, VOKS Bulletin Moscow USSR Society for Cultural Relations with Foreign Countries, cited in Herschel B. Chipp, *Theories of Modern Art* (University of California Press, 1968), pp. 20–36.

9 Clement Greenberg, 'Abstract, Representational and So Forth', in *Art and Culture: Critical Essays* (Beacon, 1961), pp. 133–8.

10 Clement Greenberg, 'The School of Paris 1946', in *Art and Culture.*

11 Walter Darby Bannard, *Art Forum*, vol. 10, June 1971, pp. 58–66.

12 Correspondence between Pablo Mukherjee and the author, 23 March 2017.

13 *The New York Times,* 1 March 1974.

14 Tony Shafrazi interviewed by Owen Wilson, *Interview* magazine, 4 March 2009.

15 Felix Gmelin interviewed on the Saatchi Gallery website, http://www.saatchigallery.com/artists/artpages/felix_gmclin_kill_lies.htm, retrieved 10 June 2017.

16 The film can be seen on Vimeo at https://vimeo.

com/39115724, retrieved 10 June 2017.

17 Faith Ringgold, *We Flew Over the Bridge: Memoirs of Faith Ringgold* (Duke University Press, 2005), p. 157.

18 An Evening with Faith Ringgold, 7 December 2016, The Museum of Modern Art: Public talk with Anne Umland, The Blanchette Hooker Rockefeller Curator of Painting and Sculpture, and Thomas J. Lax, Associate Curator, Department of Media and Performance Art.

AT SOME POINT IN THE NEAR FUTURE

1 Andrea Giunta, 'Picasso's *Guernica* in Latin America', *Ciha 2008: Crossing Cultures: Conflict, Migration, Convergence: the University of Melbourne, 13–18th January 2008* (University of Melbourne, 2008), pp. 747–750.

2 Public Law 95-426, 95th Congress, 7 October 1978, 92 Stat 987, Sec.605 (a).

3 See Ellen C. Oppler (ed.), 'Introductory Essay: *Guernica* Its Creation, Artistic and Political Implications, and Later History', in *Picasso's Guernica* (Norton, 1988), pp. 45–136.

4 Telephone conversation with the author, 25 October 2016.

5 Correspondence with the author, 21 March 2017.

6 For fuller details of the process and negotiations involved in *La Vuelta,* see Gijs

van Hensbergen's *Guernica: the Biography of a Twentieth-Century Icon.*

7 Mary Ann Caws, *Pablo Picasso* (Reaktion Books, 2005), p. 131.

8 *El País*, 31 October 1981, cited by van Hensbergen, *Guernica*, p. 309.

9 Rafael Alberti, 'El *Guernica* debe venir a una España segura', *El País*, 30 April 1981, cited in Casey Lesser, 'The *Guernica* Effect: The Power and Legacy of Picasso's *Guernica*' (College of William & Mary Undergraduate Honors Theses, 2011), paper 376. http://publish.wm.edu/ honorstheses/376, retrieved March 2017.

10 Herschel B. Chipp, 'El *Guernica* y sus trabajos preparatorios', in *Guernica-Legado Picasso: Museo del Prado, Casón del Buen Retiro, Madrid, Oct. 1981* (Ministerio de Cultura, Madrid, 1981), pp. 124–148.

BEAUTY AND THE BEAST

1 Antonio Saura, *Contra el Guernica* (La Central/ Fundación Archives Antonio Saura/Museo Reina Sofía). My translations are from the French edition (1992).

2 'Requiem for *Guernica*', in ibid, p. 94.

3 'Pour Sauver *Guernica*', in ibid, p. 105.

4 UN Press Release SG/ SM/6782, 3 November 1998.

5 '*Guernica* Cover-Up Raises Suspicions', *Los Angeles Times*, 6 February 2003.

6 Cited in David Walsh, 'UN conceals *Guernica* from Powell's Presentation', World Socialist Web Site, 8 February 2003.

7 'The Guernica Myth', Claudia Winkler, *The Weekly Standard*, 16 April 2003.

8 'Powell without Picasso', Maureen Dowd, *The New York Times*, 5 February 2003.

9 Conversation with the author, November 2016.

10 'Collecting Art by Women', Whitechapel Gallery, Saturday 4 March 2017, organized together with AWARE: Archives of Women Artists, Research and Exhibitions.

11 David Craven, 'C. L. R. James as a Critical Theorist of Modern Art', in Kobena Mercer (ed.), *Cosmopolitan Modernisms* (Institute of International Visual Arts).

12 'Remaking Picasso's *Guernica*', https:// remakingpicassosguernica. wordpress.com, retrieved 1 April 2017.

13 Quotations from Denise De La Rue are taken from conversations with the author in 2017.

PICASSO, BABY!

1 Statement to Marius de Zayas, reproduced in Barr, *Picasso: Forty Years of His Art*, p. 11.

2 Jay-Z's *Picasso Baby: A Performance Art Film*, in which the rapper performs the track at New York's Pace Gallery in front of an audience of celebrities, fans and artists, can be seen on Vimeo: https:// vimeo.com/80930630, retrieved 13 June 2017.

Selected Bibliography

Adorno, T. W., *Aesthetic Theory* (1970), trans. Robert Hullot-Kentor (London: The Athlone Press, 1997).

Anfam, D., *Abstract Expressionism* (London, Thames & Hudson, 1990).

Arnheim, R., *The Genesis of a Painting: Picasso's Guernica* (Berkeley: University of California Press, 1962).

Ashton, D., *Picasso on Art: A Selection of Views* (London: Thames & Hudson, 1972).

Ashton, D., (ed.), *The Writings of Robert Motherwell* (University of California Press, 2007).

Barcelona City Hall, *Art contra la Guerra: Entorn del pavelló espanyol a l'exposició internacional de París de 1937* (Barcelona: Ajuntament de Barcelona, 1986).

Barr, A.H. (ed.), *Picasso: Forty Years of his Art* (New York: Museum of Modern Art, 1939).
_____ *Picasso: Fifty Years of his Art* (New York: Museum of Modern Art, 1946).

Becker, L., *Cut and Paste: European Photomontage 1920–45* (Estorick Collection, 2008).

Benfey, C., and Remler, K., *Artists, Intellectuals, and World War II: The Pontigny Encounters at Mount Holyoke College 1942–44* (Amherst: University of Massachusetts Press, 2006).

Bjerkof, S. (ed.), *Asger Jorn: Restless Rebel* (Munich: Prestel, 2014).

Bjerstrom, C.-H., *Josep Renau and the politics of culture in Republican Spain, 1931–1939: Re-imagining the nation* (Eastbourne: Sussex Academic Press, 2016).

Blesh, R., *Modern Art U.S.A.* (New York: Alfred A. Knopf, 1956).

Blunt, Anthony, *Picasso's Guernica* (Oxford University Press, 1969).

Brassaï, *Conversations with Picasso* (Chicago: University of Chicago Press, 1999).

Brooksbank Jones, A., *Visual Culture in Spain and Mexico* (Manchester: Manchester University Press, 2007).

Buchanan, T., *The Impact of the Spanish Civil War in Britain: War, Loss and Memory* (Eastbourne, Sussex Academic Press, 2007).

Caws, M. A., *Pablo Picasso* (London: Reaktion Books, 2005).
_____ *Dora Maar: With and Without*

Picasso (London: Thames & Hudson, 2000).

Chipp, H. B., *Picasso's Guernica: History, Transformations, Meanings* (London: Thames & Hudson, 1989).

Clark, T. J., *Picasso and Truth: From Cubism to Guernica* (Princeton, Oxford: Princeton University Press, 2013).

Clark, T. J., and Wagner, A. W. (eds.), *Pity and Terror: Picasso's Path to Guernica* (Madrid: Museo Nacional Centro de Arte Reina Sofía, 2017).

Cox, A., *Art-as-Politics: the Abstract Expressionist Avant-garde and Society* (Ann Arbor, Michigan: UMI Research Press, 1982).

Cowling, Elizabeth, *Visiting Picasso: The Notebooks and Letters of Roland Penrose* (Thames & Hudson, 2006).

Galantière, L. (ed.), *America and the Mind of Europe* (London: Hamish Hamilton, 1951).

Gale, M., *Arshile Gorky: Enigma and Nostalgia* (London: Tate Publishing, 2010).

Goodyear, A.C. (Preface), *Art In Our Time: an exhibition to celebrate the tenth anniversary of the Museum of Modern Art and the opening of its new building, held at the time of the New York World's Fair* (New York: Museum of Modern Art, 1939).

Greenberg, C., *Art and Culture: Critical Essays* (Boston, Massachusetts: Beacon Press, 1961).
_____ *The Collected Essays and*

Criticism, 4 vols. (Chicago: University of Chicago Press, 1944, 1986, 1993).

Guggenheim, P., *Out of This Century: The Informal Memoirs of Peggy Guggenheim* (Dial Press, 1946).

Guilbaut, S., *How New York Stole the Idea of Modern Art* (Chicago: University of Chicago Press, 1983).

Giunta, A., 'Picasso's *Guernica* in Latin America', in *Ciha 2008: Crossing Cultures : Conflict, Migration, Convergence* (University of Melbourne, 2008).

Hammer, M., *Bacon and Sutherland: Patterns of Affinity in British Culture of the 1940s* (London: Yale University Press, 2005).

Harris, J., and Koeck, R., *Picasso and the Politics of Visual Representation: War and Peace in the Era of the Cold War and Since* (Liverpool: Liverpool University Press, 2013).

Harrison, H. A., *Dawn of A New Day: The New York World's Fair 1939/40* (New York University Press, 1980).

van Hensbergen, G., *Guernica: the Biography of a Twentieth-Century Icon* (London: Bloomsbury, 2004).

Irujo, X., *Gernika, 1937: The Market Day Massacre* (Reno: University of Nevada Press, 2015).

Joachimedes, C. M., and Rosenthal, N., *American Art in the Twentieth Century: Painting and Sculpture 1913–1993* (London: Royal Academy of Arts, 1993).

Kurczynski, K., *The Art and Politics of Asger Jorn: The Avant-Garde Won't Give Up* (Ashgate, 2014).

Larrea, J., *Guernica, Pablo Picasso*, (New York: C. Valentin, 1947).

Klein, P. K., *The Saint-Sever Beatus and its Influence on Picasso's Guernica* (Valencia: Patrimonio, 2012).

Lesser, C., 'The *Guernica* Effect: The Power and Legacy of Picasso's *Guernica*' (College of William & Mary Undergraduate Honors Theses, 2011).

Lindqvist, S. A., *A History of Bombing* (London: Granta, 2001).

Luckow, D., and Hermes, C. J. (eds.), *Picasso in Contemporary Art* (Cologne: Snoeck, 2015).

Macuga, G., *The Nature of the Beast* (London: Whitechapel Gallery, 2009).

Malraux, A., *La Tête d'obsidienne* (Paris: Gallimard, 1974), translated into English as *Picasso's Mask* (1976).

Martin, S., *Conscience and Conflict: British Artists and the Spanish Civil War* (Lund Humphries, 2014).

Minchom, M., *Spain's Martyred Cities: From the Battle of Madrid to Picasso's Guernica* (Eastbourne: Sussex Academic Press, 2016).

Morris, L, and Grunenberg, C., *Picasso: Peace and Freedom* (London: Tate Publishing, 2010).

Naifeh, S., and Smith, G., *Jackson Pollock: An American Saga* (London: Barrie and Jenkins, 1989).

Nash, S. A., and Rosenblum, R. (eds.), *Picasso and the War Years 1937–45* (London, New York: Thames & Hudson, 1988).

O'Brien, P., *Picasso* (London: Collins, 1976).

Obrist, H. U., *Lives of the Artists, Lives of the Architects* (London: Allen Lane, 2015).

Oppler, E. C. (ed.), *Picasso's Guernica* (New York: W. W. Norton & Company, 1988).

Pérez Sánchez, A. E., and Gallégo, J., *Goya: The Complete Etchings and Lithographs* (Munich: Prestel, 1995).

Penrose, R., *Picasso: His Life and Work* (London: Granada, 1981).

Picasso, P., *Collected Writings* (London: Aurum, 1989).

Preston, P., *The Spanish Civil War* (London: Weidenfeld & Nicolson, 1986).

Rankin, N., *Telegram from Guernica* (London: Faber & Faber, 2003).

Richardson, J., *A Life of Picasso*, 3 volumes (London: Jonathan Cape, 1991, 1996, 2009).

———— *The Sorcerer's Apprentice: Picasso, Provence and Douglas Cooper* (London: Jonathan Cape, 1999).

Ringgold F., *We Flew Over the Bridge: Memoirs of Faith Ringgold* (Durham, North Carolina: Duke University Press, 2005).

Russell, M., *Picasso's War: the Extraordinary Story of an Artist, an*

Atrocity, and a Painting that Shook the World (London: Scribner, 2003).

Sabartés, J., Picasso, Portraits and Souvenirs (Paris: Louis Carré, 1946).

Sandler, I., The Triumph of American Painting (New York: Harper & Row, 1970).

Saura, Antonio, Contra el Guernica (La Central/Fundación Archives Antonio Saura/Museo Reina Sofía, 1981).

Scandiani, G., and Fister, C. E., Pollock and the Irascibles: The New York School (New York: Whitney Museum of American Art, 2013).

Schwartz, K., Rises in the East: A Gallery in Whitechapel (London: Whitechapel Gallery, 2009).

Scott, William B., and Rutkoff, Peter M., New York Modern: the Arts and the City (The Johns Hopkins University Press, 1999).

Shaw, G., Smith, E., and Stanley, M., Graham Sutherland: An Unfinished World (Oxford: Modern Art Oxford, 2011).

Southworth, H., Guernica! Guernica! A Study of Journalism, Diplomacy, Propaganda and History (Berkeley: University of California Press, 1977).

Stafford, K. O., Narrating War in Peace: The Spanish Civil War in the Transition and Today (Basingstoke: Palgrave Macmillan, 2015).

Steer, G. L., The Tree of Gernika: A Field Study of Modern War (London: Hodder and Stoughton, 1938, Faber & Faber, 2012).

Sylvester, D., Interviews with American Artists (London: Chatto & Windus, 2001).

_____ The Brutality of Fact: Interviews with Francis Bacon (London: Thames & Hudson, 1987).

Thomas, Hugh, The Spanish Civil War (London: Penguin Books, 1986).

Trevelyan, J., Indigo Days (London: MacGibbon & Kee, 1957).

Tusell, J., Spain: From Dictatorship to Democracy: 1939 to the present (Oxford: Wiley-Blackwell, 2007).

Utley, G. R., Picasso: The Communist Years (New Haven: Yale University Press, 2000).

Werckmeister, O. K., Icons of the Left: Benjamin and Eisenstein, Picasso and Kafka after the Fall of Communism (Chicago: University of Chicago Press, 1997).

Weschler, D. B., Territorios de Dialogo 1930–45: España, México, Argentina (Buenos Aires: Mundo Nuevo, 2006).

Picture Credits

p.7
Dora Marr, *Picasso working on Guernica in his studio in the rue des Grands Augustins*, 1937 © ADAGP, Paris and DACS, London 2017 / Photographic Archives Museo Nacional Centro de Arte Reina Sofia.

p.10
French postcard of bombed Guernica: Roger Thorp.

pp.14–15 Picasso, *Guernica*, 1937 © Succession Picasso/DACS, London 2017 / Museo Nacional Centro de Arte Reina Sofia.

p.19
Robert Capa, *Paris. May 1st, 1937. May Day celebrations* © Robert Capa © International Center of Photography/Magnum Photos.

p.35
Dream and Lie of Franco I, 8 January 1937 © Succession Picasso/DACS, London 2017 / Guggenheim Collection, Venice, Italy / Bridgeman Images.

p.47
Spain Against the Invaders, 1938: James Attlee.

p.48
Francisco Goya, 'Ravages of War', from *The Disasters of War*, 1810–14. Private Collection / Index / Bridgeman Images.

p.49
Picasso, *The Studio: The Painter and his Model: Arm Holding a Hammer and Sickle*, 1937 © Succession Picasso/DACS, London 2017 / © RMN-Grand Palais (Musée National Picasso – Paris) / Sylvie Chan-Liat.

p.51
Picasso, *Sketch for Guernica*, 1 May 1937, I. © Succession Picasso/DACS, London 2017 / Photographic Archives Museo Nacional Centro de Arte Reina Sofia.

p.51
Picasso, *Sketch for Guernica*, 1 May 1937, II © Succession Picasso/DACS, London 2017 / Photographic Archives Museo Nacional Centro de Arte Reina Sofia.

pp.52–53
Dora Maar, *Photo Report of the Evolution of 'Guernica'*, stage I, 1937 © ADAGP, Paris and DACS, London 2017 / Photographic Archives Museo Nacional Centro de Arte Reina Sofia.

pp.56–57
Dora Marr, *Photo Report of the Evolution of 'Guernica'*, stage II, 1937 © ADAGP, Paris and DACS, London 2017 / Photographic Archives Museo Nacional Centro de Arte Reina Sofia.

p.59
Reconstruction of the 1937 Spanish Pavilion in Barcelona, 1992: James Attlee.

pp.68–69
Francisco Goya, *The Third of May 1808*, 1814. Prado, Madrid, Spain / Bridgeman Images.

p.71
Photomural by Josep Renau, 1917. © RMN – François Kollar/ Localisation: Charenton-le-Pont, Médiathèque de l'Architecture et du Patrimoine / Photo © Ministère de la Culture - Médiathèque du Patrimoine, Dist. RMN-Grand Palais / François Kollar.

p.72
Brassaï, *Picasso in his studio in the rue des Grands Augustins with The Catalan*, 1939 © Estate Brassaï – RMN-Grand Palais / Localisation: Paris, Musée National Picasso, Paris /Photo © RMN-Grand Palais (Musée National Picasso, Paris) / Franck Raux.

p.77
Picasso, *Guernica*, 1937 (detail) © Succession Picasso/DACS, London 2017 / Museo Nacional Centro de Arte Reina Sofia.

pp.78–79
Picasso, *Minotauromachy*, 1935 © Succession Picasso/DACS, London 2017 / Museo Picasso, Barcelona, Spain / Index / Bridgeman Images.

p.83
Picasso, *Guernica*, 1937 (detail) © Succession Picasso/DACS, London 2017 / Museo Nacional Centro de Arte Reina Sofia.

pp.88–89
Dora Marr, *Photo Report of the Evolution of 'Guernica'*, stage VI, 1937 © ADAGP, Paris and DACS, London 2017 / Photographic Archives Museo Nacional Centro de Arte Reina Sofia.

p.95
Picasso, *Guernica*, 1937 (detail) © Succession Picasso/DACS, London 2017 / Museo Nacional Centro de Arte Reina Sofia.

pp.96–97
Francisco Goya, *The Second of May 1808* or *'The Fight Against the Mamelukes'*, 1814. Prado, Madrid, Spain / Bridgeman Images.

p.100
Beatus de Liebana, Commentary on the Apocalypse of Saint-Sever (detail), eleventh century. Photo 12/ UIG via Getty Images.

p.103
Picasso, *Study for a Weeping Head (I). Preliminary drawing for Guernica*, 1937 © Succession Picasso/DACS, London 2017 / Photographic Archives Museo Nacional Centro de Arte Reina Sofia.

p.107
Picasso, *The Three Dancers*, 1925 © Succession Picasso/DACS, London 2017 / © Tate, London 2017.

p.108
Picasso, *Nude Standing by the Sea*, 1929 © Succession Picasso/DACS, London 2017 / The Metropolitan Museum of Art/Art Resource/ © Photo SCALA, Florence.

p.111
Picasso, *Nude Reclining by the Window*, 1934. © Succession Picasso/DACS, London 2017 / © RMN-Grand Palais (Musée National Picasso – Paris) / Sylvie Chan-Liat.

p.116
Horacio Ferrer de Morgado, *Madrid 1937 (Black Aeroplanes)*. Photographic Archives Museo Nacional Centro de Arte Reina Sofia.

pp.122–123
Asger Jorn, *The Troll and the Birds*, 1944 © Asger Jorn/ copydanbilleder.dk. / Museum Jorn, Silkeborg, Denmark.

p.132
Graham Sutherland, *Gorse on a Sea Wall*, 1939 © The estate of Graham Sutherland / Collection Ulster Museum.

pp.136–137
Poster for an exhibition of Picasso's *Guernica* at the New Burlington Galleries, London, October 1938 © The National Galleries of Scotland.

p.140
The Labour Party leader Clement Attlee opens the *Guernica* exhibition at the Whitechapel Art Gallery, January 1939. © The National Galleries of Scotland.

p.143
Leaflet announcing the *Guernica* exhibition, distributed by the Manchester Foodship for Spain campaign, 1939. Courtesy the Working Class Movement Library, Salford.

p.146
The torch-bearing arm of Bartholdi's Statue of Liberty. Wikimedia Commons.

p.157
No. 507 in *Jackson Pollock : a catalogue raisonné of paintings, drawings, and other works* vol. III (Newhaven, London: Yale University Press, 1978). Brown pencil on paper. 8 11/16 by 8 1/4 in (22.1 x 20.9 cm), c. 1939–40 © The Pollock-Krasner Foundation ARS, NY and DACS, London 2017.

p.157
No. 537 in *Jackson Pollock : a catalogue raisonné of paintings, drawings, and other works* vol. III (Newhaven, London: Yale University Press, 1978). Brown pencil on paper, 8 11/16 by 8 1/4 in (22.1 x 20.9 cm), c. 1939–40 © The Pollock-Krasner Foundation ARS, NY and DACS, London 2017.

p.183
Rudolf Baranik, *Stop the War in Vietnam Now!*, 1967 © Rudolf Baranik / Center for the Study of Political Graphics, Culver, California.

p.184
Mathieu Tremblin, *Kill Lies All 2.0*, (After Pablo Picasso) [1937], Tony Shafrazi [1974] Guillaume Pellay [2010], 2012 © Mathieu Tremblin © Guillaume Pellay © Succession Picasso/DACS, London 2017.

pp.186–187
Faith Ringgold, *American People Series #20: Die*, 1967. © Faith Ringgold / ARS, NY and DACS, London 2017 / The Museum of Modern Art, New York/©Photo SCALA, Florence.

p.191
Postage stamp, Czechoslovakia. 1967: James Attlee.

pp.214–215
Goshka Macuga, *The Nature of the Beast*, tapestry, 2009 © Succession Picasso/DACS, London 2017. Courtesy Goshka Macuga.

p.218
Photograph of Havana by David Craven, November 2003 © Succession Picasso/DACS, London 2017 © David Craven.

pp.222–223
Denise De La Rue, *A Cry for Peace*, film still, 2014. © Succession Picasso/DACS, London 2017 © Denise De La Rue, 2014.

p.229
Gernika, 2016: James Attlee.

Every effort has been made to contact copyright holders for permission to reproduce material in this book, both visual and textual. In the case of any inadvertent oversight, the publishers will include an appropriate acknowledgement in future editions of this book.

Index

Illustrations are denoted by the use of *italics*.

A

Abstract Expressionism 147, 150, 179
Adorno, Theodor W. 87, 170, 171
Aftermath: World Trade Center Archive (Meyerowitz) 217
Agence Espagne 20
Aguirre, José Antonio 118, 139
Al-Nasser, Muna Rihani 221
Alberti, Rafael 201
American Abstract Artists 154–5
American Artist's Congress Against War and Fascism (AAC) 148
American People Series #20: Die (Ringgold) 185–7, 187
Annan, Kofi 208–9
'Anthropometry' (Klein) 230
Aragon, Louis 33, 67
Araquistáin, Luis 25, 26, 196
Artists International Association (AIA) 126, 130, 141
Astray, José Millán 34–6
At the Front (Puyól) 115
Atkins, Guy 125
Attlee, Clement 138–9, 140
Aub, Max 20, 119–20, 196
Azaña Díaz, Manuel 41

B

Bacon, Francis 133
Baines, Harry 142
Baldwin, Stanley 29

Balzac, Honoré de 23–4
Bannard, Walter Darby 179
Baranik, Rudolf 183
Barcelona 22
 Barcelona Museum of Art 115
 Picasso Museum 190–1, 192
Barr, Alfred H. 92, 154–5, 163, 164, 167, 174–5, 177
Barrault, Jean-Louis 23
Bartholdi, Frédéric Auguste 146,
Basque region 13, 30, 37, 39–40, 102, 119, 197
Basquiat (film) 185
Basquiat, Jean-Michel 185
Bataille, Georges 23, 99
Bauhaus 31
Bayreuth 27
Baziotes, William 155, 158
Beatus de Liebana, *Commentary on the Apocalypse of Saint-Sever* 99, 100
Becker, Lutz 67, 70
Beckmann, Max 75
Benjamin, Walter, *Work of Art in the Age of Mechanical Reproduction* 171
Bergamín, José 20, 33
Berger, John 92
Bilbao 30, 37, 38, 40
 Guggenheim Bilbao 228
Blazwick, Iwona 212–13, 217
Blum, Léon 20, 29
Blunt, Anthony 93, 127, 141
Bombardment (Fernández Cuervo) 115
Borja-Villel, Manuel 231
Boston Museum of Modern Art 155
Braque, Georges 172
Brassaï 12, 70, 72
Breton, André 81, 99, 131
British Union of Fascists 129, 130
Brunner, Kathleen, *Picasso Rewriting Picasso* 48
bullfighting 11, 76, 82, 84, 85–6, 219–20
Buñuel, Luis 118
Burra, Edward 129

C

Cahiers d'Art (journal) 120, 154
Calder, Alexander 59, 213
Calley, Lieutenant William 182
Calvo-Sotelo, President Leopoldo 201
Capa, Robert 18, 19, 33, 70, 84
Casón del Buen Retiro (Prado annex) 199, 200, 201, 206
catalogue raisonné of paintings, drawings, and other works, vol. III (Pollock) 157
Cavero, Iñigo 200, 201, 203, 206
Caws, Mary Ann 200
Centennial International Exhibition of 1876 (Philadelphia) 146
Cervantes, Miguel de 104
Chagall, Marc 172
Chamberlain, Neville 130
Chipp, Herschel B. 76, 80, 202
Clark, T. J. 101, 106
Clark, Vernon 93
Command of the Air (Douhet) 31
Communist art 114, 117
Conde, Javier 220–1
Condor Legion 30–1, 39
Consequences of War (Rubens) 105
Constructivism 31, 67, 155
Contra el Guernica (Saura) 207–8
Contre-Attaque (left-wing group) 23
corrida see bullfighting
Craven, Arthur 176–7
Craven, David 218
Craxton, John 126
Cry for Peace, A (De La Rue) 219, 222–3
Cuba 217–18
Cubism 32, 90, 91, 106

D

Dadaism 67, 155
Daladier, Édouard 130
Dalí, Salvador 131, 149
Daskall, George 99
de Kooning, Willem 150, 154
De La Rue, Denise 219–24, 222–3